ART AND HISTORY
OF
UMBRIA

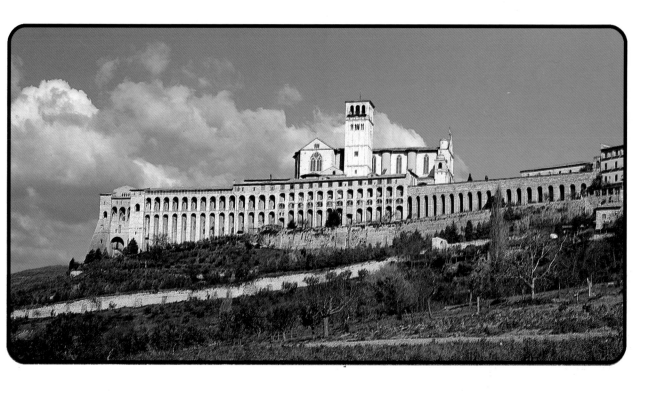

BONECHI

© Copyright by CASA EDITRICE BONECHI
Via Cairoli, 18/b - 50131 Firenze - Italia
Tel. 55/576841 - Fax 55/5000766 - Telex 571323 CEB

Printed in Italy by Centro Stampa Editoriale Bonechi

Text by: *Giuliano Valdes* - Editing Studio, Pisa

ISBN 88-7009-984-9

The author and publisher are grateful to Prof. Bruno Dozzini
and Guido Lemmi of Perugia for their valid collaboration
in the preparation of this volume.

PHOTO CREDITS

Paolo Giambone:
pages 1; 20; 23; 29 above; 31 below; 38-39; 94; 95 below; 100 left;
101 below left; 109; 120.

Gaetano Barone:
pages 5; 6; 7; 10; 11; 12; 13; 14; 15; 16; 36; 37; 39 below; 40; 41; 42;
43; 44; 45; 46 left; 48 above; 49; 50; 53 left; 54; 55; 56; 57; 60; 61;
62; 63; 64 below; 66; 67; 69; 70 above; 73; 74; 76; 77; 78; 80; 81; 82;
83; 84; 85; 86; 87; 91 above; 93; 96 above; 98; 101 above; 102; 103
below; 105 below; 106; 108; 110; 111 below; 114 above; 115 below;
117; 118; 119; 121; 125.

Giuliano Valdes-Editing Studio, Pisa:
pages 48 below; 52; 75; 107 above; 115 above; 122; 123; 124.

Studio Fotografico Gavirati,Gubbio:
page 53 right.

Andrea Pistolesi:
pages 8; 9; 18; 19; 28 above; 30 below; 31 above; 32; 34; 46 right;
47; 51; 64 above; 65; 68; 70 below; 71; 72; 79; 88; 89; 90; 91 below;
92; 95 above; 96 below; 97; 99; 100 right; 101 below right; 103
above; 111 above; 112; 113; 114 below; 116.

Foto Scala, Florence:
pages 17; 58; 59.

Father Gerhard Ruf:
pages 22; 24; 25; 26; 27; 28 below; 29 below; 30 above; 33 below.

By the courtesy of
Azienda di Promozione Turistica del Ternano:
pages 104;105 above; 107 below.

Ufficio Stampa-Promozione del Comune di Umbertide:
page 126.

INTRODUCTION

GEOGRAPHICAL BACKGROUND

Surrounded by Tuscany, Lazio and the Marches, Umbria is one of the smallest regions of Italy (8456 sq.kms) and is the only one whose boundaries do not touch the sea. Nonetheless, there is a wide range of different landscapes to be found here, ranging from the Apennine mountains and the sweeping expanses of hilly ranges, to the large valleys and broad lowlands. All these multifarious landscapes combine to form an overall picture of such scenic beauty that the definition of Umbria as "the Green heart of Italy" would seem to be an extremely suitable one. The inland basins are all tributaries of the Tiber, which runs in a north-south-easterly direction, making up the watershed between the Tyrrhenian and Adriatic Seas.

The Umbrian-Marches Apennine runs from the Bocca Trabaria to the Forca Canapine and comprises Mt. Catria, Mt. Pennino and Mt. Vettore, which forms part of the Sibillini mountain range. In fact, the Apennines themselves run along the same course, changing direction on the reliefs of Mt. Urbino, Mt. Subasio and Mt. Coscerno. At the mouth of the upper Valtiberina, between the river courses of the Tiber, the Topino and the Nera lie the lower reaches of the Martani Mountains. The inland lowlands were formed as a result of the silting up of ancient lakes during the Quaternary period (a well-known example being the immense Lake Tiberino which once stretched from Sansepolcro to Terni): worthy of note are the plains of Gubbio, Gualdo Tadino, Norcia and Terni.

As well as the Valtiberina (in the north), two other valleys worthy of note are the Valle Umbra, between Torgiano and Spoleto, along which runs the Marroggia, the Clitunno, the Topino and the Chiascio rivers, and the wild Valnerina valley, nestling between picturesque gorges up until the point where the Terni plain opens out.

As well as the other sources of water which cover the surface area (widespread examples of Karst phenomena are to be found on the slopes of the Sibillini mountains), mention should be made of the river Paglia, the river Nestore and the lakes. These lakes include the enormous Lake Trasimeno (the largest of the region), Lake Piediluco and the artificial basins of Corbara, Alviano and Valfabbrica.

The population of Umbria is just over 800,000 inhabitants which is evenly distributed throughout the region. There are only two provincial capitals: Perugia and Terni. However, there are also many large towns and places of great artistic, urban and historical interest. These include Foligno, Spoleto, Città di Castello, Gubbio, Assisi, Orvieto, Todi and Norcia.

The climate of Umbria is influenced by its geographical position, being so close to the Apennine mountains and relatively far away from the sea (in fact, none of its boundaries touches the sea at all). Therefore, in winter it is cold and damp, while in summer, the weather is hot and often sultry. The annual rainfall is around 800mm. The lower reaches of the valleys are sometimes steeped in mist and fog. Although there are only occasional and sporadic spells of snow along the plains and across the hills, it falls more frequently and lingers longer along the higher reaches of the Apennine mountains.

HISTORY

Archaeological remains dating back to the Palaeolithic and Neolithic periods document Man's presence in Umbria since the most remote times. On the other hand, the history of this region must obviously date back thousands of years, given its geographical position - at the centre of the Italian peninsular - forming a dividing line between Northern and Southern Italy, as well as being a watershed between the Tyrrhenian and Adriatic Seas. The first Oscan-Umbrian colonies were formed in the 11C B.C., during the same period that the town settlements appeared, initially extending far beyond the region's present boundaries.

Later, as other tribes moved into the region - above all, the Etruscans, - but also the Celts, Piceni and the Sabines, the Umbrians were forced to reside in more compact and restricted territory. The seven bronze Eugubine Tablets (3C-1C B.C.) give indisputable proof of the existence of the ancient language of the Umbrian people, as well as furnishing an interesting insight into the life and customs of those times. The presence of the Etruscans in Umbria, verified by the findings made mainly in the areas lying to the right of the Tiber, is thoroughly documented at Perugia and Orvieto (Volsinii). The Roman colonization of Umbria, which took place after they had beaten the Etruscan, Samnite and Gaulish confederates at Sentino (295 B.C.), led to the decline of the Umbrian civilization which gradually became more integrated with that of Rome. This came about as a result of the founding of new towns and important public works and buildings, but above all by the conferring of Roman citizenship upon the Umbrian people (90 B.C.). The magnitude of the work the Romans accomplished in Umbria cannot fail to be noticed by even the least observant of visitors. The ruins of many roads, bridges, temples and entire cities (Carsulae) and also theatres, amphitheatres, walls and town gates, demonstrate the Romans' skill as builders and engineers (a well-known example being the splendid irrigation system in which the waters of the Velino river were diverted into those of the Nera, creating the Cascata delle Marmore).

The Early Christian period marked not only the beginning of a new faith but also foreshadowed the construction of splendid churches and basilicas, which make Umbria one of the most important regions in terms of monuments and landmarks. These also provided the basis for the innovative, and

in a certain sense, revolutionary religious uprisings, defended by the Western Monasticism of St Benedict and the Franciscan movement, which came into being with the advent of the great saint of Assisi. Meanwhile, the various struggles between the Goths and the Byzantines, and the later arrival of the Lombards, finally led to the territories of Umbria being divided up between the Lombards (the Dukedom of Spoleto) and the Byzantines, who took control of Perugia, Narni and Terni.

Between the 8C and the 9C, as a result of land donated by the Franks, the Church was able to gain control of the territories which had been under Lombard and Umbro-Byzantine control. From the 11C onwards, the setting up of free communes marked a greater awareness of their individuality on the part of the major towns (Perugia, Assisi, Spoleto, Foligno, Terni, Gubbio, Città di Castello). At the same time, this period foreshadowed the beginning of bitter feuds between the Guelphs and the Ghibellines, paladines of the Papacy and the Empire.

During the 14C and the 15C, in spite of the strong domination of noble lords (e.g. Baglioni at Perugia, Atti at Todi, Trinci at Foligno, Monaldeschi at Orvieto) and the presence of "condottieri" (leaders of mercenary troops) (e.g. Braccio Fortebraccio da Montone, Niccolò and Iacopo Piccinino, the Gattamelata), the region became gradually more integrated with the territories controlled by the Papacy. Between the 15C and the 18C, in spite of some attempts at rebellion against the Papal government (the so-called "Salt War" of 1540 at Perugia being a famous example), Umbria seems to have taken an aloof stance towards the upheavals of that time, even though some remarkable and innovative trends (above all in art and architecture) were taking place in the region.

At the time of Napoleon Bonaparte's arrival in Italy, Umbria, between 1798 and 1799, was part of the Roman Republic. Afterwards, it became a part of the Papal State once again, as the result of the re-establishment of the Viennese Assizes (1815). After frequent rebellious uprisings, which fuelled the Risorgimento movement in the region, Umbria was annexed to the new Italian Kingdom in 1860.

ART HISTORY

Burial grounds, necropolises, tombs and the ruins of polygonal walls are just some of the numerous and highly significant features, which remain as a result of the Etruscan period in Umbria. Of great historical importance are the Etruscan Arch, the Porta Marzia and the Ipogeo dei Volumni at Perugia. At Orvieto can be found the Necropolises of the Cannicella and the Crucifix of Tufa.

The romanization of Umbria resulted in both major public buildings and important centres being erected. Such is the case of the Via Flaminia (parts of which are paved with large blocks of stone) and the ancient ruins of Carsulae. There are also numerous Theatres, the most outstanding being those of Gubbio and Spoleto; Amphitheatres (Spoleto, Assisi, Spello, Todi), Bridges (Narni, Spoleto), Temples and Mausoleums (Assisi, Gubbio, Campello sul Clitunno).

As a result of the first Christian uprisings and the establishing of primitive communities of believers, sacred buildings and Early Christian basilicas were erected. These include the Basilica of the Saviour at Spoleto (4C); the Temple of Clitunno, re-converted into the Church of the Saviour (4C); the Church of St Angelo (6C) and the Basilica of St Peter (10C) at Perugia.

The remarkable flourishing of the Romanesque style in Umbria is often found accompanied by motifs and features of Lombard design. Worthy of note are the marvellous Cathedral of Spoleto (12C) and the Church of St Euphemia (12C); the Cathedral of Assisi (12-13C), the Churches of St Michael and St Silvester at Bevagna (late 12C) and the Church of the Saviour at Terni (parts of which are Early Christian).

At Assisi, the Basilica of St Francis, a shining masterpiece of the Umbrian transition style (13C), represents a milestone in the art of this region, due to its wonderful frescoes painted by Giotto, Cimabue, Pietro Lorenzetti and Simone Martini. The Basilica inspired the building of numerous churches at that time, both within the town (e.g.St Clare) and elsewhere (St Francis in Terni, St Francis "al Prato", in Perugia).

The Cathedral of Orvieto, a famous example of the architectural style of Maitani, represents one of the most vivid examples of the Gothic style in Umbria (13C-14C). Other examples of Gothic architecture are the People's Palace and the Captain's Palace (both 13C) at Todi; the Priors' Palace (13C) at Perugia and the Consuls' Palace at Gubbio (14C). The bas-reliefs of the facade of the Cathedral of Orvieto (by Maitani) and the sculptures of the Fontana Maggiore at Perugia (Nicola and Giovanni Pisano) are considered to be the most famous examples of Gothic figurative art in Umbria.

Considerable evidence of the Renaissance period can be seen in the Bramante-influenced Temple of St Mary of Solace (16C) at Todi; the Ducal Palace at Gubbio (15C) - the architect Laurana used theDucal Palace of Urbino as a model; the Porta San Pietro and the Oratory of San Bernardino (Perugia, both dating from the 15C); the Spada Palace at Terni, the last work of Antonio da Sangallo the Younger (16C). Renaissance painting in Umbria boasts contributions made by the great Tuscan masters such as Benozzo Gozzoli, Filippo Lippi, Beato Angelico (Foligno and Orvieto) and Masolino da Panicale (Todi, Church of San Fortunato). The beautiful frescoes which adorn the Cappella Nuova of the Cathedral of Orvieto are the works of another Tuscan artist, Luca Signorelli. The most important painters of the Umbrian school are Pietro Vannucci (Perugino), whose works are exhibited in the National Gallery of Umbria and in the Collegio del Cambio at Perugia, and Bernardino di Betto (Pinturicchio) whose wonderful frescoes can be seen at the Cappella Baglioni (Church of S. Maria Maggiore at Spello).

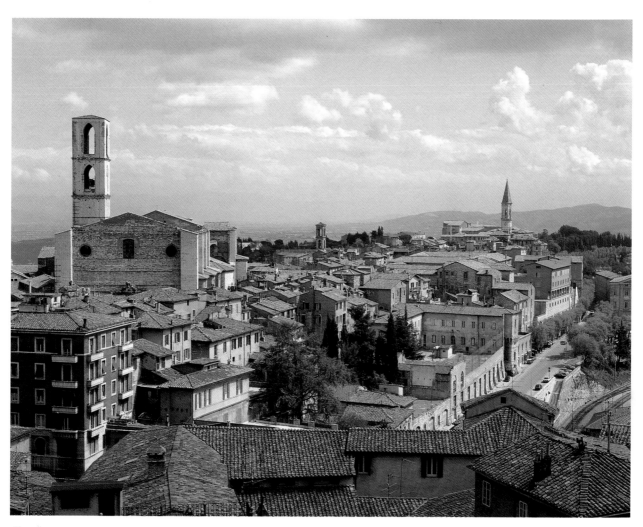

Perugia, panorama.

PERUGIA

HISTORICAL BACKGROUND - *The capital city of Umbria and of the Province (i.e. Province of Perugia), Perugia stretches out on a hilly ridge situated between the basin of Trasimeno and the Valtiberina. The city is extremely imporant in artistic monumental and urban terms and is the seat of major cultural institutions. Prehistoric finds have provided proof of the existence of extremely ancient human settlements in the area. Herodotus, Pliny and Dionysius of Halicarnassus made references to the founding of a proto-historic settlement by the Sarsinate Umbrians. Between the 6C and 5C B.C. the Etruscans had penetrated most of the region of Umbria. Having become one of the twelve key cities of the Etruscan federation (4C-3C), it then went on to become a Roman colony after the epic battle of Sentino (295 B.C.), which brought an end to its Etruscan domination. Allied to Rome during the Punic Wars, it became a place of refuge for the soldiers who survived the fatal battle which Rome lost at Trasimeno (217 B.C.). After a period of relative calm and well-being, the city was involved in the Civil War between Octavian and Mark Anthony, whose brother Lucius tried in vain to resist the troops of Octavian. Having won the war, Octavian's troops then ravaged and sacked the city. Some years later, Octavian, by then Emperor Augustus, rebuilt the city and named it after himself (Augusta Perusia). The city then passed into oblivion during the Imperial Age. The first Christian settlements appeared in the city around the 4C; for certain, it is known that since the second half of the 5C a diocese existed in Perugia. During the Gothic War S.Ercolano (548 B.C.) was martyred here. It was controlled by the Byzantines for a long period before being subjected to ecclesiastical rule (8C). From the 11C onwards, the first free communes were set up. The 12C and 13C heralded a period of struggle and unrest, when Perugia fought against Chiusi, Cortona, Assisi, Todi and Foligno. After the city of Assisi was defeated at Collestrada (1202) Perugia extended its power and control over the Valdichiana and the Apennine ridges. Perugia's political stance (which was openly pro-*

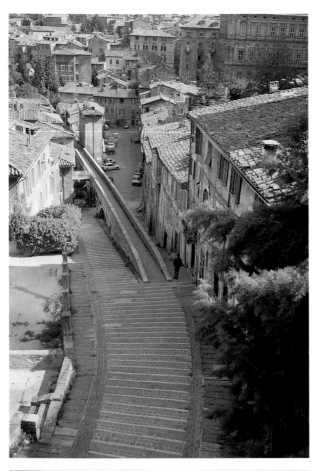

Guelph) led to a growth in the city's prestige, resulting in an increase in both economic and military power. Even in Perugia at the beginning of the 14C, disruptive elements came to the surface, engendered by the social structure of the city itself. The battles fought out between the Raspanti (the wealthy merchant class) and Beccherini nobles, as well as the never ending struggles between the most important local "bigwigs" (Vincioli, Montesperelli, Montemelini, Della Corgna, Baglioni, Oddi) led to the town being subjected to the Church. During the period of noble rule, several individuals rose to power, including Biordo Michelotti, Braccio Fortebraccio, Niccolò Piccinino and Braccio Baglioni. Meanwhile the weakening of the commune's structure led to the disintegration of the social and economic fabric of the city. The so-called "Salt War" (1540) resulted in the definitive collapse of the city, which was reconquered by Pope Farnese and deprived of all liberty and autonomy. To mark this turning point in the history of the town (which would result in Perugia being dependent on the State of the Church for over three centuries), the Paolina Fortress (it was named after Pope Paul III (Farnese)) was built on top of the ruins of the Baglioni Palaces. After the vain expectations of liberty created by Napoleon, the city factions became a united front in the battles for the national "Risorgimento", during which the abhorred Papal fortress (built as a symbol of Papal absolutism) was destroyed, and the Swiss Guards were thrown out of the town. As a result, the city became a part of the Kingdom of Italy (14 September 1860).

Today Perugia is a busy centre of administration and public services. The city has several important industries, as well as the ancient handicrafts produced by the traditional ancient artisan industry (woodcarving and manufacture, jewellery, embroidery work, textiles, stained glass and masks). The State University and the University for Foreigners are two other features of the city, whose leading sector however remains that of tourism. Lying at the heart of the town, the corso Vannucci is exactly the place to go shopping, as it is lined with elegant and charming shops. Artisan ceramics, terracotta objects and other products of the local handicraft industry can be bought at the stalls in Piazza Dante. Various goods are on display at the street market, which takes place every Saturday in Via S.Ercolano. The typical local wines and top quality olive oil can be bought at the covered market in Piazza Matteotti.

Amongst the outstanding features of the local cuisine are the black truffles (when in season) of Norcia, while the local sweets and biscuits include the delicious chocolate almond-flavoured figs, almond biscuits ("death's bones") and the "torciglioni" (almond flavoured cakes in the shape of a coiled serpent). Among the principal local festivities, which enliven the Umbrian capital are La Desolata, ("desolate"), a pageant depicting the scenes from the Passion (Good Friday); the television awards ceremony of Umbria Fiction TV (second week in April); Innovations in Tourism Forum (last ten days in May, biennial); the rock music festival called Rockin' Umbria (mid-July); the music festival Umbria Jazz (mid-July); the Sagra Musicale Umbra (sacred music in Perugia's churches) (first fortnight in September); the antiques exhibition The Jewel and The Antique (end of October-beginning of November); All Souls Fair at Pian di Massiano, which has stalls selling sweets, cakes and handicrafts (2-5 November).

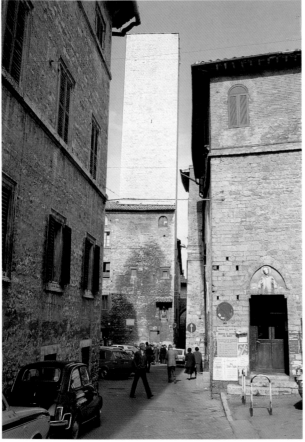

Perugia, a picturesque view of the Via Appia.

Perugia, the Torre degli Sciri, ancient monument of the mediaeval city.

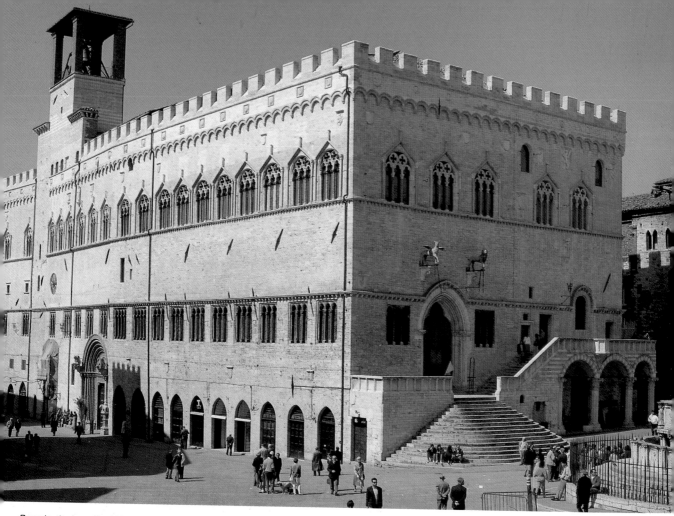

Perugia, the imposing Priors' Palace.

PRIORS' PALACE - Also known as the *Town Hall*, the building is an outstanding example of medieval architecture and is considered to be amongst the most elegant and famous in Italy. Begun by Giacomo di Servadio and Giovannello di Benvenuto (1293), it was completed in 1443, when further additions, in the form of houses and pre-existing towers, were all combined under one huge roof. The splendid facing, built of travertine and limestone from Assisi, together with white and red marble of Bettona, is an extremely impressive sight. The main **facade** facing out over *Corso Vannucci*, has breathtaking proportions; it is surmounted by a Tower, which was reduced in height in the second half of the 16C. The building also has a wealth of mullioned windows with three and four lights. The splendid round **portal** resembles those found in cathedrals, as it is rich in ornamental decorations. The splayed portal has friezes, twisted columns, sculptures and ornamental foliage. The beautiful lunette contains the figures of *St Lawrence, St Ludovic of Toulouse* and *S.Ercolano*. The facade looking out over *Piazza IV*

November has a flight of steps leading up to a pointed portal. On the left side is a loggia containing a pulpit. Above the portal are bronze statues of a *Griffin* (the symbol of the city) and a *Lion* (symbol of the Guelphs), which constitute the first attempts at large-scale casting made in 13C Italy. Above are five mullioned windows with three lights. The whole building is crowned by Guelph merlons. The **Atrium** (entrance-hall) is a covered courtyard with pillars and vaults, from which a large staircase leads up to the **Sala dei Notari** (the lawyers' meeting hall). The imposing medieval hall with grandiose arches has frescoed vaults depicting *Scenes from the Bible and episodes from Aesop's Fables*. These frescoes were painted by pupils of P. Cavallini (13C-14C). On the walls are the coats of arms of the Podestà and Captains of the People. Other rooms in the building include the **Sala del Consiglio Comunale** (the Hall of the City Council) (containing a fresco by Pinturicchio) and the **Sala Rossa** (the Red Hall) (containing a mural by Dono Doni of Perugia).

7

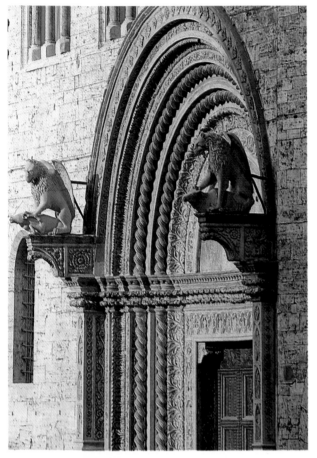

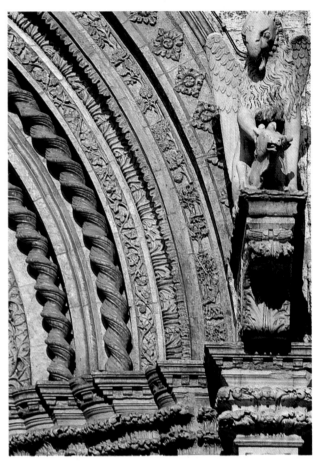

Perugia, details of the wealth of sculptures enriching the magnificent Priors'Palace.

Perugia, the entrance to the Cathedral of St Lawrence with the pulpit of S. Bernardino and the bronze statue of Pope Julius III.

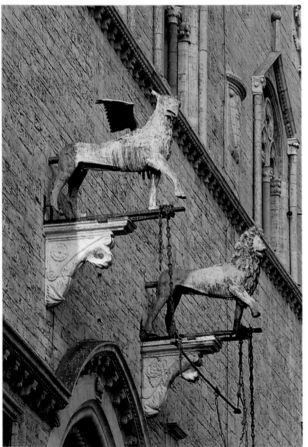

CATHEDRAL OF ST LAWRENCE - This imposing Gothic temple was constructed between the 14C and 15C, although a large amount of its external facing remains incomplete. The simple, coarse stone **facade** has a massive Baroque portal by P. Carattoli (first half of the 18C). In the upper part of the facade is an enormous round window. The **left side** of the building, which looks out over the central *Piazza IV Novembre* is decorated by a portal built by Alessi with ornamental masks by Scalza. Above the portal is a votive *Crucifix*, placed here by the people of Perugia in 1539. To one side of the portal is the pulpit of S. Bernardino (15C). On the other side of the portal, on top of a flight of steps, stands the *Statue of Pope Julius III*, a masterly bronze work by V. Danti (16C).

The **interior**, which is divided into a nave and two aisles by robust octagonal pillars, has the appearance of a large hall of harmonious proportions. The cross vaults contain 18C frescoes. To the right is the *Tomb of Andrea Baglioni* by Urbano da Cortona. The **Chapel of S. Bernardino**, which is enclosed by beautiful wrought iron railings, contains a

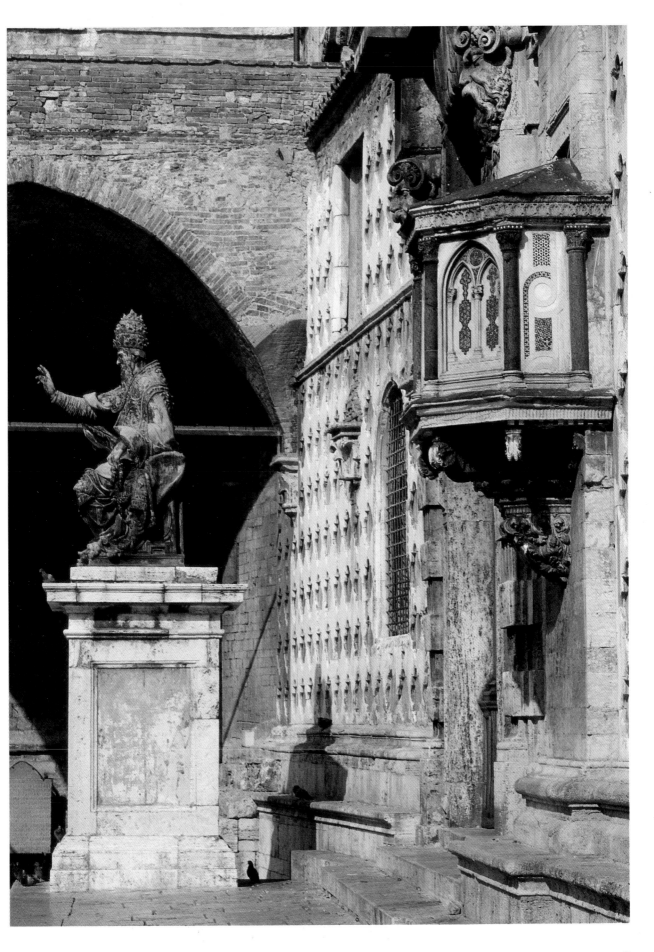

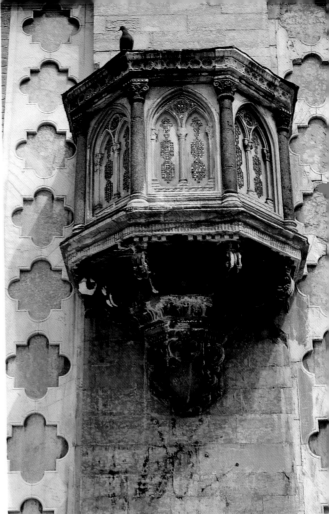

Perugia, a Baroque portal opens up the rough facade of the Cathedral.

Perugia, detail of the pulpit where S. Bernardino used to preach.

16C fresco by Federico Barocci depicting the *Deposition*, generally believed to be the masterpiece of this artist. Also to be seen are the multicoloured stained glass windows by Arrigo Fiammingo (16C) and 16C pews by Jacopo Fiorentino and Ercole di Tommaso. The stained glass window and all the frescoes in the **Chapel of the Baptistry** are by Domenico Bruschi (19C). Along the nave (third pillar) is the venerated image of the *Madonna of the Graces*, by Giannicola di Paolo, a pupil of Pietro Vannucci. The **Chapel of the Sacrament** designed by Alessi has late 18C frescoes by Marcello Leopardi. In the right transept are the *Tombs of Pope Martin IV, Pope Urban IV and Pope Innocenzo III* and the marble sculpture dedicated to *Pope Leo XIII* (19C).

The presbytery is lit by modern stained glass windows and contains beautifully carved choir stalls by Giuliano da Maiano and Domenico del Tasso (15C).

Other features include two 15C lecterns and a bishop's throne. A beautfiul 16C wooden *Crucifix* decorates the altar of the left transept. The walls of the left aisle contain fragments of a sculptured altar-frontal by A. di Antonio di Duccio and Benedetto Baglioni. The altar of the banner is decorated with a 16C processional standard by Berto di Giovanni. The **Chapel of the Holy Ring**, enclosed by beautiful wrought iron railings (15C), is lit by a modern stained glass window. Within the chapel, is a silver and gold plated copper tabernacle, a masterly 16C piece of engraving by Federico di Francesco and Bino di Pietro. This contains the holy relic of an onyx wedding ring, which is supposed to have been worn by the Virgin Mary. Also to be seen is the *Tomb of Mark Antonio Oddi*, a 17C work by Domenico Guidi. The **Sacristy** contains ancient inlaid furnishings by Mariotto di Paolo (15C). The walls have frescoes depicting the *Stories from the Bible, Figures of Popes* and *Doctors of the Church* (G. Antonio Pandolfi 16C). On the walls of the annexed cloister are decorations and sculptures transferred here from the ancient cathedral and other churches in Perugia.

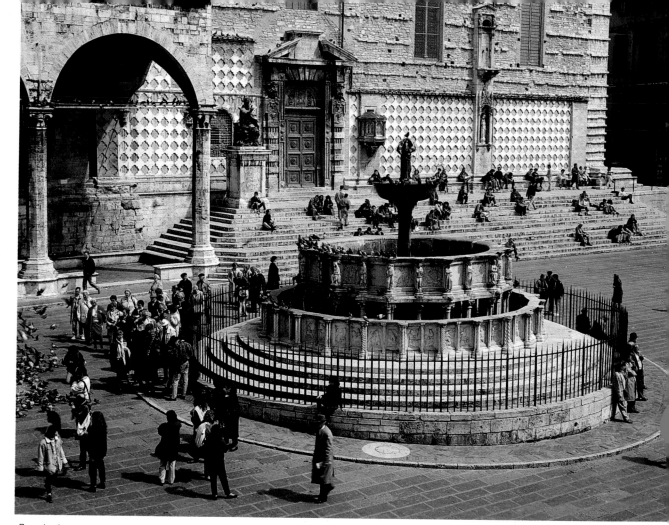

Perugia, the magnificent Fontana Maggiore; in the background the Loggias of Braccio and the side of the Cathedral.

Perugia, detail of sculptures by Nicola and Giovanni Pisano embellishing the Fontana Maggiore.

FONTANA MAGGIORE (THE GREAT FOUNTAIN) -

The fountain stands in the central *Piazza IV Novembre*, the main tourist attraction and monumental heart of medieval Perugia. Looking out over the square are the Priors' Palace, the Bishop's Palace and the Lawyers' Palace (Palazzo dei Notari), the side of the Cathedral and the Loggias of Braccio Fortebraccio. The fountain was built in 1275-78 and designed by Fra' Bevignate, assisted by Boninsegna da Venezia. The marble decorative sculptures were carved by Nicola and Giovanni Pisano, who also built the three bronze *Water Carriers*. The casting of the top bronze basin and column is attributed to Rosso Padellaio. The upper stone basin, sustained by small columns with capitals, consists of 24 red marble panels separated by 24 statues. The bas-reliefs represent *Views, Historical events, Scenes from the Bible, Historical and mythological figures, Allegorical representations of religious and theological subjects, Saints*. The lower basin has 50 panels, on which are depicted the *Months of the Year*, the *Signs of the Zodiac, Liberal Arts, Scenes from the Old Testament, The founding of Rome, Aesop's Fables*.

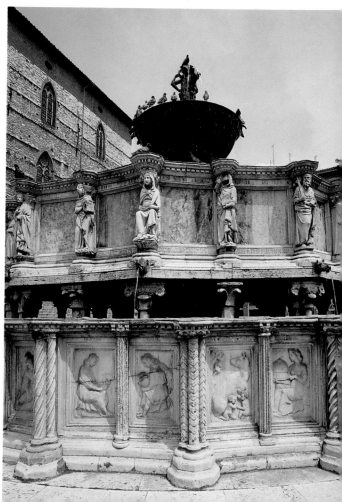

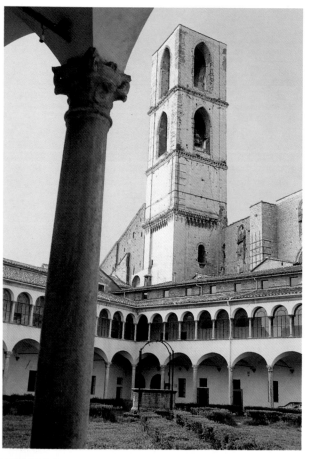

BASILICA OF ST DOMENIC - The imposing Gothic construction (14C) was rebuilt by Carlo Maderno in the first half of the 17C. On either side of the bare **facade** are buttresses which continue around to the sides of the church. An elegant late 16C portal and a double flight of steps decorate the facade. The enormous stark **interior** of the church contains side chapels. The fourth chapel on the right is part of the original building and contains an altar frontal by A.di Antonio di Duccio. The transept chapels contain many votive frescoes. Works of art include an 18C organ; the *Tomb of Elisabetta Cantucci*, carved by Algardi; the *Tomb of the Danti family*; the splendid *Tomb of Pope Benedict XI*, the work of a pupil of Arnolfo di Cambio. The apse is lit by a large window (23 metres in height), beautifully decorated by Fra' Bartolomeo di Pietro and Mariotto di Nardo (15C). The 15C inlaid wooden choir is the work of Crispolto da Bettona and Antonio da Mercatello. Moving towards the entrance, the first chapel on the right is part of the original church and is decorated with 14C frescoes influenced by the Siennese school. At the altar of the third chapel is a painted banner, depicting *Perugia at the beginning of the 16C*. The **sacristy** contains some sacred vestments belonging to Pope Benedict XI.

BASILICA OF ST PETER - In front of the building is an elegant porticoed courtyard, which one enters by means of a 17C loggia. The building is dominated by a beautiful **Campanile**, which has an elevated spire and is exquisitely decorated by mullioned windows with two lights situated above a series of large jutting corbels, which resemble a cornice; it was designed by Rossellino and completed by Giovanni di Betto and Puccio di Paolo in the 15C. The **interior** of the basilica is divided into a nave and two aisles by 18 Roman columns from the original church. The wealth of art works, which decorate the church contribute to the atmosphere of majestic solemnity, which pervades the interior. The church, built in the 10C on the site of the ancient cathedral, has a lacunar (or panelled) ceiling over the nave by Benedetto di Montepulciano (16C). There are ten large canvases by Aliense (Antonio Vassilacchi), depicting *Scenes from the Old and New Testaments* decorating the nave. On the counter - facade is an imposing painting of the *Benedict Order;* at the sides of the portal are the *Scenes from the Lives of St Peter and St Paul* (O. Alfani, L Cungi). The walls of the presbytery contain frescoes by S. Pecennini, B. Bandiera, G. Fiammingo and Giambattista della Marca. Also to be seen is the masterly high altar by V. Martelli (17C), the carved pews by Benedetto de Montepulciano and Benvenuto da Brescia; and the choir, one of the most beautiful in Italy, the work of a considerable number of 16C artists. In the **sacristy** are works by Perugino, Caravaggio and Algardi, as well as some 15C furnishings. In the left aisle, moving towards the entrance, is a *Pietà* (B. Bonfigli); the **Vibi Chapel** (containing a fine marble tabernacle by Mino da Fiesole); the **Ranieri Chapel** (with paintings by G. Reni); the **Chapel of the Sacrament** (containing paintings by Vasari) and finally a *Pietà* by Perugino. The annexed convent buildings, which have been taken over by the University, contain a beauti-

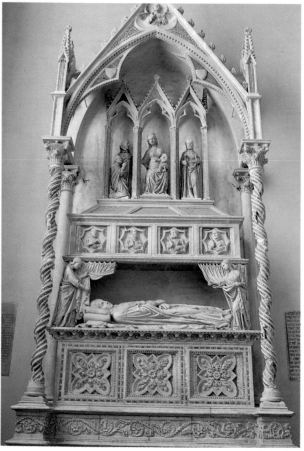

Perugia, view of the Cloister, in two orders of loggias, annexed to the Basilica of St Domenic; in the background, the mighty campanile.

Perugia, Benedict XI's tomb in the interior of the Basilica of St Domenic.

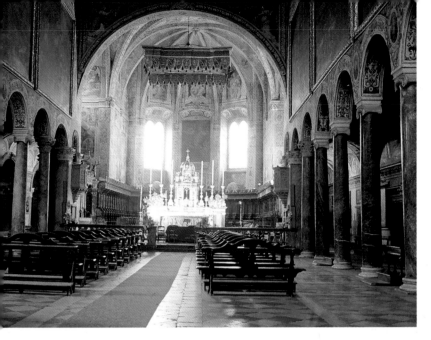

Perugia, internal view of the Basilica of St Peter.

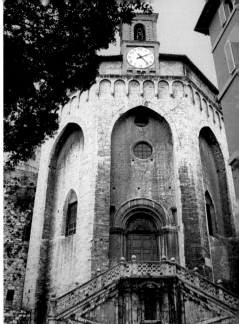

Perugia, partial view of the Church of S. Ercolano.

ful **Large Cloister** with an architrave over the portal (16C); the **Refectory** which contains a terracotta washbasin by Benedetto Buglione, a pupil of the Della Robbias (15C) and the **Star Cloister** (16C) built to designs by Alessi.

ORATORY OF S. BERNARDINO - The date of completion (1461) can be seen in the inscription situated on the frieze below the tympanum dominating the facade. The building is the masterly work of the Florentine Agostino di Antonio di Duccio and clearly shows the maturity gained by the artist as a result of working alongside Leon Battista Alberti (Rimini, Malatesta Temple). A wonderful cycle of sculptures, depicting *Saints* and *Celestial Hierarchies,* and the *Glory of S.Bernardino* are important examples of the Perugia-Renaissance style. The 15C interior, in the Gothic style, contains (at the high altar) the *Tomb of Beato Egidio,* a Roman sarcophagus (4C A.D.). By going through the annexed **Oratory of St Andrew** (16C) which

is a Neoclassical building, and the sacristy of the oratory, one enters the Baldeschi Chapel, where Bartolo da Sassoferrato, a famous 14C jurist and a teacher at the General "Studium" of Perugia, is buried.

THE CHURCH OF S. ERCOLANO - The church, which is dedicated to the patron saint of Perugia, stands on the spot, where S.Ercolano was martyred by Totila, during the period when the Goths besieged the city (547). The Gothic building, built between the 13C and the 14C, has an octagonal plan and is characterized by slender, large pointed arches, with a series of small blind arches under the upper cornice. One enters the **interior** by means of a beautiful double staircase (1607). The upper Baroque additions serve, if nothing else, to highlight the beauty of the original medieval features. At the high altar, a noteworthy Roman sarcophagus (3C) contains the mortal remains of the patron saint. The cupola has frescoes painted by Giuli and Carlone.

Perugia, Christian sarcophagus of the fourth century inside the Oratory of S. Bernardino.

Perugia, the facade of the Oratory of S. Bernardino.

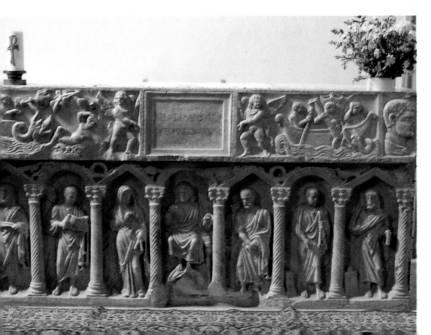

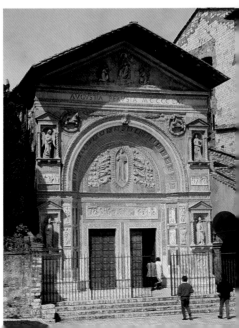

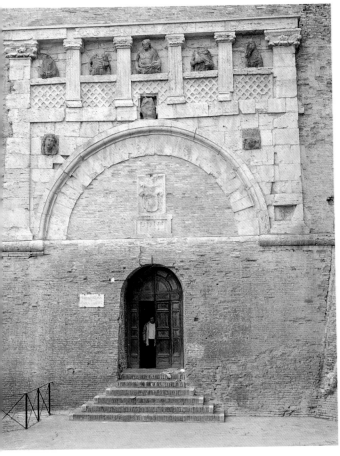

MARZIA GATE - The gate is situated in the encirclement of the external walls of the **Paolina Fortress**. It was transferred (even if only by a short distance) from its original site by Sangallo, during the period when the Fortress was constructed. It is a superb example of Etruscan architecture (IIIC B.C.) and is decorated with *Reliefs of Equestrian Heads* and with *Virile Figures*.

ETRUSCAN ARCH - Otherwise known as the *Arch of Augustus*, the construction dates from the 3C-2C B.C. and incorporates later Roman and 16C additions. The gate is comprised of two robust Etruscan towers; the one on the right has been lowered, while the one on the left has a beautiful fountain (1621) decorating its base and a 16C portico on its upper part. Above the gate is a sentinel arch, which has now been walled up.

THE CHURCH OF S.FRANCESCO AL PRATO - An imposing 13C construction, which has an outstanding **facade** flanked by two turreted towers. The influence of the Cosmatesque sculptors is clearly visible. Various elements and features combine together to create an exquisite mosaic: square tiles, diamond shapes and small marble panels all blend in perfectly with the geometric proportions of the facade, which is crowned by a triangular tympanum and superbly decorated with small arches, a rose window and an elegant portal. At present, large scale reconstruction work is being carried out in the **interior**, which nowadays, therefore, has the appearance of a large, partly covered, empty hall. From the left side of the building, decorated by a central portal and a mullioned window with two lights, one enters the **Chapel of the Banner**, once known as the *Oddi Chapel*. This building contains a painted banner depicting the *Madonna della Mercede* (lit. reward) by Bonfigli (15C). In the Chapel, the famous "condottiere" Braccio Fortebraccio is buried.

THE UNIVERSITY FOR FOREIGNERS - The building, which looks out over *Piazza Fortebraccio* was once known as the *Antinori Palace* and then later on as the *Gallenga Stuart Palace*. The University is an imposing Rococo construction in three orders and is decorated by pillars. It was built in 1758 by Pietro Carattoli, to plans by Bianchi. Amongst the numerous features of its interior, which houses the **University for Foreigners**, are the elegant vestibule and the beautiful staircase with 18C stucco decorations.

TEMPLE OF ST MICHAEL THE ARCHANGEL - A charming Early Christian construction dating back to the 5C. The circular shaped temple was constructed with building materials taken from ancient pagan buildings. The central lantern rests on 16 Roman columns. The altar has been carved out of a shaft of a column with a marble slab dating from the Roman period. The church is more simply known as the *Church of S.Angelo*.

Perugia, view of the Marzia Gate with the approach to the Paolina Fortress.

Perugia, view of the so-called Etruscan Arch opened in the mighty city walls.

Perugia, the splendid facade of the Church of S. Francesco al Prato.

Perugia, University for Foreigners, housed in the Gallenga Stuart Palace.

Perugia, a charming outlook on the Temple of St Michael the Archangel.

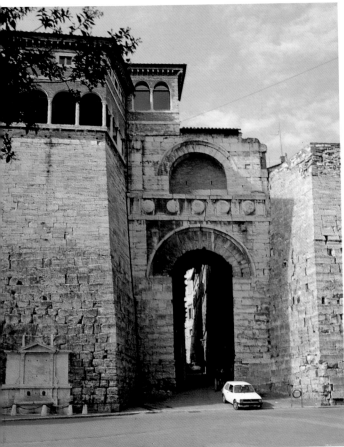

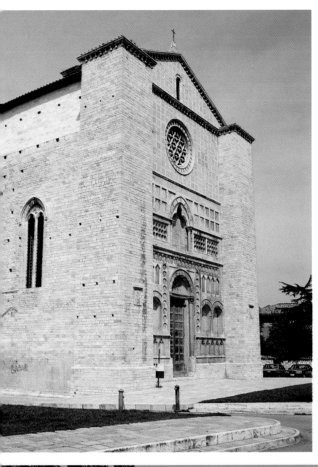

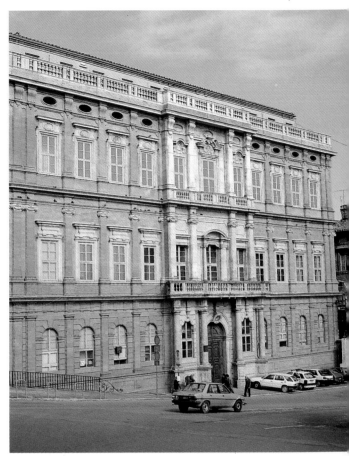

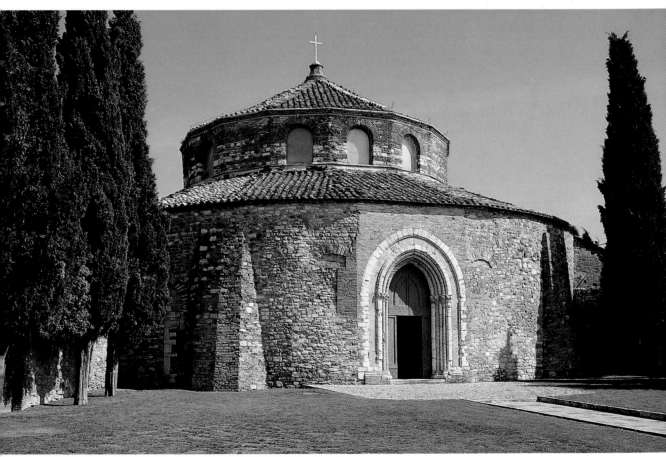

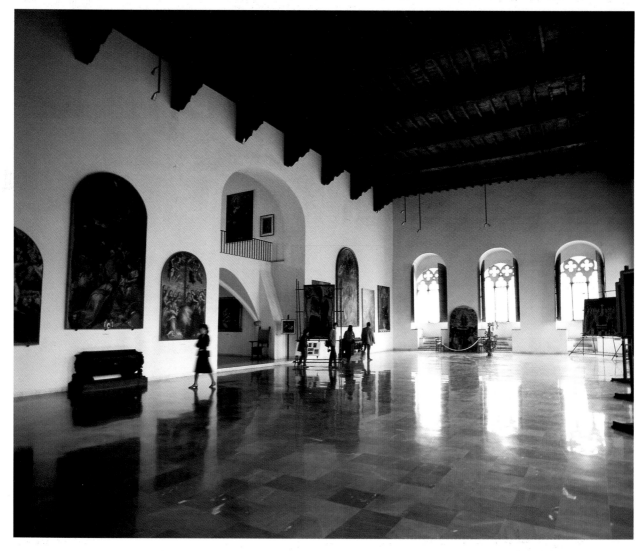

Perugia, a hall of the National Gallery of Umbria (Priors' Palace).

Perugia, National Gallery of Umbria (from top to bottom and clockwise): polyptych of St. Anthony (Piero della Francesca); Adoration of the Magi (Perugino); Virgin and Child (Duccio di Buoninsegna); altarpiece of Santa Maria dei Fossi (Pinturicchio).

THE NATIONAL GALLERY OF UMBRIA - The gallery is situated on the third floor of the Priors' Palace and contains masterly examples of the paintings of the Umbrian school, which date from the 13C to the 19C. The **Sala Maggiore** (Great Hall) contains detached frescoes (12C-15C) and a wooden *Deposition* dating from the 13C; **Room 1**: *Madonna and Child* by Duccio di Buoninsegna; *Crucifixion* by Maestro di S.Francesco. **Room 2**: reliefs originating from a town fountain by A. Di Cambio. **Rooms 3-4**: works of the Siennese and Perugian schools; *Crucifixion* (stained glass) by G. di Bonino; *Saints*, a panel attributed to Francesco da Rimini. **Room 5**: paintings of the Siennese school (14C-15C); bronze *Lion* and *Griffins* (formerly located at the Great Fountain). **Room 6**: Late Gothic and International Gothic paintings; *Madonna and Child* by Gentile da Fabriano. **Room 7**: Renaissance paintings, a triptych by Fra Angelico and a polyptych by Piero della Francesca.

Rooms 8-9: paintings by artists from the Marches and works by the Umbrian School; works by B. Bonfigli, G. Boccati, B. Caporali, F. di Lorenzo. **Room 10**: works by Antoniazzo Romano, Giuliano da Cremona and others. **Room 11**: *Adoration of the Shepherds* by Fiorenzo di Lorenzo. **Rooms 12-13**: *Adoration of the Magi*, by Perugino; *Miracles of S. Bernardino* (Pinturicchio, Perugino and probably Bramante). **Room 14**: *The Dead Christ* by Perugino; *S.Maria dei Fossi* by Pinturicchio. **Rooms 15-21**: paintings dating from the first half of the 16C; paintings by Alfani and Doni. **Room 22**: gold jewellery, ivory objects and bronzes. **Room 23** (Priors' Chapel): frescoes by Bonfigli. **Room 24**: sculptures by Agostino di Duccio. **Room 25**: 13C-15C detached frescoes. **Rooms 26-32**: Mannerist paintings and works dating from the beginning of the 17C; handicrafts; maps; ancient Perugian tablecloths; works by A. Fiammingo, O. Gentileschi, P. da Cortona and A. Sacchi.

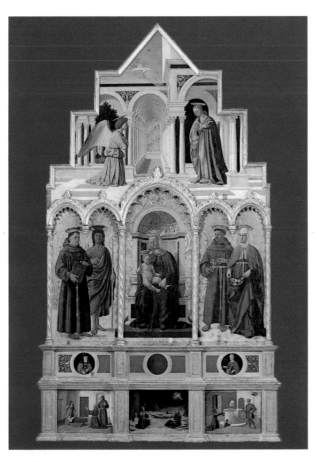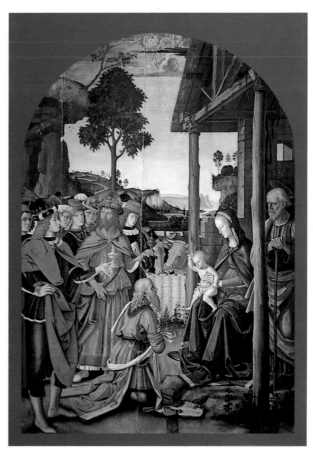

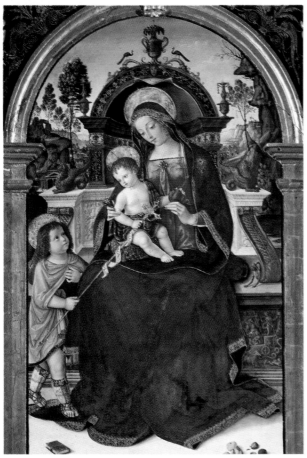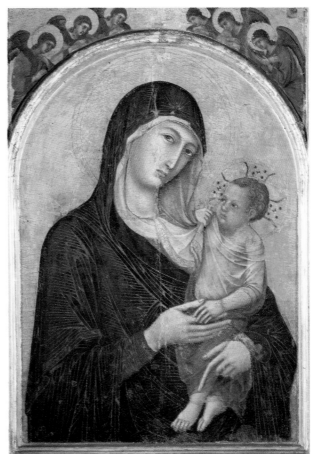

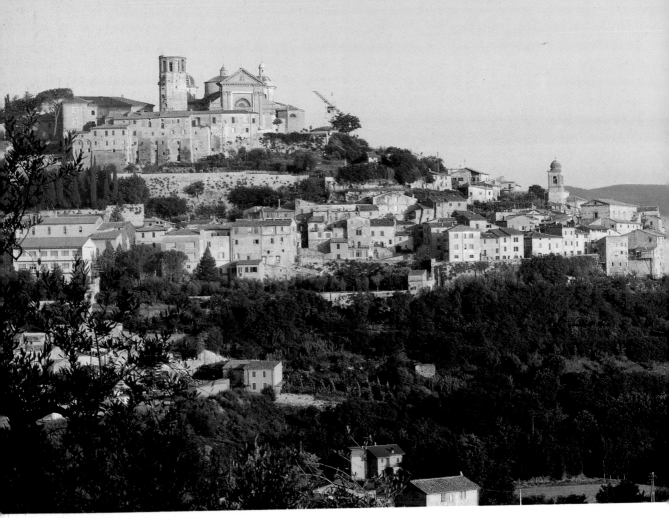

Amelia, panoramic view of the picturesque town and a characteristic alley in the historical centre.

AMELIA

Amelia is the largest town of the Amerino and is beautifully located on a hilly ridge between the Tiber and Nera valleys. Believed to be the oldest town in Umbria (some claim it was founded by Ameroe twelve centuries before Christ), *Amelia* was an Umbrian-Italic settlement, and it would not be hazarding too much of a guess to say that the first human settlements were established here between the 10C and the 11C B.C. Having become a *Municipium* (90 B.C.) and known as *Ameria*, it was later developed as a river port (situated on the Tiber, near Orte) and had frequent dealings with Rome. With the decline of the Roman Empire, it fell prey to Barbaric invaders, suffering at the hands of the Goths and the Lombards. After having been ruled by the Roman Byzantine Empire, it then passed into the hands of the Church, becoming an important staging post along the *Via Amerina* (or *Vejetana*) which connected Rome with Ravenna. During the Medieval period, it was a free commune, suffering the consequences of the battles between the Guelphs and the Ghibellines. Finally it became established as a Papal possession.

Of great interest, due to their mighty structure and their considerable length, are the **polygonal walls**, which completely enclose the town; the oldest parts, dating back to between the 6C and 5C B.C., were used to defend the

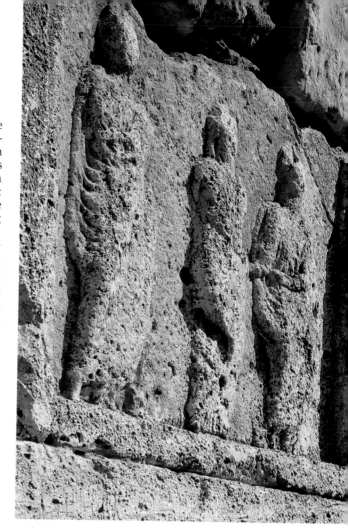

Amelia, these bas-relief figures are inserted into the very ancient polygonal walls.

Arrone, a partial view of the charming medieval hamlet.

acropolis. The **Cathedral**, first built in the Romanesque style, was later re-built in the 17C, after a fire had destroyed the original building. The interior, with a Latin cross-shaped plan, contains nineteenth century frescoes by Luigi Fontana. Also worthy of note are two Turkish standards which were probably won from the Turks at the naval battle of Lepanto (1571). At the side of the Cathedral stands the **Civic Tower** (11C), an imposing twelve-sided Romanesque construction.

The Church of St Francis has a delightful Romanesque-Gothic facade, a beautiful rose window and a fine portal. The building, once dedicated to *St James and St Philip*, has ancient 12C origins, even if later transformations are also evident. The bell tower was rebuilt at the beginning of the 1930s. Other places of worship include the **Church of St Augustine**. Also known as the *Church of St Pancras* (or of *St Mary of the Elm*), this is a 14C construction with Romanesque-Gothic motifs, a beautiful portal decorated with small columns and a lunette with a fresco of the Siennese school.

The Farrattini Palace was built in the first half of the 16C and designed by Antonio da Sangallo the Younger, who was inspired by the Farnese Palace in Rome. The building, which has simple and yet striking Renaissance features, has a Latin inscription in the facade commemorating Cardinal Bartolomeo Farrattini. The **Petrignani Palace** is also a 16C building and is decorated by windows dating from the same period, which were built from the ruins of a former ancient building.

Amongst the other palaces in the town, the Town Hall Palace is worth visiting. Its courtyard contains archaeological exhibits dating back to the Roman Age. Whilst on this subject, it should be pointed out that over the last ten years considerable remains of Roman settlements in the area have been discovered in the environs of Amelia. These consist mainly of villas dating back to the 1C and 4C A.D. Amongst the most important finds made at Amelia is the so-called *Colossus of Amelia*, a bronze sculpture of the Imperial Age, an astonishing work, both as regards its size (over 2.20m) and its artistic value. The work, which most probably represents *Germanicus*, son of Drusus the Elder, was discovered in the early 1960s.

ARRONE

Picturesque village with a decidedly medieval configuration, Arrone lies on a green hill dominating the Nera valley, in an area characterized by woody reliefs. During medieval times, its strategically important position controlled the access to the valley along the important main thoroughfare which ensured links between Abruzzo and the Duchy of Spoleto.

In the oldest part of the village, known as *"La Terra"* (lit. the ground), one comes across the **Fortress** - a typical example of medieval architecture. Also in the Terra quarter can be seen the **Church of St John**, a Gothic construction dating from the 13C and 14C, which is characterized by a polygonal apse. In the interior, there are 15C votive frescoes along the walls, while frescoes of the Umbrian school, dating from the same period, decorate the apse.

The **Church of St Mary**, built originally in the 13C, was enlarged in the 16C. The fine 15C portal and the frescoes decorating the apse are also interesting features.

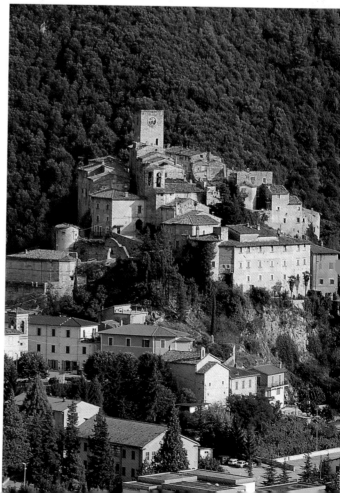

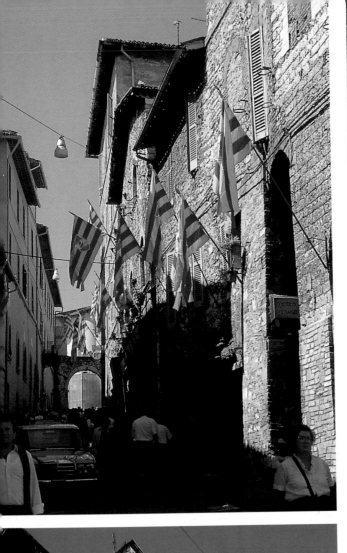

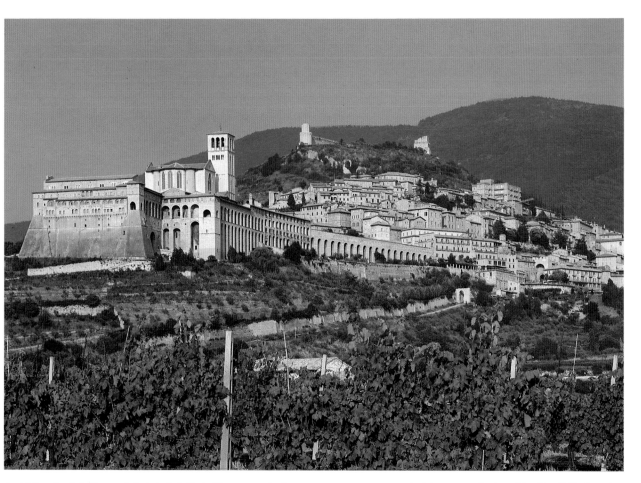

Assisi (from top to bottom and clockwise) via Frate Elia; panoramic view; Fonte Marcella, called Fontebella; a medieval building.

Assisi, a panoramic view of the city with the imposing Basilica of St Francis.

ASSISI

HISTORICAL BACKGROUND - *Beautifully situated on a fertile hill brightened up by olive groves and cypress trees, Assisi stretches out along the slopes of Mount Subasio in a lovely spot along that part of the Valle Umbra situated between the Tescio, Topino and Chiascio rivers. Originally an Umbrian settlement, the city developed along with other territories controlled by the Etruscans, under whose influence it prospered. Under Roman domination it was known as* Asisium. *Having become a flourishing* Municipium, *it was evangelized by the martyr Rufino (3C) who became its first bishop. With the fall of the Roman Empire, it was subjected to Barbarian invasions; destroyed by the Goths (545), it was then conquered by the Byzantines and afterwards fell into the hands of the Lombards. Incorporated into the territories controlled by the Duchy of Spoleto, it then became a free commune from the 11C onwards, achieving its greatest period of prosperity in the 13C. After a period of war and strife, it was besieged and conquered by Barbarossa (1174) who resided here three years later. Frederick II of Swabia was baptized here, but more importantly, Assisi is the birthplace of two people who have influenced both the history of the city and humanity itself: St Francis (1182) and St Clare (1193). Later the city was ruled in turn by the Popes, Perugia, the Visconti family of Milan, the Montefeltro family and Braccio Fortebraccio, before finally coming under the con-*

trol of the Sforza dynasty. Profoundly influenced by the internal struggles between the Nepis (of the upper town) and the Fiumi (of the lower town) factions, Assisi was then firmly established as a Papal possession from the 16C onwards.

Modern-day Assisi has the characteristic configuration of a medieval town which is still encompassed within its ancient town walls. An extremely interesting centre for art and culture, it is also a religious hub of world-wide fame, and attracts pilgrims and tourists from all corners of the globe. The city streets, which accommodate modern-day traffic, the bright pinkish stone of Subasio which distinguishes its buildings, the religious intimacy which emanates from its most sacred corners, are all elements that make Assisi an undoubtedly fascinating place for visitors. In the city, which is also quite a popular spa resort, numerous traditional events are held throughout the year. Apart from the usual traditional events, religious festivals such as the Festival of the Vows (22 June), *the* Festival of the Pardon *(1st/2nd August) and the* Festival of St Francis, Patron Saint of Italy *(3rd/4th October) are held every year. Amongst the traditional folk festivals are the famous* Calendimaggio *(a May Day celebration with medieval songs and themes). Art exhibitions, cultural events and musical concerts, together with an important Antiques Fair, complete the broad spectrum of tourist attractions.*

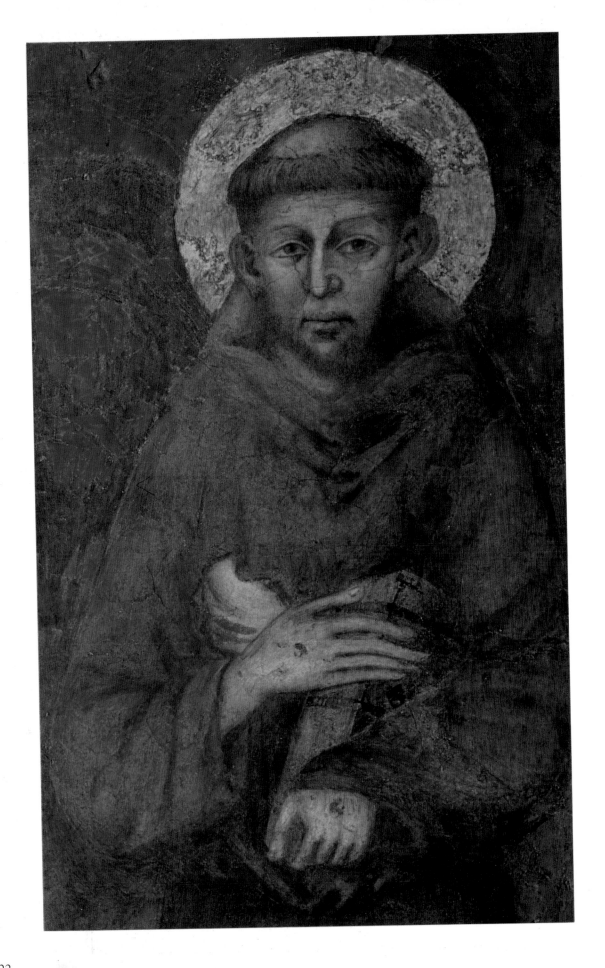

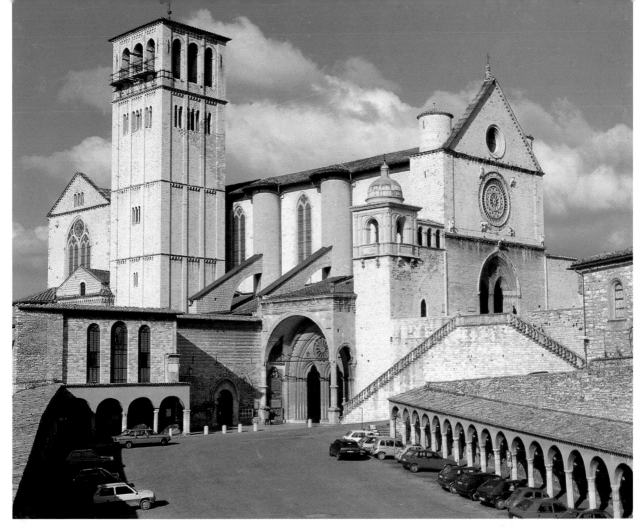

Assisi, detail of Cimabue's Maestà portraying St Francis (right transept of the Lower Church).

Assisi, the Basilica of St Francis soars up over the porticoed Piazza Inferiore, also named after the Seraphic Father.

THE BASILICA OF ST FRANCIS - The majestic Basilica and Sacred Convent have characterized the serene rural landscape of the Umbrian countryside since remote times. One approaches the building from the *Piazza Inferiore di S. Francesco* (Lower Piazza), an enchanting open space lined with a series of low 15C-16C arcades. The immense structure of the Basilica, regarded as being one of the most famous places of Christian worship, consists of two churches placed one on top of the other: the Lower Church (1228-1230) and the Upper Church (1230-1253). The building is dominated by a robust square **bell tower** in four orders and decorated with mullioned windows of two and three lights and also has large arches. The building was completed in 1239. The Basilica is commonly thought to have been conceived by Friar Elias, the Vicar General of the Franciscans, immediately after the death of St Francis.

The Lower Church: One usually enters the church by means of the fine double portal surmounted by three beautiful rose windows and a portico, added in the 15C. The austere Romanesque-Gothic plan of the building has the form of a double T-shape. The **interior**, which consists of a single nave divided up into five bays, has a double transept and a semi-circular apse. In the dim light which pervades the whole church, the star-spangled blue vaults are quite breathtaking. To the left of the first bay is the **Chapel of St Sebastian**, decorated with 17C frescoes by G.Martelli and C. Sermei; on the right are two Gothic tombs and a tribune. Through the **Chapel of St Anthony the Abbot** one comes to a small cloister, once the site of a cemetery. Opening out on the right is the **Chapel of St Catherine** with frescoes painted by Andrea da Bologna depicting *Episodes from the Life of St Francis*. Remarkable 13C frescoes by the Maestro di S.Francesco decorate the walls of the nave: on the right are frescoes depicting the *Life of Christ*, whilst on the left are those depicting the *Life of St Francis*. Of note, almost at the end of the left wall, is a Cosmatesque (i.e. of the Cosmati sculptures) tribune with pulpit, embellished with a fresco of the *Coronation of the Virgin* by Puccio Capanna (14C). In the middle part of the nave, a staircase leads down to the **Crypt**, where the sacred remains of St Francis are contained in a stone urn. The **Side Chapels** are all beautifully decorated with 13C-

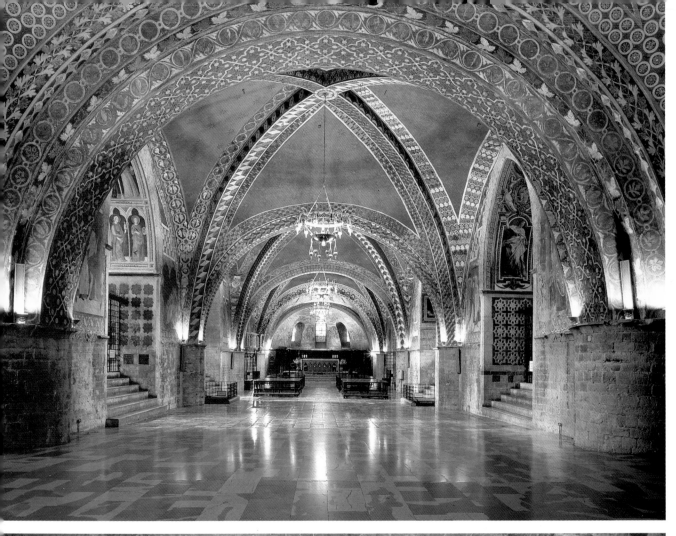

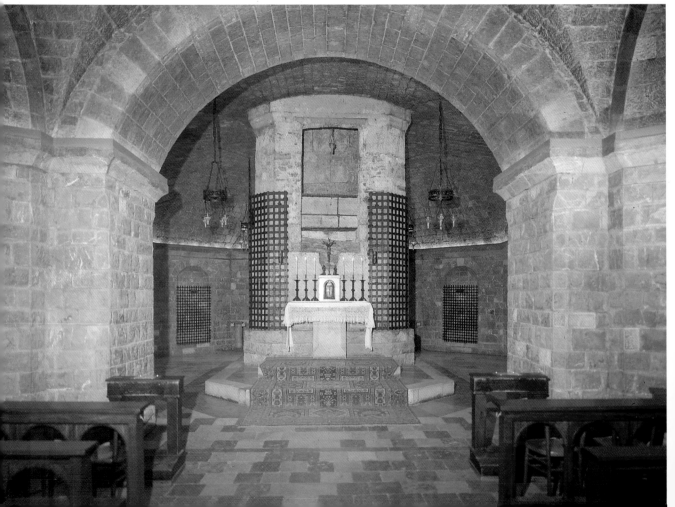

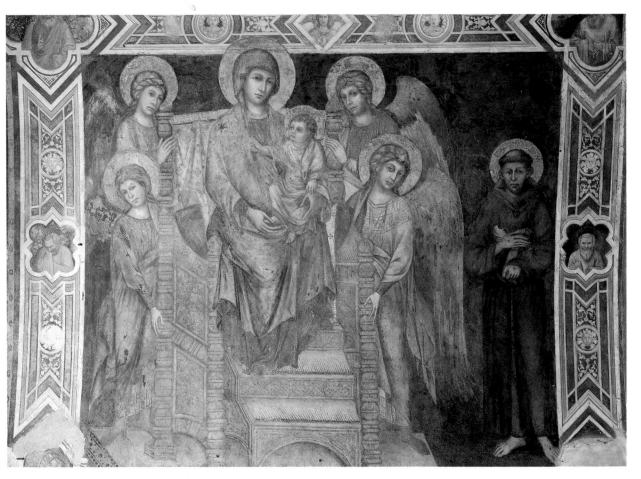

Assisi, architectonic and ornamental proposals of the Lower Church.

Assisi, right transept of the Lower Church: Cimabue's splendid Maestà; on the right is the figure of St Francis.

14C stained glass windows. On the right is the **Chapel of St Stephen** with 16C frescoes by Dono Doni; next to this are the **Chapel of St Anthony of Padua**, decorated by Sermei, and the **Chapel of St Mary Magdalene** with frescoes by Giotto and his school. In the **Chapel of St Martin** (the first on the left) there are some magnificent frescoes painted by Simone Martini depicting the *Saints* and the *Life of St Martin*. In the presbytery, which contains the high Cosmatesque altar (13C), the vaults have frescoes attributed to an unknown pupil of Giotto (known as the Master of the Vaults), which depict the *Allegory of Poverty, Chastity and Obedience* and the *Triumph of St Francis*. In particular, in the right transept one can see frescoes by Giotto and pupils (*Life of Christ and St Francis*), but pride of place goes to the magnificent *Madonna, Child and Angels with St Francis*, one of the most beautiful works by Cimabue, and the *Five Saints* generally believed to be the work of Simone Martini. The **Chapel of St Nicholas** contains frescoes by Giotto and a Gothic tomb of Giovanni Orsini, the work of the Cosmatesque sculptors. The left transept contains not only frescoed ceilings painted by Pietro Lorenzetti and pupils (the *Passion of Christ*), but also some of the Master's most famous works (*Madonna*

dei Tramonti ("of the Sunset"), *Crucifixion, The Last Supper, Descent from the Cross, Resurrection of Christ, Entombment*). Another fresco by Lorenzetti (*The Virgin and Child with St Francis and St John*) can also be seen in the **Chapel of St John the Baptist**.

The Upper Church: One enters the church by means of a flight of steps rising from a terrace on the 15C **Large Cloister**, which has two series of arcades. The **interior** is bright and airy, consisting of one nave with a transept and a polygonal apse. A gallery runs along the whole perimeter of the building, which has a well-defined Gothic lay-out and is decorated with cross vaults. 13C frescoes by Cimabue and pupils decorate the walls of the apse and the transept. Although the frescoes have not been well preserved, it is possible to make out the *Story of St Peter*, the *Apocalypse*, the *Crucifixion* and the *Scenes from the Life of the Virgin*. The extraordinary inlaid wooden choir is the work of Domenico Indivini (1491-1501). The frescoes of the *Evangelists* on the vaults above the high altar are also by Cimabue. The upper part of the walls of the nave, embellished by 13C stained glass windows, has a cycle of frescoes (unfortunately badly deteriorated) de-

25

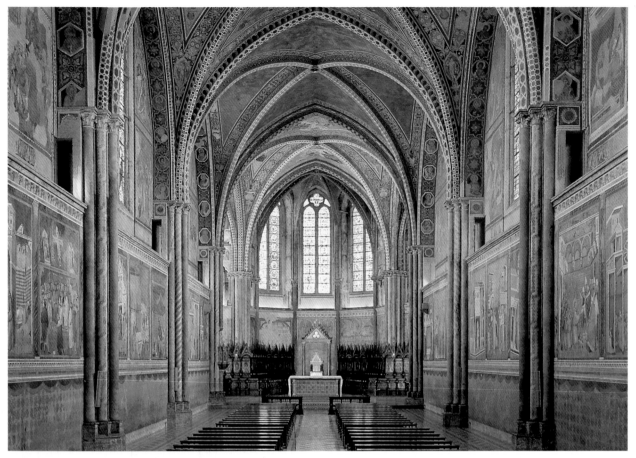

Assisi, internal view of the Upper Church, admirably frescoed by Giotto and a detail portraying St Francis preaching to the birds.

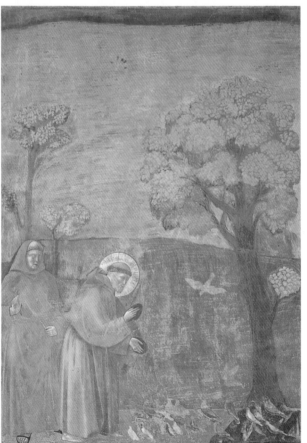

picting *Scenes from the Old and New Testaments* (on the right and on the left respectively). These date from the second half of the 13C and were painted by Jacopo Torriti and Cimabue's pupils, the most eminent being the young Giotto.

Under the gallery, the walls are covered by a magnificent cycle of twenty-eight frescoes painted by Giotto (however, the last five were completed by his pupils). These depict *Scenes from the Life of St Francis* and show the painter's unique skill and mastery of composition. They are considered to be amongst the finest masterpieces painted by the artist from Mugello.

Among the most interesting features of the **Sacred Convent**, mention should be made of the *Treasury Museum*, which contains valuable, rare illustrated manuscripts, paintings, reliquaries, church ornaments and vestments, altar-frontals and tapestries. It also contains the *Perkins Collection* (14C-15C paintings of the Florentine-Siennese schools). The **facade** of the Upper Church, which faces the town of Assisi and looks out over the wide lawn of the *Piazza Superiore di S. Francesco*, has pure Gothic linear features and is decorated by a large rose window, the work of the Cosmatesque sculptors. This is surrounded by stone reliefs of the *Evangelists*. In the facade is a beautiful double portal.

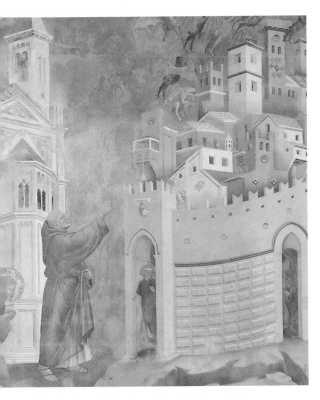

Assisi, Giotto's frescos in the Upper Church: St Francis chases the demons from Arezzo.

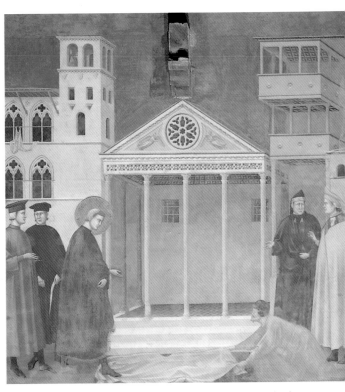

Assisi, Giotto's frescos in the Upper Church: St Francis revered by a citizen of Assisi.

Assisi, Giotto's frescos in the Upper Church: St Francis clothes the nobleman fallen on bad times.

Assisi, Giotto's frescos in the Upper Church: St Francis receives the stigmata on Mt Verna.

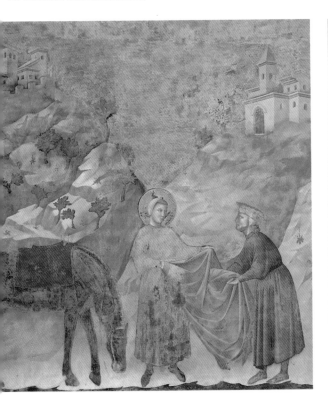

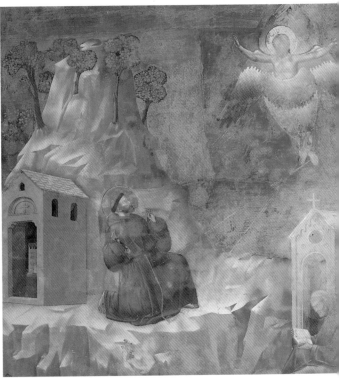

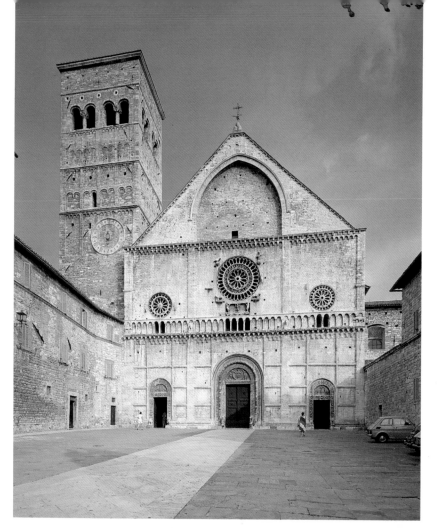

THE CATHEDRAL OF S. RUFINO -

The building looks out over a piazza bearing the same name, upon which also stands a medieval palace believed to be the house of St Clare's father. The beautiful Romanesque facade is divided into three orders. The uppermost order is triangular in shape and has a pointed Gothic arch. The middle order of the facade, divided vertically by pilasters and crowned with a long series of small blind arches, is decorated with three magnificent rose windows and stone carvings. At the bottom, there is a tiny gallery which separates the central section of the facade from the lower one, which has three portals. To the side of the Cathedral stands a massive stone **Bell Tower**, adorned with mullioned windows with two lights and blind arches. The **interior**, renovated in the second half of the 16C, according to

Assisi, the facade of the Cathedral of S. Rufino with the imposing bell tower.

Assisi, Cathedral of S. Rufino: the Roman sarcophagus containing the mortal remains of the titular saint.

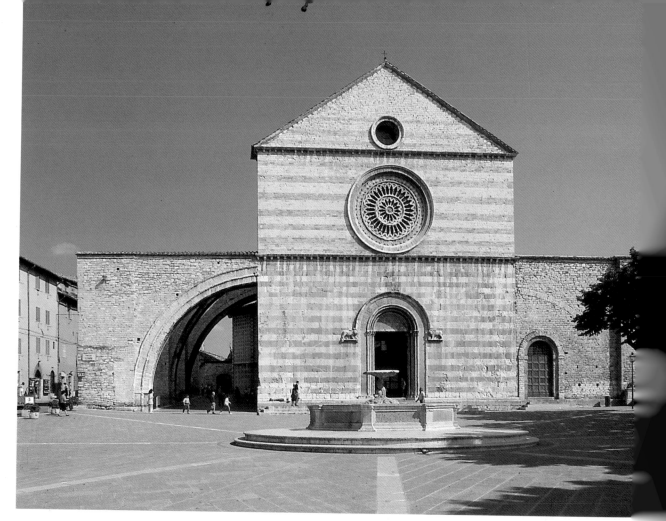

Assisi, the beautiful facade of the St Clare's Basilica dominates the Piazza S. Chiara.

Assisi, St Clare's Basilica: painting attributed to Cimabue among others, portraying episodes of the Saint's life.

plans drawn up by Galeazzo Alessi, consists of a nave and two aisles.

The christening font in the right aisle was transferred here from the Cathedral of St Mary of the Bishopric. St Francis, St Clare, St Agnes, St Gabriel "dell'Addolorata" (lit. of our Lady) and the future emperor Frederick II of Swabia were all baptized here. To the left of the high altar is the small **Chapel of the Madonna del Pianto** (lit. the weeping Madonna). In the apse is an outstanding 16C wooden choir. In the **Crypt**, situated underneath the Cathedral, and once part of a pre-existing church, is a *Roman sarcophagus*, which once contained the remains of S. Rufino. Situated in the left aisle is the entrance to a **Roman Cistern**. From the church one can go through to the **Museo Capitolare** (Chapter House Museum), which contains the works of Alunno, Matteo da Gualdo and Puccio Capanna.

BASILICA OF ST CLARE - An outstanding example of Gothic-Italian architecture, built in the second half of the 13C and perhaps designed by Filippo da Campello, the Basilica is attached to the Church of St George, in which the body of St Francis was buried before being transferred to its present location. The construction is characterized by three large flying buttresses, which are attached to the left side of the building, while a slender **Bell tower** with a

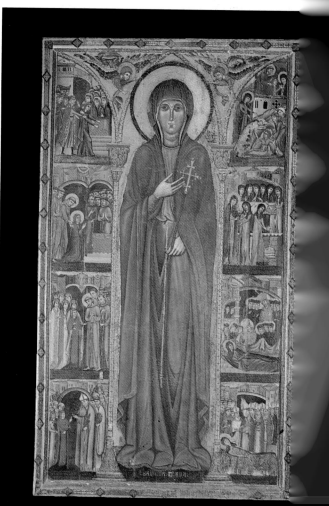

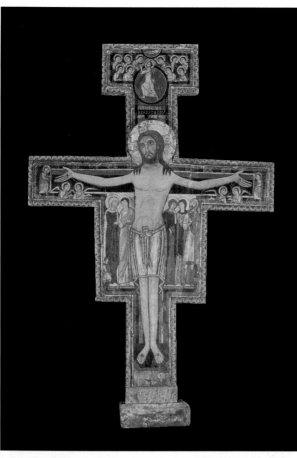

spire rises up from the apse. The beautiful **facade** in three orders, decorated by two coloured horizontal bands of stonework, has a beautiful rose window and a portal. The **interior**, in the form of a Latin cross with a single nave, is simple and bare. A flight of steps leads down to the **Crypt** where the mortal remains of St Clare are contained in a glass coffin. The vault of the presbytery has frescoes by an unknown pupil of Giotto. In the apse, is a beautiful painted *Cross*, which was obviously influenced by the paintings of Giunta Pisano. In the left transept is a fresco of the *Nativity* (14C) of Umbrian-Siennese origin. In the right transept is a painting depicting *St Clare* and *Scenes from the Life of St Clare*, believed to be by Cimabue. On the right side of the nave is the entrance to the restored **Church of St George**, in which stands the **Chapel of the Sacrament**, decorated by frescoes in the style of Giotto and the **Chapel of the Crucifix**, containing the famous Byzantine painting of a *Crucifix* (12C), which, according to legend, is supposed to have spoken to St Francis in the Church of St Damian. Beyond a lattice window are the mortal remains of St Clare and St Francis. At the side of the Basilica stands the imposing **Monastery of the Poor Clares**.

THE CHURCH OF ST PETER - The church, built in the 13C on the site of a previous church, has elegant Romanesque-Gothic features. The rectangular **facade** in two orders is particularly beautiful. The upper order, completed in 1268, has three magnificent rose windows. The lower section of the facade, decorated at the top by a series of blind arches, has a 12C portal. Worthy of note is the unusual cupola, built above a raised presbytery, and a beautiful **Bell Tower** which rises up close to the apse. The **interior**, which has one nave and two aisles, contains 14C frescoes and the ruins of some tombs dating from the same period.

PIAZZA DEL COMUNE - Situated at the heart of the town and built on the site of the ancient Roman forum, the piazza is surrounded by ancient medieval buildings, and a fountain stands in the middle of the square. Buildings in the piazza include the **Priors' Palace** (14C), which nowadays houses the town council offices, and the **Municipal Picture Gallery** (containing frescoes by the Byzantine, Umbrian and Siennese schools, as well as those painted by the followers of Giotto, paintings by O. Nelli, N. Alunno and Tiberio d'Assisi). To the side of the **Palazzo del Capitano del Popolo** (lit. the Palace of the Captain of the People), a turreted 13C building, stands the beautiful **Municipal Tower** (14C), in which the *Bell of Lauds* was placed (1926). Another building in the square is the **Temple of Minerva** which was re-converted into the **Church of S. Maria sopra Minerva** (first half of the 16C, with Baroque transformations added at a later date). This construction is a superb example of a temple of the *Augustan* period (1C B.C.). Worthy of note is the beautiful pronaos, formed by six fluted columns, which rise up from a flight of steps, with Corinthian capitals supporting a triangular tympanum. Goethe was an enthusiastic admirer of this building.

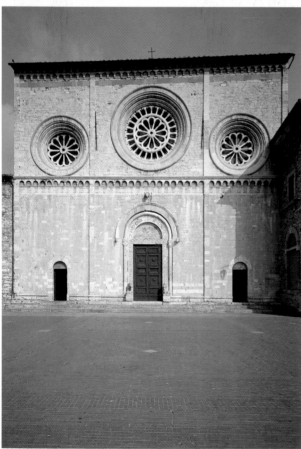

Assisi, St Clare's Basilica: the Crucifix which, according to tradition, talked to St Francis in the Church of St Damian.

Assisi, the elegant facade of the Church of St Peter.

THE CASTLE OF THE ROCCA MAGGIORE

THE CASTLE OF THE ROCCA MAGGIORE - Passing through the **Perlici Gate** (near which can still be seen the elliptical-shaped area, which was once the site of the Roman amphitheatre), one comes to the castle, which, with its imposing ramparts and towers, dominates the town below. The ancient fortress of Assisi, built before the Lombard occupation, was the scene of many historical events. Once inhabited by Barbarossa in 1174, it was then the home of Corrado di Lutzen, who raised the young Frederick II of Swabia here, until the building was razed to the ground by the inhabitants of Assisi (1198). Rebuilt by the Papal legate, Egidio Albornoz (second half of the 14C), it was later enlarged by Popes Pio II and Paul III. In ancient times, it was attached to the **Rocca Minore** (Smaller Fortress), which was reconstructed by the Visconti family.

Assisi, facing onto the Piazza del Comune are the Palazzo del Capitano del Popolo, the Municipal Tower and the Temple of Minerva (Church of S. Maria Sopra Minerva).

Assisi, the powerful glacises of the Castle of the Rocca Maggiore rise to dominate the city.

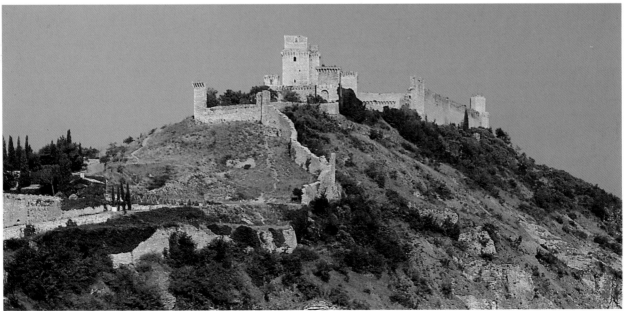

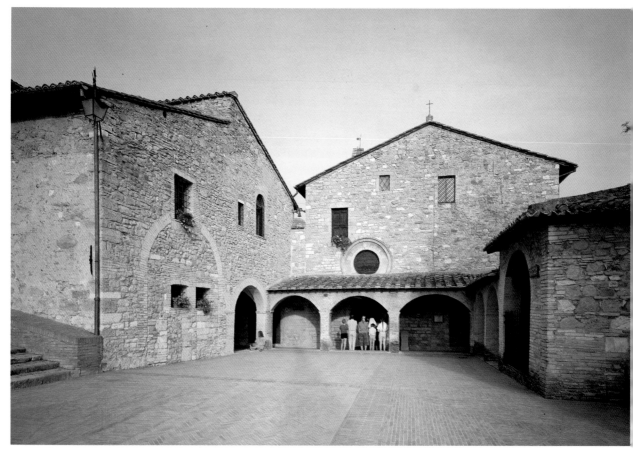

Sanctuary of St Damian (Assisi), view of the monastic complex.

Environs

Surrounded by cypress trees and situated just outside the town, is the **Sanctuary of St Damian**. According to legend, the small church, which has a portico, was restored by St Francis (1207) in obeyance to orders given to him by the Crucifix ("Go forth Francis, and rebuild my crumbling house"). Five years later, he brought St Clare and her first followers here. In this spot, which embodies the true Franciscan ideal, Francis wrote his famous *Canticles of All Things Created*. In particular, one can see the **Chapel of St. Jerome** (frescoes by Tiberio d'Assisi); the **interior** of the church (14C frescoes and a 17C wooden *Cross* by Fra' Innocenzo da Palermo). Also worth seeing are the **Small Garden** and the **Oratory of St Clare** (the saint died in the small dormitory here).

The Eremo delle Carceri (lit. Hermitage of the Cells) is charmingly located in a densely wooded spot on Mt. Subasio. The serene tranquillity of its location and the sense of peace and meditation which pervades the whole environment, make it one of the most peaceful locations along the Franciscan trail. The **Convent** was built near the cave where the saint used to spend many hours praying and meditating. In the 15C, it was enlarged and a church was added. Nearby, the numerous **caves** of the hermits can still be seen.

The **Basilica of St Mary of the Angels** is situated on the plain below Assisi, in a small modern town which bears the same name. The magnificent, immense building was begun in 1569 and designed by Galeazzo Alessi. After being completed in 1679, it was almost immediately rebuilt after being considerably damaged by an earthquake

(1832). One can observe the elegant architectural features of the dome, built by Alessi, and the huge golden statue of the Virgin which dominates the church from the top of the **facade**. The solemn, majestic **interior** has a nave and two aisles and contains many Baroque chapels. There are paintings by Pomarancio, Appiani, Sermei and other artists. The major attraction of the interior is without doubt the **Porziuncola** (Little Portion, or Portion of Stone), a charming Franciscan oratory, in which the first religious community formed at the "Tugurio" (the hovel) of Rivotorto gathered. In this spot, Clare (of the Scifi family) decided to take her vows of poverty and follow in the footsteps of Francis (1211). The small chapel, situated directly below the imposing dome, is surmounted by a Gothic aedicule and has 14C-15C frescoes. The 19C frescoes on the facade of the chapel are by F. Overbeck. In the deeply mystical atmosphere of the **interior** is a large painted panel (polyptych) on the high altar by Ilario da Viterbo (14C). St Francis died in the nearby Cappella del Transito (Chapel of the Passing Away of the Saint) (3-10-1226); here there are frescoes by Spagna (16C) and an enamelled terracotta statue of St Francis by Andrea della Robbia. An altar-frontal in the **Crypt** is also the work of the artist. Other features of the Basilica include the **Chapel of the Roses** with frescoes by Tiberio d'Assisi, the **Miraculous Rose Garden** and the **Convent** (in which the **Ethnographical Museum of Missionary Work** is located, as well as a collection of art works, including works by Maestro di S. Francesco, Giunta Pisano and others)

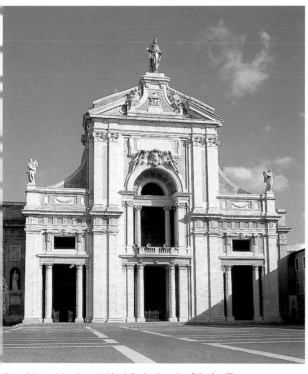

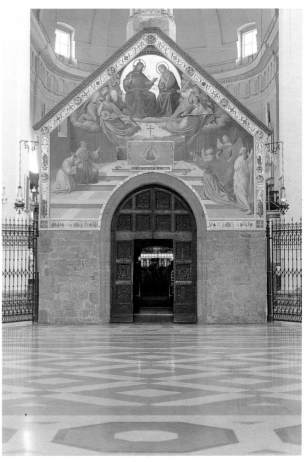

Saint Mary of the Angels (Assisi), the facade of the basilica dominated by a gilded statue of the Virgin Mary.

Saint Mary of the Angels (Assisi), part of the interior of the basilica with the celebrated Porziuncola.

The Eremo delle Carceri (Assisi), a lovely view of the monastic complex on the wooded slopes of Mt Subasio.

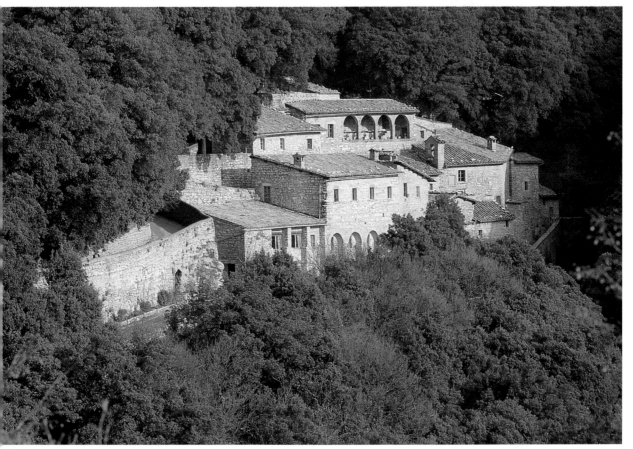

33

BASCHI

Picturesque Umbrian village with prominent medieval features, Baschi stands on a ridge dominating the Valtiberina, a short way downstream from the confluence of the Paglia river. Below the village, lies a stretch of the A1 motorway (the Orvieto to Attigliano section). The origins of the village date back to Roman times, but Baschi enjoyed its period of greatest splendour in the Medieval Age. During this period, the noble family of Baschi, who were the owners of the village and its surrounding district, built a castle on this spot, which soon became part of the possessions of Orvieto. After the setting up of a free commune (15C), Baschi became established as one of the territories controlled by the Church.

The typical features of medieval building work can still be seen in the village today, even if nothing remains of the impressive defence systems of long ago. The only outstanding element is the **Church of S. Nicolò**, built in the second half of the 16C, and designed by Ippolito Scalza. In the interior is a 15C painted panel (polyptych) of the Siennese school (Giovanni di Paolo). The hamlet of **Civitella del Lago**, forms part of the commune. It was built on the site where the Roman settlement of *Civitula* once stood, in an area populated since ancient times. During the medieval age, a castle was built here which allowed its owners to control the underlying valley of the Tiber. Today, the large artificial lake of **Corbara** can be seen in the valley, which stretches out like a Nordic fjord in the idyllic landscape of the Umbrian hills.

Baschi, two charming views of the picturesque, medieval agglomeration.

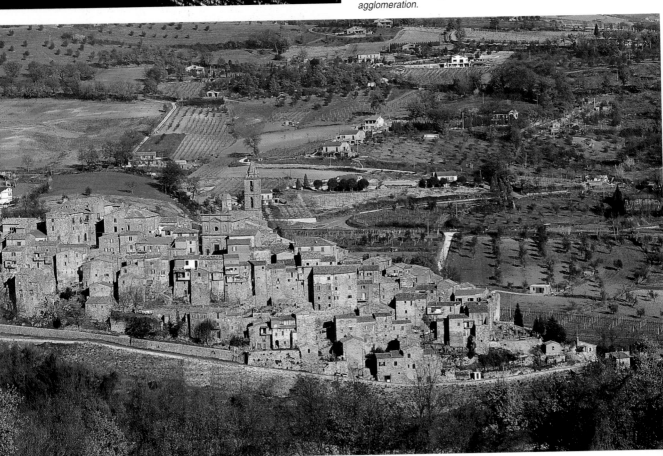

BEVAGNA

An important town in the Foligno district, Bevagna is situated near the foothills of the Martani Mountains There is documentary evidence to suggest that the surrounding areas were inhabited since the Iron Age. An Umbrian-Etruscan foundation, it was known as *Mevania* in Roman times and grew in importance during this period, thanks to the construction of the *Via Flaminia*. Even up to the present day, Bevagna has managed to retain its overall medieval character, although the Roman configuration of the town is still largely evident. The **Consuls' Palace** is a beautiful example of 13C architecture, with an external flight of steps, a double order of mullioned windows with two lights and a Gothic portico on the ground floor. The **Church of St Sylvester** is a beautiful Romanesque building completed by the Cosmatesque sculptor, Binello, in 1195, as testified by the plaque on the side of a fine portal decorated by *Christian symbols*. The enchanting facade which is built in travertine and pink Subasio stone is decorated by a mullioned window with three lights and by two lateral mullioned windows with two lights and small twisted columns. At the top of the facade is a relief decorated with animal sculptures. The **Cathedral of St Michael the Archangel**. is a Romanesque construction built in the 12C, upon plans by the Cosmatesque sculptors Binello and Rodolfo, but subjected to many alterations between the 18C-19C . The facade has three portals; the middle portal is rich in decorative motifs.

Bevagna the polygonal fountain and the Church of St Sylvester; the splendid facade and the campanile of the Cathedral of St Michael the Archangel; partial view of the elegant facade of the Consuls' Palace.

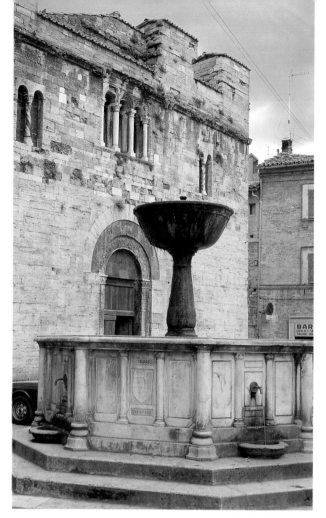

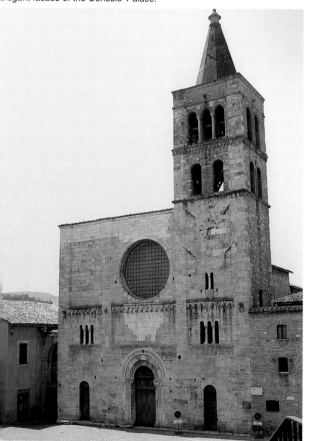

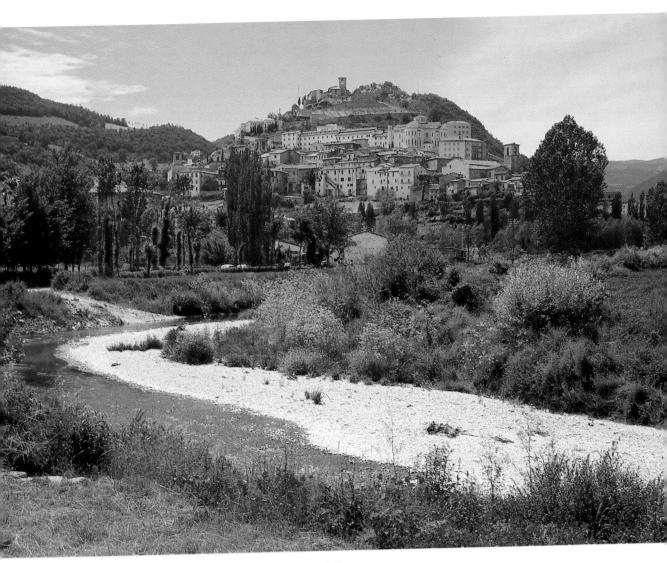

Cascia, a charming panorama of the village in the green
Umbrian countryside.

CASCIA

HISTORICAL BACKGROUND - *Well-known tourist resort
in the district of Valnerina, the town of Cascia is huddled
around the Colle S. Agostino, lapped by the winding course of
the river Corno, and surrounded by a chain of green moun-
tains. The town, together with Assisi, is a religious centre of
world-wide fame, associated with the memory of St Rita, who
was born here and lived in Cascia up until the time of her
death. An ancient Reatine foundation (6C-5C B.C.), it subse-
quently fell into the hands of the Umbrians, the Etruscans, the
Sabines and the Romans, who built the centre of Cursula here.
Destroyed by an earthquake (63 B.C.) and rebuilt, it was then
razed to the ground by the Goths (4C), plundered by the
Lombards (6C) and destroyed once again by the Saracens (9C).
Having become an autonomous Republic in the 12C, it under-
went a period of change and upheaval during the struggles with
the neighbouring city and the disputes between the Guelphs
and the Ghibelline factions. In the second half of the 15C, Pope
Paul II ordered a fortress to be built on top of the hill, in order
to take military control of the town. In the first half of the 16C,
Cascia was subjected to the attempts on behalf of the followers
of the Roman family of Colonna to take control of the fortress,
which was finally dismantled by Leo X in 1517. The sacking of
the town by the armies of Sciarra Colonna (1527) and a further
conflict with Spoleto contributed even further to the downfall of
the town, which also suffered serious damage during several
earthquakes (1599, 1703, 1950, 1962).
More recently, the catastrophic earthquake of 19 September
1979 inflicted a harsh blow on the art and the monuments of
the Valnerina. A clear example of its devastating effects is to be
seen at the 16C Sanctuary of the Madonna of the Snow (built
by Bramante, containing frescoes by the Camillo brothers and
by Fabio Angelucci), which was almost totally destroyed in the
earthquake. Amongst the most typical products of the local
handicraft industry are textiles, wrought-iron work, wooden
objects and copperware, as well as wicker work and terracotta
objects. As in many other Umbrian centres, local folk events are*

closely bound to religious celebrations; these include the Procession of the Dead Christ (Good Friday) *and the* Fire of the Faith *(a charming "Luminaria", in which the whole town is lit up by thousands of small torches on the eve of St Rita's Day) (21 May).*

BASILICA OF ST RITA - The modern basilica has become a characteristic feature of the landscape around Cascia. Work on its construction was begun in 1936, when it was decided to replace the pre-existing small church with a larger building, in order to accommodate the ever-increasing number of pilgrims who came to pay homage to the remains of St Rita. The design of Monsignor Spirito Chiapetta, re-elaborated by Martinenghi and Calori, was completed in 1940. Having been opened as a place of worship eight years later, the building was then consecrated as a basilica by a Papal decree signed by Pio XII (1955). The building, which was influenced by features of Romanesque-Byzantine architecture, has a white travertine facade, which has two twin bell towers on either side. At the side of the portal are some reliefs executed by E.Pellini, depicting *Scenes from the Life of St Rita*; above the architrave is a large *Cross*, sustained by statues of angels. The **interior** is in the shape of a Greek cross and contains many modern works of art.

A women's gallery runs along the whole perimeter of the building. The high altar, by Giacomo Manzù, was placed here in 1981, during the celebrations held to commemorate the 600th anniversary of the birth of St Rita (1381-1447). Amongst the numerous contemporary frescoes, which adorn the walls of the church are : *The Paradise of the Augustinian Saints* (**Cupola**, L.Montanarini); *Exhaltations of the Cross* (**Apse at the entrance**, S.Consadori); *Glorification of St Rita* (**Chapel of St Rita**, F.Ferrazzi); *Assumption* (**Chapel of Our Lady of the Assumption**, G.Ceracchini); *Last Supper* (**Chapel of the Sacrament**, L.Filocamo). All of these frescoes were painted between 1950 and 1956. The stations of the *Cross*, executed in marble, are by E.Pellini. The **Chapel of St Rita** is the most interesting feature of the interior in both artistic and religious terms. Its architectural style is a modern reworking of Byzantine motifs and models. The urn containing the body of the saint stands on a marble plinth, which has decorations along its front by Pellini. On the exterior corners of the urn are sculptures of the *Cardinal Virtues*, in gilded bronze. The vaulted ceiling of the chapel has eight frescoed medallions depicting the *Augustinian Saints* by F.Taragni. Some paintings by G.B.Galizi, along the walls, depict *Scenes from the Life of St Rita*. The so-called **Lower Basilica** is a modern building, constructed at the end of the 1980s, as a result of restructuring work carried out on the pre-existing crypt. A silver ostensory contains the "Sacred Relics" of *Corpus Christi*. The *tomb of Mother Maria Teresa Fasce*, (patron of the construction of the new sanctuary) can also be seen.

THE MONASTERY OF ST RITA - The building stands near the basilica and belonged originally to the Benedictines, becoming an Augustinian monastery in the first half of the 14C. Amongst the features of the monastery worth visiting are the 16C **Cloisters**, with a gallery running along a part of the upper order, which contain the so-called "miraculous vine"; the **Oratory**, where St Rita received the stigmata (1432), and the **Cell** where the saint lived and died. Here one can see the *Sarcophagus* (painted by an unknown artist) in which St Rita's body was placed after her death in 1457.

Cascia, the modern facade of the Basilica of St Rita.

CHURCH OF ST FRANCIS - This Gothic building was constructed in the first half of the 15C, and the eastern side contains some remaining architectural features of a 13C dismantled church, together with a monastery annexed to the church in modern times. The **facade**, in two orders, is separated by a stringcourse and is decorated by an impressive rose window and a beautiful splayed Gothic portal. The lunette is decorated with a 15C fresco (*Madonna and Child with St Francis and St Clare*).

The **interior** with a Latin cross plan has 17C stucco decorations. Numerous frescoes include the *Virgin and Child* by Siennese artists of the 15C (on the left); *St Anthony of Padua, St Anthony the Abbot and Catherine of Alexandria*, by the Umbrian school (15C, on the right); *Trinity and Adoration of the Shepherds* (near the 17C wooden pulpit) and *St Benedict*, both by Bartolomeo di Tommaso da Foligno (15C). Another interesting feature is the beautiful 14C wooden choir. Near the altar of St Francis (on the left cross vault), is a powerful interpretation of the *Ascension* (second half of the 16C) by Niccolò Circignani (Pomarancio).

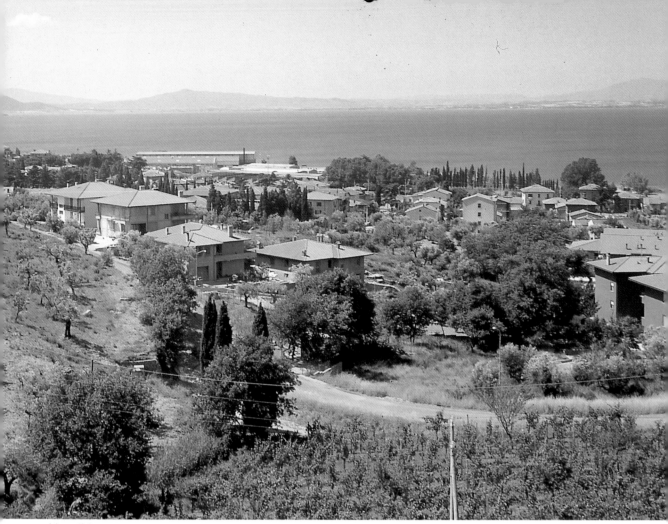

A beautiful panorama of the Lake Trasimeno and the green hills surrounding it.

LAKE TRASIMENO

In terms of dimension, Lake Trasimeno is the fourth largest lake in Italy. It is situated in the province of Perugia and is in fact the biggest stretch of water on the Italian peninsular. It has a surface area of almost 128 square kms, reaches a maximum depth of 6.55 metres and has a perimeter of 54 kms. Formed as a residual lake of an ancient and vast basin situated in the Valdichiana, the width of the lake has altered considerably over the centuries, being in fact dependent on the seasonal and cyclic trend of the rainfall. The problem of regulating its waters has existed since Roman and Medieval times, and it was only in 1423, under Braccio Fortebraccio of Montone, a nobleman of Perugia, that the so-called **Vecchio Esautore** (lit. one deprived of authority) was built. This, in fact, consisted of an artificial drain which, by means of an underground network of canals and tunnels, allowed the excess waters to be drained off. When deprived of a natural outlet, the excess waters would cause widespread and devastating flooding along the riverside territories, causing great damage to crops. From 1423 up to the beginning of the 17C, various Popes had to supervise the periodic maintenance and servicing of the drainage system. At the end of the 19C, the construction of a new drainage tunnel brought an end to the age-old problem, which the Vecchio Esautore had never completely managed to resolve. In more recent times, the occurrence of long periods of drought has led to a fall in the level of the waters and an abnormal increase in algae. As a remedy to this worrying phenomenon, which puts both the existence of the lake itself and the life of numerous aquatic species in jeopardy, the streams of Rio Maggiore and Tresa have been artificially deviated into the lake. Lake Trasimeno, in all its resplendent beauty, lies surrounded on three sides by a backdrop of gently undulating hills, covered with olive groves and Mediterranean scrub. On the side facing towards Tuscany, a wide open plain stretches out. Three islands emerge out of the calm waters of the lake: the **Polvese** (the largest in terms of dimension), the **Maggiore** (the most populated) and the **Minore** (the smallest and unpopulated island). The territory of Trasimeno was inhabited since Etruscan times, as numerous tombs discovered around the hills of Castiglione and Città della Pieve have testified. Later, the area around the Lake came under Roman domination, and here the Romans were subjected to one of the most disastrous defeats in their military history. On 23rd June, 217 B.C., during the course

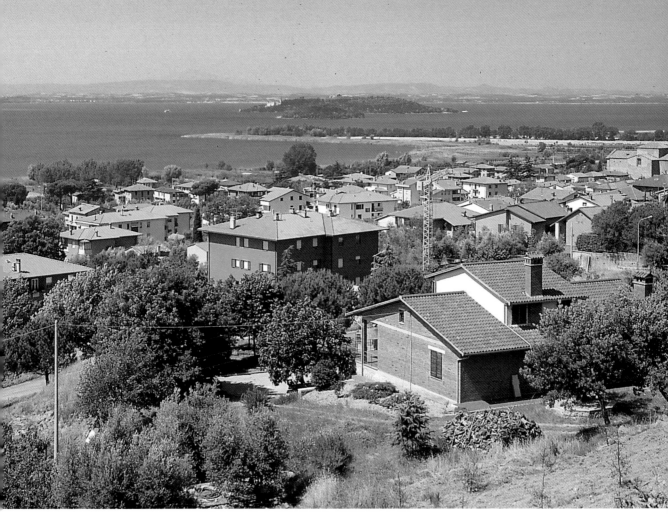

Castiglione del Lago, panorama from the air.

of the second Punic War, the Carthaginian army fought against the Roman soldiers on the northern shores of the lake. The Carthaginians, led by Hannibal, wiped out the Roman army led by the Consul Flaminius, who was killed in battle. In the Early Middle Ages, the territories were donated by Otto I to the Papacy. Perugia and Florence fought over its possession, before it later became disputed over by the Church and the Grand Duchy of Tuscany. Between 1797 and 1798, Trasimeno gave its name to a district of the Roman Republic, while between 1809 and 1815, the lake gave its name to one of the districts of the Empire created by Napoleon Bonaparte. Today, the dense conglomeration of fortified hill villages, fortresses, castles, fortifications and the towers remind us that the area of Trasimeno has always been a contested frontier.

CASTIGLIONE DEL LAGO

The largest resort in the tourist district of Trasimeno, Castiglione stands on a calcareous promontory covered with olive groves, near the western shores of the lake. A fertile alluvial plain stretches out behind Castiglione. The formation of the flood plain dates back to the time when the waters of the largest basin on the Italian peninsular once completely surrounded the promontory, creating the

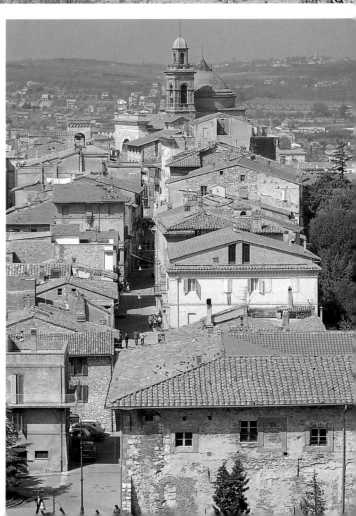

fourth island of Trasimeno. The first people to inhabit the land were the Etruscans who, according to Pliny, were defeated by the nearby population of Chiusi. Pliny, in fact, always referred to the locality as *Clusium Novum*. Due to its advantageous strategic position and its famously fertile soil, Castiglione was long disputed over by the dominating powers. During the Early Middle Ages, it belonged to the abbots of S.Gennaro di Campoleone, before passing into the hands of the people of Perugia, who made it into a fortified defensive stronghold (12C). For a long time, it was contested by the towns of Arezzo, Orvieto and Cortona. It then fell to the Della Corgna dukes, under whose rule it became a marquisate from the middle of the 16C to the middle of the 17C. In the meantime, Pope Paul V transformed it into a duchy, and it then became integrated into the State of the Church (18C).

Today, Castiglione is a popular tourist and holiday resort, which has a wide range of accommodation facilities. The lively town centre, for the most part still encompassed within the medieval town walls, and the flourishing handicraft industry (lace and fishing nets), together with local festivities like the *Tulip Festival* (April) and the *Kite Festival* "Let's colour the skies" (25-4/1-5), biennial) make the town one of the jewels of the enchanting chain of hill centres situated along the shores of the lake.

The **Castle** was built by Frederic II of Swabia and rises up over the town, offering good views of the lake. The polygonal castle walls are crowned with merlons and have alternating round and square towers. The high central keep has a triangular plan. In the vast inner gardens an open air theatre has been set up in which plays and concerts are held during the summer.

The **Ducal Palace**, the seat of the present Town Council, was originally built as a tower-house by the Baglioni counts of Perugia. At the beginning of the 16C, Giampaolo Baglioni gave hospitality to Machiavelli and Leonardo da Vinci here. Leonardo designed plans for a new revolutionary drainage system for the territories lying between Trasimeno, the Valdichiana, the Valdarno and the Valtiberina. In the second half of the 16C Ascanio Della Corgna transformed the building into the Ducal Palace we see today, based on plans by either Vignola or Alessi. A covered passageway, now partly ruined, connected the palace to the castle. The construction, which is regarded as being one of the most masterly examples of Renaissance architecture in Umbria, has interesting frescoed rooms painted by G.A. Pandolfi and S.Savini (second half of the 16C).

The present day **Church of St Mary Magdalene** is the result of transformation work carried out in the 19C. It has a Neoclassical facade; in the interior, which has a Greek cross plan, is a *Madonna del Latte* (14C) and a painting believed to be by Eusebio da S.Giorgio and pupils (16C) depicting *The Virgin and Child with St Anthony the Abbot and Mary Magdalene*.

The **Church of St Domenic** is the result of 18C reconstruction work and contains *The Tomb of the Della Corgna family*. The building has an interesting lacunar ceiling.

Castiglione del Lago, a patrol catwalk round the Castle with its Guelf crenellation and a keep.

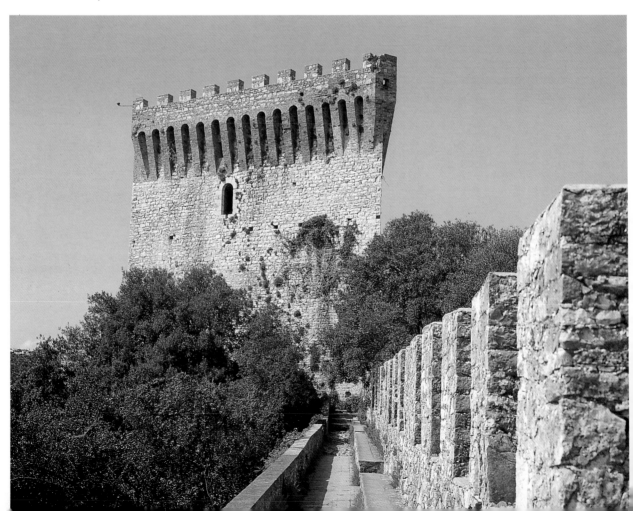

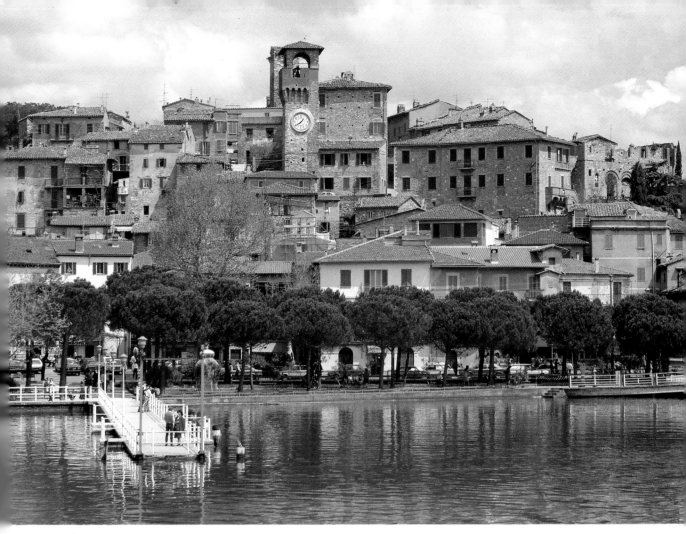

Passignano sul Trasimeno, view of the mediaeval nucleus and the road alongside the lake from the boat landing stage.

PASSIGNANO SUL TRASIMENO

A small jewel of a town set along the northern shores of Trasimeno. The locality is divided into two parts. The more ancient medieval part of the town lies on the slopes of a small ridge facing towards the lake, while the more modern part of the town stretches out along the shores of the largest lake basin of the Italian peninsular. It was a place of transit even in remote times (a fact that would explain the origins of the modern place name) and was both an Etruscan and Roman centre, as well as a Byzantine stronghold during the Gothic War. It was annexed to the Marquisate of Tuscany by Charlemagne and referred to as *Castrum Passiniani* by Berengario (10C). At the turn of the 12C, the locality had exerted its influence over most of the northern territories. Having been seized by the people of Perugia, who built important fortifications to combat the rival armies of Arezzo, it was then subjected to serious retaliations in which the town suffered both considerable damage and loss of life.

Under Bonaparte, it once again became extremely important in administrative terms, when it was made the seat of the District of Trasimeno, whose jurisdiction extended as far as the neighbouring Communes, with the exception of Castiglione del Lago. The locality was subjected to repeated air raids during the Second World War.

Passignano sul Trasimeno is nowadays a popular holiday attraction and a well known bathing resort. The economy of the locality is largely based on tourism, although the ancient fishing industry is also a thriving activity. Local folk events include the *Palio delle Barche* (Boat Race), an age-old traditional event, which takes place on the last Sunday in July.

The town, which is dominated by the ruins of the **Fortress** has ancient towers (one of which has a clock), steep medieval streets and pointed Gothic gates.

In the **Church of St Christopher**, once known as the *Parish Church of St Mary of Passignano* (13C) one can see fine votive frescoes painted by 15C Umbrian artists.

Worthy of note are the **Church of S.Rocco** (Renaissance) and that of **S.Bernardino**, which has a typical Umbrian sandstone facade (15C). In the outlying district stands the 16C Church of the **Madonna dell'Uliveto**, which has architectural features reminiscent of the work of Bramante. In the interior is a 17C holy-water font (or stoup) and a fresco of the *Madonna and Angels* by Caporali.

41

Città della Pieve, panorama.

CITTÀ DELLA PIEVE

A charming medieval town pleasantly set out along a hilly ridge, between the river courses of the Chiani and the Nestore, Città della Pieve is situated in the enchanting setting of the Umbrian hills, a short distance from the Tuscan border. Probably built in Etruscan times, as a dependency of Chiusi, it became a municipality under the Romans. After having been conquered by the Lombards, it was then donated to the Church by the Carolingian dynasty. At the turn of the 12C, it was acquired by the Papacy, and the status of a town was conferred upon it by Pope Clement VIII (1601). The town, previously known as *Pieve di S. Gervasio* and *Castel della Pieve*, is universally famous for being the birthplace of the great Renaissance painter, Pietro Vannucci. The artist, who is known by the nickname "Perugino", has handed down to posterity a wealth of paintings depicting the life and colours of the fascinating landscape of hills and lakes around the Trasimeno area.

Nowadays, Città della Pieve has an enchanting aura, conferred upon it by its picturesque arrangement of ancient brick constructions, which seem to keep vigil over the rolling hills dotted by the lakes of Trasimeno, Chiusi and Montepulciano. The lively atmosphere of the medieval town, with its wealth of artistic and historical heritage, the characteristic ironwork produced by local craftsmen

and the historical connotations of the *Palio dei Terzieri* (Cart Race) (second Sunday in August) are all factors which contribute to make Città della Pieve an extremely interesting tourist resort.

Piazza Gramsci lies at the heart of the town, and it is here that the **Cathedral of SS Gervasio and Protasio** is located. The building (12C) was substantially reconstructed during the course of the 16C and the 17C. On the site of the modern building, an ancient Early Christian church (reconverted from a pagan temple) once stood. To the side of the facade stands the **Public Tower**, a masterly example of Romanesque (travertine sections) and Gothic architecture (brick sections), with mullioned windows with two and four lights. The tower measures 38 metres in height. The interior of the church, which has a Latin cross plan, has a nave and several side chapels. Below the apse are the remains of a 14C crypt. Amongst the numerous works of art, mention should be made of two frescoes by Perugino depicting *The Baptism of Christ* and *Madonna and Child with St Peter, St Paul, S.Gervasio and S.Protasio*; a 16C fresco by Alfani of *The Virgin and Child with St Martin, St Mary Magdalene and Angels*; the fresco in the apse by Pomarancio (N.Circignani) of *The Eternal and Angels*; and a wooden *Crucifix* (16C), probably the work of the pupils of Giambologna. Near the sacristy is a small *Museum* containing interesting paintings, detached frescoes and jewellery belonging to the Diocese.

The **Mazzuoli** (*ex-Della Corgna*) **Palace** was built by Alessi

in the second half of the 16C. The vaults of the interior have frescoes with decorative motifs, painted by the Florentine artist Salvio Savini (1580).

The ancient **Oratory of the Disciplined,** today annexed to the **Church of S.Maria della Mercede** (lit. "of the reward") (or *dei Bianchi*), was built as an 18C extension to a previous church and is famous for the fact that it contains a large fresco by Perugino, which is considered to be the artist's masterpiece amongst the works on display in his native town: *Epiphany* (1504) or the *Adoration of the Magi*, as it is more commonly known.

The turreted **Fortress** was built by the Perugians in the first half of the 14C and was enlarged and reinforced in the following century. It was in this building that Cesare Borgia gave orders for Paolo Orsini and the Duke of Gravina to be strangled to death, so as to gain revenge after a plot had been organized to overthrow him at Magione. The *Castellana, Maestra* and *Serpentina* towers still remain today; two other towers were knocked down during the first half of the 17C.

The **Church of St Augustine**, which is nowadays used for cultural events, was constructed towards the middle of the 13C and then later rebuilt. Here, one can admire a beautiful *Ascension* by Pomarancio (N.Circignani) and two paintings by Salvio Savini, depicting *The Madonna with Saints and Brothers* and *Scenes from the Life of S.Nicola da Tolentino*. The **Sanctuary of the Madonna di Fatima** (once the *Church of St Francis*) is the result of partial reconstruction work (18C) carried out on the original 13C building. The brick facade has three blind arches; to be seen in the interior are a *Pentecost* by Niccolò Circignani and an *Enthroned Virgin and Saints* by D. Alfani. Nearby stands the **Oratory of St Bartholomew** which contains a 15C *Madonna and Child with St Francis and St Anthony of Padua* and a large fresco by Maestro degli Ordini (influenced by the works of Taddeo Gaddi (1342-1360)) depicting the *Crucifixion*, more commonly known as the *Pianto degli Angeli (The Weeping of the Angels)*.

The **Church of St Peter**, once known as the *Church of St Anthony the Abbot*, is the result of reconstruction work done on a pre-existing church, carried out at the beginning of the 16C. It contains a fresco by Perugino (painted on a canvas) which can only partially be made out, depicting *St Anthony the Abbot enthroned between S.Marcello and St. Peter the Hermit*.

Where a place of worship dedicated to the *Madonna of the Star* once stood, the **Church of S. Maria dei Servi** was built during the 13C and 14C. It later underwent Baroque reconstruction work (17C). In the interior, one can admire a masterly *Deposition* by Perugino, which recent restoration work has now restored to its former splendour. Finally, mention should be made of the Baroque **Della Fargna Palace** (18C), the present seat of the Town Council, and the **Bandini Palace** (16C) originally a 14C construction, re-designed by the young Alessi.

Città della Pieve, view of the mediaeval turreted walls.

Città della Pieve, an ancient bell tower in the historical centre.

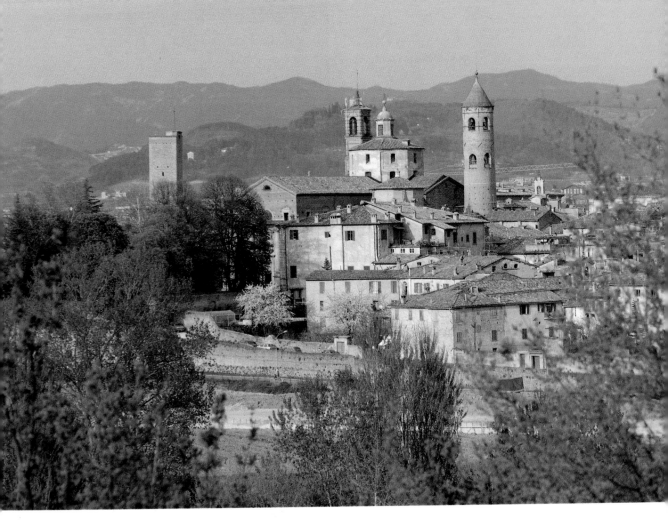

Città di Castello, panorama over the town and the Upper Tiber Valley.

CITTÀ DI CASTELLO

HISTORICAL BACKGROUND - *Umbria's northernmost city in the Upper Valtiberina, situated to the left of the Tiber (as seen on the map), lying almost at the heart of the Valley, Città di Castello is a lively tourist town, full of important medieval and Renaissance buildings. Originally an Umbrian foundation, it had some dealings with the Etruscans, although it still retained its independence. As a part of the Early Roman Empire at the turn of the IC AD, it became a flourishing municipality known as* Tifernum Tiberinum. *The Roman town was further enlarged by the construction of temples and public buildings, and Pliny the Younger proved to be an excellent patron to the town. Razed to the ground by the armies of Totila, it was then rebuilt by Bishop Florido into a fortress town. It fell firstly into the hands of the Byzantines and then to the Lombards and was referred to as* Castrum Felicitatis *in a document dating from the 8C. Passing from the Franks to the control of the Church, Città di Castello became a free town (12C), when, once again, its name was changed to* Civitas Castelli *(from which the actual place name is derived). Growing in importance and power, it ex-tended its territorial possessions beyond the Apennines, while, with the advent of the Vitelli family (end of the 15C), new churches and palaces soon flourished, whose Tuscan-Renaissance architectural features still characterize the present day city. Valentino (Cesare Borgia) took control of the city for the Papacy and, even though it was later subjected to periods of upheaval, it remained a Papal possession until it was annexed to the Kingdom of Italy (1860).*

Today, Città di Castello is the main tourist attraction in the Upper Valley of the Tiber. It has a composite economic structure, in which the more traditional rural activities (it is well known for its tobacco cultivation) and handicraft industries are flanked by a thriving industrial sector. The excellent local cuisine, largely based on a wide range of game dishes, pork products and roasts, blends perfectly with the high quality wines of the valley. Amongst the handicrafts produced here, mention should be made of the wrought-iron work, ceramics "alla castellana", local cloth and table linen, period furniture and jewellery. The Fairs of S. Florido (mid-November) are traditional events which date back to long ago.

THE CATHEDRAL OF SS FLORIDO AND AMANZIO -

The Church, which still contains traces of the restructuring work carried out during the Gothic period, has a magnificent **facade** divided into sections by columns, pilaster strips and niches. The front of the building, which has remained incomplete, dates from the 17C and stands at the top of a majestic flight of steps. The features which mark the passage from the Renaissance to the Baroque style, are very much in evidence. The construction has an intriguing round 13C **campanile** with a spire and bears obvious similarities to the Byzantine style of the towers of Ravenna. The **interior** of the church has a Latin cross plan with one nave and has a decidedly 16C layout, even if numerous features have obviously been borrowed from 15C Florentine architecture. The coffered ceiling dates from the end of the 17C. One of the most outstanding side chapels is that of the **Holy Sacrament** which contains the *Transfiguration of Christ* (first half of the 16C) by Rosso Fiorentino. Other interesting works of art include a painting by Pomarancio (Niccolò Circignani) depicting the *Fall of St Paul*, some frescoes by Sguazzino and Marco Benefial. The **Lower Church** (15C) has an 18C altar and a sarcophagus containing both the relics of the patron saints and other local saints. In the adjoining **Cathedral Museum** one can see the highly valuable *Treasure of the Sanctuary of Canoscio*, a collection which includes numerous examples of Early Christian art (5C-6C). There is also a lovely 12C silver altarpiece, a beautiful 14C pastoral painting attributed to Goro di Gregorio, and several church utensils and paintings, the most outstanding being a *Madonna with Child and Saints* by Pinturicchio.

TOWN HALL -

A masterly example of 14C architecture, the building was designed by Angelo da Orvieto. The rough stonework of its facade and the charming trilobal mullioned windows with two lights on the upper order contribute to the overall elegance of the building. On the ground floor, there is a beautiful portal with a lunette bearing the civic coat of arms. The entrance hall has robust octagonal pillars with finely decorated capitals supporting the cross vaults. In one of the rooms inside the building one can see Roman tombstones and plaques dating from the 2C B.C. to the lC A.D.

THE CHURCH OF S. MARIA MAGGIORE -

Built between the years spanning the end of the 15C and the beginning of the 16C, the building has a tripartite **interior** divided by brick columns with the coat of arms of the Vitelli family, the patrons who financed the construction of the church. The building, which has been "liberated" of its upper Baroque sections and whose original Late Gothic-Renaissance features were restored a few years ago, has some 15C-16C frescoes and a carved walnut choir dating from the 16C.

BISHOP'S TOWER -

This square, slender, stone construction was built in the 13C. The earthquake of 1789 (in which the small roof above the entrance tower collapsed) greatly damaged a fresco by Luca Signorelli (*The Enthroned Virgin and Child with St Peter amd St Paul*) above the entrance door. Some fragments of paintings, which were discovered in the 1930s, are on display to the public in the Municipal Picture Gallery.

Città di Castello, view of the Porta di S. Maria Maggiore.

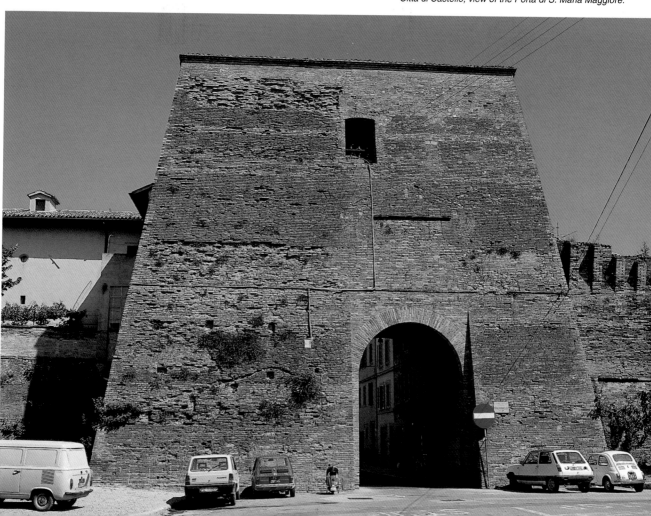

Città di Castello, a view of the central Piazza Matteotti.

A ceramics worker on the job in his artisan's workshop.

MUNICIPAL PICTURE GALLERY - The gallery is set out in the 16C **Vitelli alla Cannoniera Palace**. The facade of the building is decorated with graffiti by C. Gherardi, with outlines by Vasari. The former artist was also responsible for the decorations which enliven some of the rooms inside the building. In the portico, some glazed terracottas, bearing the unmistakable features of the work of the Della Robbias, can be seen. The collection of art works on display here lie only second in importance to those of the National Gallery at Perugia. The gallery contains works by Raphael (a two-sided processional standard depicting the *Creation of Eve* and *The Holy Trinity and Saints*; the other processional standard - depicting *The Virgin of Mercy and Crucifixion* - formerly attributed to Raphael has recently been established as having been painted in the first decade of the 16C); Luca Signorelli (*St Paul*, fragments of a fresco, which was originally housed in the Bishop's Tower, *Martyrdom of St Sebastian*); Piero della Francesca (*Benedictory Christ*, attributed to the painter); Neri di Bicci (*Virgin and Child*); Giorgio di Andrea di Bartolo (*Madonna and Child*); Maestro di Città di Castello (*Majesty*, 14C), Antonio Alberti (*Tryptych*). A painting from the workshop of Domenica Ghirlandaio is also included in the collection, as well as works by Raffaellino del Colle, Santi di Tito, Pomarancio (N. Circignani) and Giacomo da Milano. Also to be seen are a valuable *Reliquary of St Andrew*, attributed to Ghiberti (15C). In the large hall are frescoes attributed by Vasari to Cola dell'Amatrice.

DERUTA

Deruta is universally famous for its ceramics and lies to the left of the Tiber, nestling against the side of a chain of high hills situated between the Chiascio river and the stream of Puglia. Although the first settlements in the district date back to the Eneolithic age, the first certain references to the place date from the medieval ages. From the 11C onwards, Deruta, whilst still maintaining its autonomous privileges, gradually came under the domination of Perugia, before finally passing into the hands of the Papacy.

Deruta, which has, in part, managed to retain the highly distinctive features of medieval buildings and town layout, is certainly the most well-known centre of the region (and beyond) for the production and design of ceramics. The origins of this ancient art go back as far as the Etruscan times, but even before the 15C it was already a well-established and widespread industry, enjoying its heyday during the 16C and 18C. Numerous Italian and foreign museums have pieces of Deruta ceramics on show, including the Victoria and Albert Museum in London and the Louvre in Paris. In particular, mention should be made of the "bianchetto", a kind of white film which is placed over the clay. Designs and outlines are then traced over this before the finished article is glazed.

The **Ceramics Museum** contains 19C-20C local majolica ware, as well as ceramics dating from the 16C and 18C. Worthy of note are some plates, votive tablets, vases, goblets, basins, pharmaceutical containers, fragments of flooring and many other exhibits.

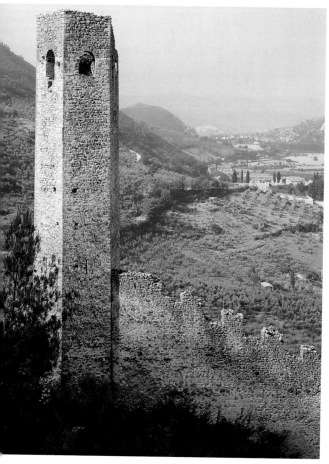

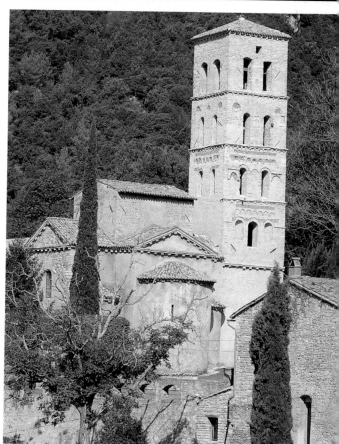

Ferentillo, an ancient sighting tower watches over the silent scenery of the Umbrian countryside.

Ferentillo, the crypt of the Church of St Stephen houses a fair number of mummified bodies.

Abbey of San Pietro in Valle (Ferentillo), a fascinating glimpse of the ancient abbey complex.

FERENTILLO

The characteristic features of a medieval village are still largely evident in Ferentillo, thanks to the ruins of the town **walls** and the two **fortresses** dating from the 14C, which seem to keep vigil over the landscape of the lower valley.

Ferentillo is famous for a large number of mummies, uniquely preserved and discovered in the Crypt of **The Church of St Stephen**. This church is a tripartite Renaissance construction (15C) substantially remoulded during the course of the 18C.

The **Church of St Mary** has frescoes by Jacopo Siculo in its interior and was built around the 13C. However, the building that we see today is the result of reconstruction work carried out during the Renaissance (15C-16C).

Worthy of note, near Ferentillo, is the **Abbey of San Pietro in Valle**, an outstanding example of great architectural and artistic importance. Above the whole building stands the stone **campanile**, decorated with symmetrical windows, reliefs dating from the 8C and suspended arches.

FOLIGNO

HISTORICAL BACKGROUND - *An extremely interesting city in the Valle Umbra, it lies to the left of the Topino river, downstream from the confluences of the Menotre, along the plain situated between the Martani Mountains, Mt. Aguzzo and Mt. Subasio. The origins of Foligno go back to ancient times, when it was known as* Fulginia. *An Umbrian foundation, it then fell into the hands of the Romans at the beginning of the 3C, after the battle of Sentino. It was an important centre during Roman times, becoming firstly a* Municipium *and later on a* Praefectura, *undergoing considerable development as a staging post along the* Via Flaminia. *It was converted to Christianity by Feliciano, who became a martyr in 251 A.D. Subsequently, it witnessed a period of upheaval and was razed to the ground by the Hungarians and the Saracens. The city flourished under the rule of Barbarossa and grew in both size and importance to become an autonomous commune. Integrated with the territories controlled by the Papacy (beginning of the 13C), it was then taken over by the Imperial forces in 1227, becoming one of the Ghibelline strongholds in Umbria. In 1305, Foligno fell to the Guelph factions led by the Trinci family, who governed the city up until 1439. It then came under the control of the Papacy once more (except for the Bonaparte interlude) and was finally annexed to the Kingdom of Italy in 1860.*
Foligno is the birthplace of the architect Giuseppe Piermarini (1734-1808) and had its own school of painters between the 15C and the 16C. Amongst the most famous artists of the Foligno School of Painting are Alunno (Niccolò di Liberatore), Pierantonio Mezzastris, Bartolomeo di Tommaso, Lattanzio di Niccolò, Ugolino di Gisberto, Feliciano de' Muti. The handicraft industries of the region include carpentry, restoration of ancient musical instruments and organ-building. Important folk celebrations held in the town include the Procession of S. Feliciano *(24 January), the arts festival called* Segni Barocchi *(lit. Baroque features) (during which plays, concerts, films and exhibitions with Baroque themes are held throughout September), and the famous* Giostra della Quintana, *an interesting medieval crossbow contest with a spectacular pageant of historical costumes (second Sunday in September). The typical features of the Roman city are still largely evident in the present-day aspect of the town, as seen by the right-angled shape of the streets and town buildings. The medieval nucleus huddled around the Cathedral, the Town Hall and the Trinci Palace can also be clearly made out.*

CATHEDRAL - The Cathedral of Foligno, dedicated to *S.Feliciano* was built in the first half of the 12C on the site where the patron saint of the city was buried. Later extension work (at the beginning of the 13C) led to the building of a second facade, which was then enlarged in the 15C and restored during the first decade of the 20C. The front of the building catches the eye due to its elegant architectural characteristics, which are a blend of Romanesque features and Gothic motifs. The most out-

Foligno, the well-known 'Giostra della Quintana'.

Foligno, detail of the beautiful main facade of the Cathedral.

standing element is the marvellous Romanesque portal, beautifully decorated with reliefs depicting *Barbarossa* and *Innocenzo III*, the *Symbols of the Evangelists* and the *Signs of the Zodiac*. The elegant dome is a 16C addition built by Giuliano di Baccio d'Agnolo.

The **interior** has one nave and betrays the features of Neoclassical remoulding work carried out by Piermarini. It also contains a baldachin,which is obviously a copy of the one in St Peter's, Rome, some paintings dating from the 18C-19C, a silver apotheosis of *S.Feliciano* (18C) and a painting by Alunno. Under the building lies the vast Romanesque **Crypt**.

THE CHURCH OF S. MARIA INFRAPORTAS - This is the oldest church in Foligno and has a 11C portico, which has been transformed in the upper section. The graceful **facade** is characterized by a trilobal mullioned window with two lights; another interesting feature is the square Romanesque campanile (12C). The **interior**, which has an oblong basilica-like plan, is divided into a nave and two aisles. The church contains numerous frescoes by the local school of painters (Alunno, Nelli, Ugolino di Gisberto, Mezzastris). Worthy of note is the **Chapel of Our Lady of the Assumption** (12C) characterized by beautiful Byzantine frescoes.

Foligno, the secondary facade of the Cathedral faces onto the central Piazza della Repubblica.

Foligno, view of the Church of S. Maria Infraportas.

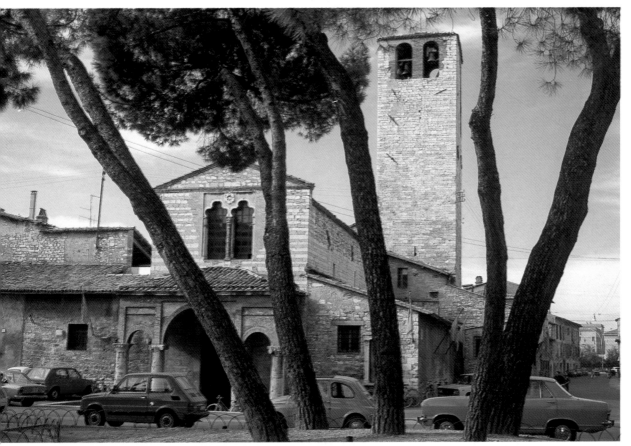

Environs

The **Fortress of Sant'Eraclio** was built by the Trinci family at the beginning of the 15C. The walls of the fortress are well preserved and contain two gates and towers. In the small church (with the Trinci coat of arms on the facade) are two frescoes by local artists.

The **Church of S. Maria in Campis** is an Early Christian basilica, enlarged in the mid 15C and reconstructed in the 19C. Numerous finds dating back to Roman times have been discovered in the district, and it is believed that a large settlement was found on this site. It was on this spot that the famous bronze sculpture entitled *Hercules of Foligno* was discovered. In medieval times, the church was known as *S.Maria Maggiore*. In the side chapels are some frescoes of great merit, painted by artists of the Foligno School (Alunno, Mezzastris, Giovanni di Corraduccio).

The **Church of S.Giovanni Profiamma** is situated along the ancient *Via Flaminia*, where the *Municipium of Forum Flaminii* stood in Roman times (218 B.C.). Its name is derived from its founder, a Roman consul. The construction, of harmonious basilica features, dates from the 11C-12C and substituted an earlier church built on this spot. The **facade** dating from the first half of the 13C is decorated with a Romanesque portal with reliefs executed by Maestro Filippo. The **interior** has a raised presbytery and a semi-circular apse containing fragments of frescoes (*Madonna of Mercy*). In the **Crypt** there are architectural exhibits dating back to the Early Medieval period.

The **Abbey of Sassovivo** stands in a green ilex grove on the slopes of Mt. Aguzzo. It was founded in the second half of the 11C; it once belonged to the Benedictines of Sassovivo and then passed into the hands of the Olivetani family. The abbey buildings date back to the 12C, and today it is a popular tourist attraction. A feature of great architectural and artistic interest is the **Cloister** (first half of the 13C), the work of the famous Roman marble sculptor, Pietro de Maria. The splendid marble entablature is supported by round arches resting on 128 double columns. There is a beautiful frieze decorated with mosaics and polychrome marble. Nearby stand the ruins of the **Chapel of Beato Alano** (13C-14C) with an ancient **Crypt**.

Thanks to its extraordinary countryside, the **Plain of Colfiorito** is counted as being one of the most interesting naturalist zones in Umbria. The vast plain has been defined as "an area of marshland of international interest". The whole district is renowned for its ornithology, botany and geology. Along the plain stood the ancient pre-Roman settlement of **Plestia**, otherwise known as *Pistia*, and numerous archaeological finds have been discovered in this spot. The ancient **Church of St Mary of Plestia** (10C) was built with left-over Roman building materials.

Abbey of Sassovivo (Foligno), partial view of the abbey complex.

Gualdo Tadino, the mighty outline of the turreted Flea Fortress dominates the view over the village.

GUALDO TADINO

HISTORICAL BACKGROUND - *The town, which lies close to the Marches' border, is situated near the Via Flaminia, along the stretch of the foothills of the Apennines dominated by Mt. Serra Santa. An Umbrian foundation, it was known as Tadinum (or Tadinae) in Roman times, when the inhabited area was situated along the consular road, in the plain located a little to the south of the present day settlement. Since the romanization of the town (266 B.C.) it suffered great upheaval and unrest; in fact it was destroyed by Hannibal (217 B.C.), sacked by the partisans of Caesar (49-48 B.C.) and was the site of the battle of "Tagina", which resulted in the war between the Goths and the Byzantines. The war was won by the latter (552). It was once again razed to the ground by Otto III (end of the 10C) and was then so badly damaged in a fire that it had to be rebuilt (1237) on the present location. Having become a free commune, under the auspices of Frederick II, it was conquered by the Perugians, before finally coming under the control of the Papacy (second half of the 15C). After vast sections of the town were destroyed by an earthquake (1751), it then became part of the Roman Republic during the Napoleonic era. It was once more assigned to the Church during the post-Napoleonic restoration period and finally annexed to the Kingdom of Italy. The present day town is a lively centre of historical and artistic importance, with extremely important monuments and sights. The place is also well-known for its waters, which are low in mineral content and originate from the Rocchetta Springs. It is also universally famous for its ceramic production. The most important folk events and festivals include the* Procession of the Dead Christ *(Good Friday); the traditional festivities of* Cantamaggio; *the* International Exhibition/Competition of Ceramics *(August-September); the* Palio delle Porte *("race of the town gate quarters") (last Sunday in September).*

THE FLEA FORTRESS - The turreted bulk of the fortress is a distinctive feature of the hill on which it stands and which, in turn, dominates the town below. Considered to be one of the most important examples of medieval military architecture, its name is derived from Fleo, a small water course which flows nearby. Largely in ruins, from the 12C onwards, it was then rebuilt in the 13C by Frederick II. Towards the end of the 14C it underwent new large-scale reconstruction work carried out by Biordo Michelotti. The fortress, which was restored many times during the period of papal domination, houses the **Town Archives**. These contain important documents and parchment manuscripts, dating back to the 13C and 18C, land registers, several deeds, proclamations and edicts. Particularly important documents include the *lyrical laud-book* (or hymn book) *of the Raccomandati di Maria* (a religious order) and a liturgical manuscript.

THE CATHEDRAL OF ST BENEDICT - Together with the annexed Benedictine monastery, the cathedral was constructed by Lombard builders in the second half of the 13C. The church, which has a flight of steps in front of it, has a Gothic **facade** in two orders. The upper order contains a masterly rose window, with round windows on either side; in the lower order are three portals, the central one having exquisite decorative motifs. On the right side of the church stands a beautiful 16C **fountain** by Antonio da Sangallo the Elder. The present day **interior** is the result of 19C remoulding work; it has a nave and two aisles and contains a marble altar-frontal on the 14C high altar. In the **Chapel of Beato Angelo** is a bronze and silver urn containing the mortal remains of the blessed Angelo.

51

GUBBIO

HISTORICAL BACKGROUND - *An ancient and noble city, majestically laid out along the ridges of Mt. Ingino. The stream of Carmignano and its tributary (which are both tributaries of the Saonda river) flow through the town. Even if the first settlements of the district around Gubbio seem to date back to prehistoric times, we are at least certain that Gubbio was founded by the Umbrians and that it soon became both a meeting point and the scene of confrontation between these and the nearby Etruscan civilization, as testified by the* Eugubine Tablets. *These constitute an important key to the understanding of the civilization and language of the Umbrians, as well as providing insight into the structure of this city-state between the 3C and 1C B.C. The seven bronze slabs, written partly in the Umbrian alphabet (derived from the Etruscan one) and partly in bastardised Latin, are a significant historical record of exceptional value. The romanization of Gubbio dates from 295 B.C. Later,* Iguvium, *included within the* Crustumina *tribe, obtained Roman citizenship. Destroyed during the Gothic War (5C), it then came under Lombard rule (8C). With the development of free communes (11C), Gubbio grew in importance, a fact which immediately led to bitter conflicts with the town of Perugia. Having been conquered by Perugia, it then came under Papal domination, before becoming the possession of the Montefeltro Dukes of Urbino for two centuries. It finally became part of the Papal States (1624).*

As a city of cultural and historical traditions, Gubbio has an exceptional wealth of artistic and monumental heritage. The layout of the town centre is steeped in the characteristic features of medieval buildings and streets, creating an interesting environment, which also includes marvellous examples of Renaissance architecture. The widespread use of limestone confers warm chromatic tones upon the buildings of the town, whilst towers and palaces intermingle with Gothic churches and the austere facades of residences and houses, which have over the years acquired a charming characteristic patina. The town plan of Gubbio betrays the characteristic configuration of medieval centres still enclosed within town walls. At the same time, both the centre and outlying areas have adapted to modern living conditions. The city is the birthplace of the miniaturist Oderisi (13C), the painter Ottaviano Nelli (15C), the ceramicist Giorgio Andreoli (Maestro Giorgio 15-16C) and the architect Matteo di Giovannello (Gattapone, 14C). If tourism, together with agriculture and industry are important factors of the city's economy, the contributions made by the local handicraft industry should not be overlooked. This secondary concern involves the production and manufacture of ceramics, together with wrought iron work, carpentry and copperware. The local cuisine is characterized by wholesome home-made dishes, whilst the white truffle is an appetizing accompaniment to both autumnal and winter fare. Amongst the local festivals, which blend elements of both the sacred and profane, in this religiously important city (it was the scene of many important episodes in the life of St Francis), mention should be made of the* Procession of the Dead Christ *(Good Friday); the* Corsa dei Ceri *("Candle"/Tower Shrines Race) held on 15th May; the* Palio della Balestra *(Crossbow Competition) (last Sunday in May). From the middle of July until the middle of August* Classical Plays *are also put on at the Roman Theatre.*

The "Corsa dei Ceri" deserves special mention. Due to its religious and secular connotations, and the exuberant atmosphere it engenders, the "Corsa dei Ceri" can be said to be on a par with the famous Palio *of Siena. On the 15th May, the eve of the patron saint's day (S. Ubaldo) Gubbio cheers on the "ceraioli" (candle makers/bearers), represented by the ancient town corpo-*

Gubbio, view of the city from the Consuls' Palace.

Gubbio, the 'Palio della Balestra'.

Gubbio, folklore and religion merge in the traditional 'Corsa dei Ceri' (Race of the Candles).

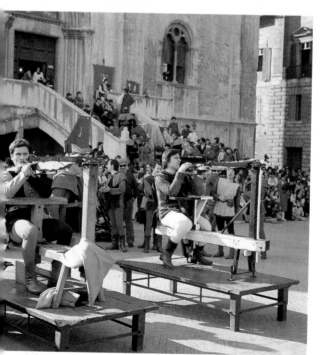

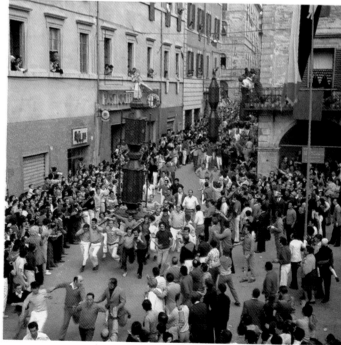

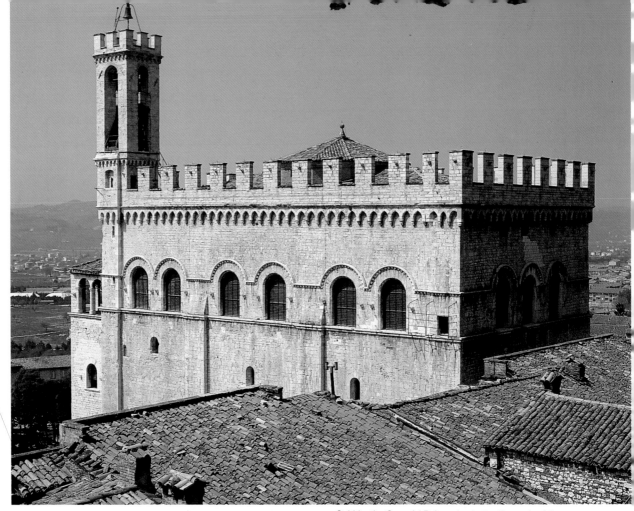

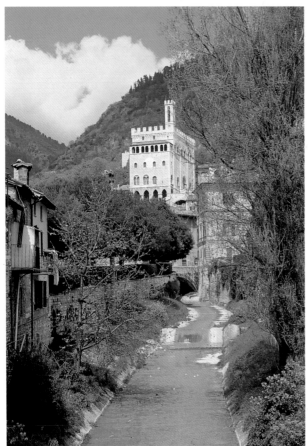

Gubbio, the Consuls' Palace dominates the roofs of the township.

Gubbio, partial view of the ancient nucleus with the Consuls' Palace in the background.

Gubbio, the imposing and scenic Consuls' Palace, a distinguishing mark of Gubbio's scenery

Following pages

Gubbio, proposals of the ancient medieval centre dominated by the Consuls' Palace

Gubbio, the magnificent stairway giving access to the Consuls' Palace and the entrance hall given over to use as a museum

rations, which carry enormous polygonal wooden towers, topped with a wax saint (Ubaldo, George and Anthony the Abbot) on their shoulders. The lively "race" finishes at the Basilica of S.Ubaldo on Mt. Ingino. This tradition, which is perhaps incorrectly defined as a "race" (because it is not a competition, seeing that S. Ubaldo must always arrive at the Basilica first), is linked (according to one of many hypotheses) to an episode in medieval history. It is supposed to commemorate the day on which the Eugubines, with the help of Ubaldo, fought back a confederation of rival communes who had surrounded the town. The event is also rooted in pagan ritual, harking back to expiatory rites and favourable auspices at the advent of the spring.

CONSULS' PALACE - PALACE OF THE PODESTÀ -

These two architecturally associated buildings look out over *Piazza Grande*, a "hanging" piazza par excellence (so-called because it occupies a ledge of the hill). The piazza

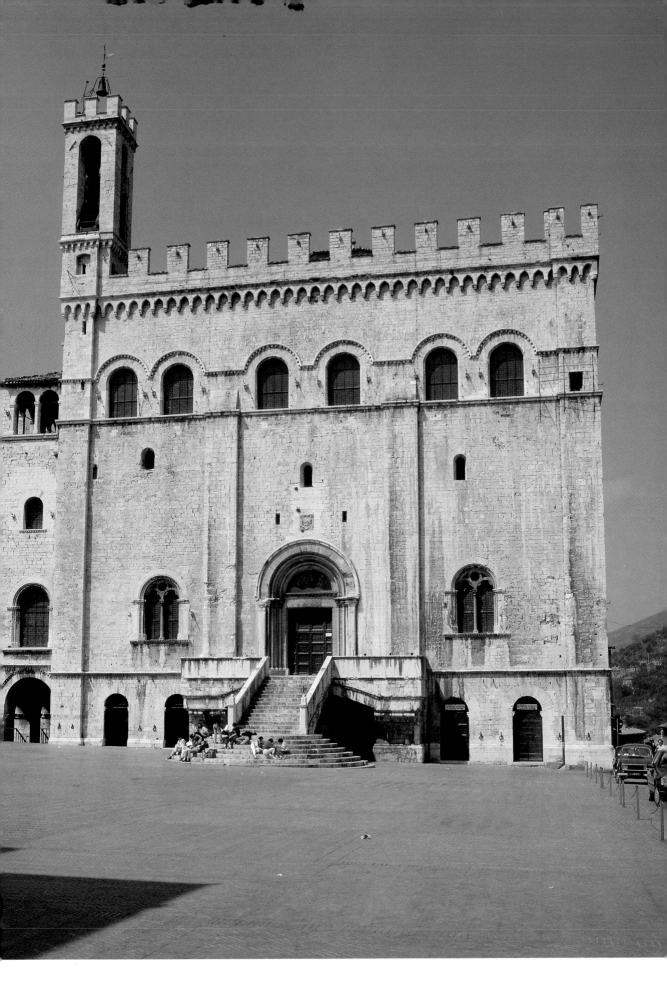

Gubbio, Archaeological Museum (Consuls' Palace), two of the seven Eugubine Tablets. The slab no. 1 with text in Umbrian-Etruscan alphabet and the slab no. 5 with text in Umbrian-Etruscan and Latin alphabet.

Gubbio, local ceramics (a cup with St. Roch and a plate with the Consuls'Palace).

constitutes the architectural and monumental heart of the city. The charming architectural and monumental proportions of these two buildings, their simple elegance, the symmetrical proportions of the windswept piazza, "invented" in the 14C, constitute some of the most outstanding focal points of the town. These features anticipate architectural themes, which would find mature expression a century later in the Florentine Renaissance.

Both palaces date from the 14C and were designed by the Eugubine architect Matteo di Giovannello, better known as Gattapone. The magnificent Gothic portal, (which has a flight of steps in front of it) set in the **facade** of the Consuls' Palace, is by Angelo da Orvieto. The facade itself is divided vertically by pilaster strips, with a series of small jutting arches along the top, which are crowned with merlons, a feature repeated in the turreted tower dominating the building. The palace, also known as

Palazzo dei Popolo (People's Palace), was once the seat of the highest magistracy of the Commune; the building also houses the **Picture Gallery** and the **Archaeological Museum**. In the Gallery are paintings by artists of Gubbio dating from the 14C to the 16C, paintings by the Venetian school, a *Madonna of Mercy* by an artist of Perugia, and a 16C *St Francis* by A. Sacchi. The most outstanding exhibit in the Archaeological Museum is the **Eugubine Tablets**, which constitute a unique key to both the understanding of the ancient Umbrian language and civilization and the study of the ancient Italic populations. Other exhibits on show include archaeological finds, ceramics and coins. The Palace of the Podestà, also known as the *Magisterial Palace*, is the seat of the local town council. Along the northern side of the piazza stands the **Ranghiasci-Brancaleoni Palace**, the only Neoclassical building in Gubbio.

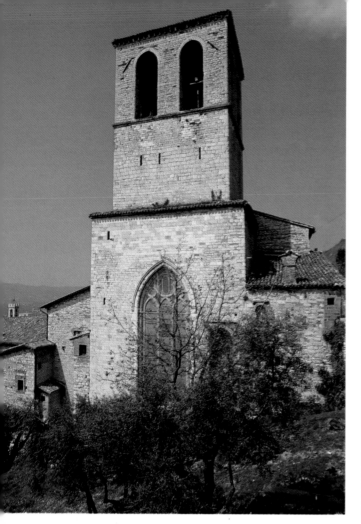

Gubbio, partial view of the Cathedral apse.

Gubbio, facade of the Cathedral.

Gubbio, view of the Cloister of the Church of St Francis;
the splendid apse with the octagonal bell tower;
the interior of the Franciscan temple.

CATHEDRAL - The present day building dates from the last twenty years of the 12C, when the ancient Roman town was abandoned in favour of the safety of the slopes of Mt. Ingino. The **facade** is characterized by a beautiful pointed portal and a large circular window, decorated around the edge with *Reliefs of the Evangelists*. In the **interior** which has a Latin cross plan consisting of one nave, the ceiling is supported by enormous pointed arches. It also contains numerous paintings and frescoes of 16C Umbrian artists. In the presbytery are two organs by the local engravers L. and G. Maffei (16C). Annexed to the Cathedral is the **Diocesan Museum** which contains 14C-15C painted panels, detached 15C frescoes, an ivory *Crucifix*, a valuable 16C cope and other interesting objects and exhibits.

THE CHURCH OF ST FRANCIS - The original building dates from the second half of the 13C and was designed by Fra' Bevignate (although this theory is much disputed). The bare **facade** has a Gothic portal and a small rose window. To the side of the tripartite apse stands an octagonal **Campanile**. In the **interior**, which has a nave and two aisles (it is the only church in Gubbio to have this internal division), traces of the 18C restructuring and remodelling work can be seen. The left chapel has frescoes depicting the *Story of the Virgin* by O. Nelli; other 15C paintings depict the *Virgin and Child with St Christopher and St Anthony the Abbot*. The right chapel has fragments of 14C frescoes and, under the vault, *Christ the Redeemer* and the *Evangelists*. An outstanding feature of the annexed **Convent** is the restored **Cloister**.

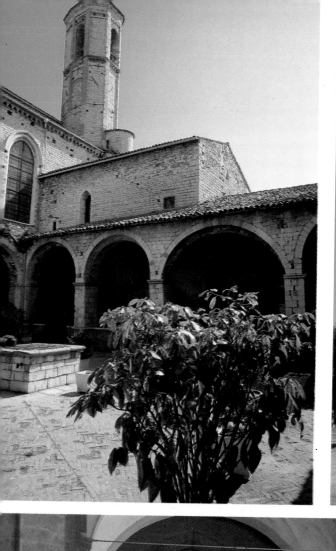
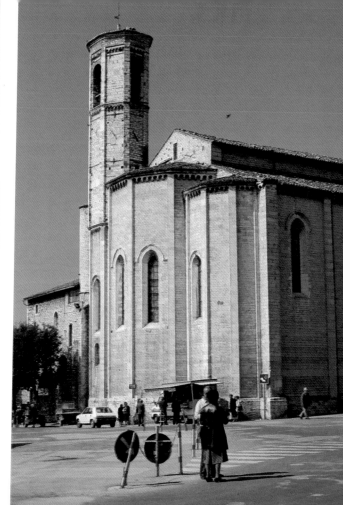
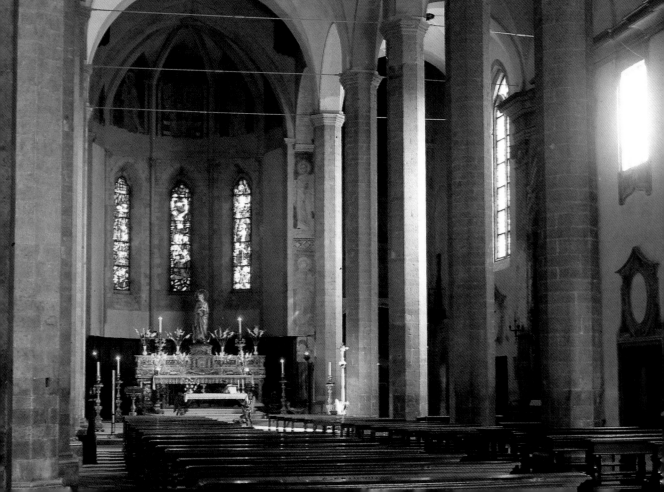

DUCAL PALACE - Masterly example of Renaissance architecture in the city, the palace was built at the behest of the Duke of Urbino, Frederick of Montefeltro sometime after 1470 upon the site of a Lombard palace. The building, which contains a splendid internal courtyard, partly surrounded by porticoes, was in all probability designed by Francesco Laurana, even if it is not certain whether he actually supervised its construction, which was probably completed by Francesco di Giorgio Martini. Inside the building some of the ancient furnishings are still to be found, although, as the property has changed hands many times, most of these have now been sold off.

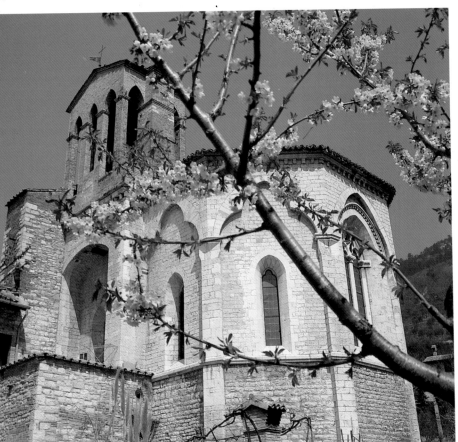

THE CHURCH OF S.SECONDO - The origins of this church are extremely ancient; documentary evidence has shown that this was once the administrative seat of the Church of Ravenna in Gubbio (6C-8C). In the present day building, later transformations carried out over the centuries can be seen. The apse, which has recently been restored, has pleasant 13C linear features. The **interior** contains some 15C-17C paintings.

Gubbio, looking towards the Ducal Palace.

Gubbio, a lovely picture of the Church of S. Secondo.

THE CHURCH OF ST JOHN - This building, which was reconstructed in the 13C on the site of an ancient baptistry, has an elegant Romanesque **facade** with a wide Gothic portal surmounted by a round window; at the side of the building stands a beautiful bell tower. The single-naved **interior** contains the customary transversal arches supporting its ceiling - a feature which is evidently derived from Gothic-Cistercian architecture.

CAPTAIN OF THE PEOPLE'S PALACE - This 13C construction, characterized by pleasant architectural features, most probably belonged to the Gabrielli family. The popular belief that says that it belonged to the Captain of the People has not been historically verified. Inside the building a most unusual **Museum of Torture Instruments Used Throughout the Centuries** has been laid out.

BARGELLO PALACE - The 13C building is characterized in the lower section of its facade by an elegant window. Its name is derived from the "Bargello" (or magistrate), an official of the free commune. During this era, the building housed the police station and governor's office.

Gubbio, view of St John's Church with the Consuls' Palace in the background.

Gubbio, partial view of the Bargello Palace with the so-called Fontana dei Matti.

Gubbio, Captain of the People's Palace (currently a museum for instruments of torture over the ages).

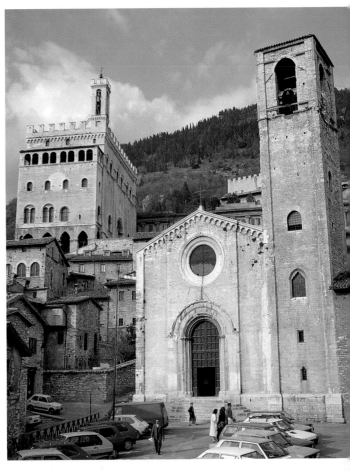

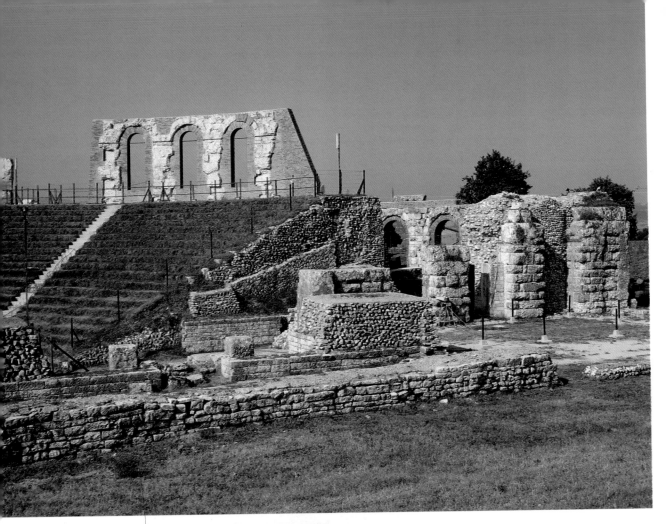

Gubbio, view of the Roman Theatre.

Gubbio, Cloister of the Basilica of S. Ubaldo.

ROMAN THEATRE - The theatre at Gubbio is counted as being amongst the largest and best-preserved in Italy. Some parts of the construction would seem to suggest that it was built in the Republican period; built of rough ashlar stones, some of its features were created using the *opus quadratum* technique. The **Cavea** (70 metres in diameter) is divided up into four wedge-shaped sections by flights of steps. During the summer months plays and classical drama are put on here. The theatre also has a proscenium (stage) and an orchestra pit, whilst an inscription, discovered in the second half of the 19C, gives details about the existence of two basilicas restored by the quadrumvir Gneus Satrius (1C A.D.).

THE HOUSE OF S. UBALDO - The 14C house is generally believed to have been the birthplace of S.Ubaldo (1084-1160). Even if the present day building (which has the salient features of a noble Eugubine house) cannot, chronologically speaking, possibly be the one in which Ubaldo Baldassini was born - it seems to have been ascertained that the building did belong to his family.

VEHIA GATE - It is the last surviving town gate of ancient *Iguvium*, which can be admired today. The Romans called it the *Janea Gate*, but over the centuries it was referred to by many other names. Today it is more well known as the *Arch of S.Marziale*, due to its proximity to the church bearing the same name. The enormous square

blocks of stone used in the construction of the arch and the lateral supports give an idea of the powerful dimensions which the ancient town walls must have had. It dates back to between the 4C and the 3C B.C.

MAUSOLEUM - This large aristocratic tomb dates back to Roman times. The burial chamber is well preserved, even though the external walls are almost totally ruined. According to Tito Livio (Titus Livius or Livy), the mausoleum is the tomb of Gentiius, King of the Illyrians, which was won in 168 B.C. and given in custody, with the family, to the inhabitants of Gubbio. However, another hypothesis suggests that it is the tomb of a certain Pomponius Gricinus or Grecinus.

THE CHURCH OF THE MADONNA DEL PRATO - Built in the second half of the 17C, it is characterized by its simple and yet refined Baroque-style features. The **interior** contains fine frescoes by F. Allegrini (*Assumption of the Virgin, Mercy, Martyrdom of St Stephen, Paradise, Faith, Charity*); G Lapis (*S.Francesco di Paola*); L Dorigny (*Baptism of Christ, S.Ubaldo, Hope*).

Almost at the summit of Mt. Ingino (827 metres in height), which can either be reached by car or by cable car, stands the **Basilica of S.Ubaldo**. The construction of the present church, built at the behest of the Governing Lateran Canons (ecclesiastical councils), dates from the 16C. Sources suggest that prior to this date another small church containing the remains of S.Ubaldo (transferred here in 1194), once stood on this site. Outstanding features include the beautifully decorated portals and the **Cloister** through which one enters the Church. The **interior** is divided into a nave and four aisles and is lit up by large windows decorated with *Scenes from the Life of S.Ubaldo*; worthy of note are the engraved marble altar and the glass urn containing the perfectly preserved body of the patron saint. Finally, it should also be remembered that the traditional "Corsa dei Ceri" (candle/tower shrine race) finishes at this spot. The three large wooden towers used in the "race" are on display throughout the year in the first aisle on the right of the church.

Gubbio, the turreted Porta Romana opens the circle of thirteenth-century city walls.

Montefalco, two picturesque views over the medieval nucieus.

MONTEFALCO

This ancient small town, which by virtue of its enviable position on a fertile hill (dominating the Valle Umbra, Foligno and the point at which the Clitunno runs into the Tiber), has been nicknamed the balcony of Umbria. It is an interesting artistic centre, characterized by distinctive medieval features and beautiful elegant buildings.

It was already a thriving locality in Roman times (it is probably the ancient seat of *Mons Faliscus* destroyed during the 1C B.C. after the civil wars) and was converted to Christianity by S.Fortunato around the 4C. Known as *Coccurione* during the Middle Ages, it was then razed to the ground by Frederick II (1249) and, after being re-built, was given the present place name. With the setting up of the free communes, it became the seat of the court of the Duchy of Spoleto. Conquered by the Trinci family (1383), after a period of upheaval and destruction, it was then handed over to Baldino di Niccolò Mauruzzi by the Papal authority, before it was taken over by the Church (1446). Numerous losses were incurred as a result of an epidemic of plague and the sacking of the locality by the armies of Orazio Baglioni (16C). It was thereafter made a town in 1848.

The local handicraft industry still manufactures cloth, while local festivities include the *Procession of Christ Arisen* (Easter Saturday), the local patron saint's day *S.Fortunato* (1st June), the *Festival of St Clare of Montefalco* (17 August) with the *Torch-lit Procession* (on the evening of 16 August), and the *Fuga del Bove* (lit. Escape of the Ox) which brings an end to the festivities of August.

Most parts of the medieval town of Montefalco are still enclosed within the encirclement of the **town walls**. These date back to the 14C and are surmounted by towers. The town gates are set within the walls. Rising up above the town stands the **Tower of St Augustine**, which is connected to a town gate bearing the same name. It is characterized by its jutting upper section, which is supported by corbels and crowned with Ghibelline crenellations along the top. Other town gates include the **Gate of Frederick II**, the **Camiano Gate** and the ancient **Fortress Gate**, demolished at the beginning of this century.

The **Church of St Francis** which was de-consacrated in the middle of the 19C, today contains an important **Museum and Picture Gallery**. It is a 14C construction, with a Renaissance portal set within its modern facade. It has a large, wide nave and a ceiling with wooden cross beams. On the right side is an aisle, which was added at a later date. Amongst the important art works are the splendid frescoes by Benozzo Gozzoli, which are located in the central apse (*Episodes from the life of St Francis, Scenes from the Life of St Jerome and Saints*); the chapels con-

taining frescoes by Giovanni di Corraduccio (15C); canvases by Fantino di Bevagna (Ascensidonio Spacca); the niche containing frescoes by Perugino (*Nativity, The Eternal Life, Annunciation*), a fresco by Tiberio d'Assisi (*Enthroned Virgin and Child with Saints*) and other works by Alunno, F. Melanzio, Antoniazzo Romano, Pier Antonio Mezzastris and others.

The **Church of St Augustine** was constructed in the years between the second half of the 13C and the first half of the 14C. The facade is decorated by a beautiful pointed portal; the interior, consisting of two aisles contains important frescoes in the Umbrian-Siennese style. Some of the artists represented here include Domenico Alfani, Ugolino di Gisberto, P. Mezzastris and G.B. Caporali.

The **Church of St Clare**, which contains the remains of St Clare of Montefalco in its interior (an eminent figure of Umbrian mysticism who lived between the 13C-14C), is a Baroque construction, remoulded in the 17C. In the **Chapel of S.Croce** are fine 14C frescoes by Umbrian artists. Near to the Church is the Augustinian **Convent** which has a cloister (15C).

The **Church of S.Illuminata** was built on the site of a pre-existing place of worship, at the turn of the 16C. The building, which contains motifs of the Lombard-Renaissance style in its interesting brick facade, contains some fine 16C frescoes, painted by Francesco Melanzio and Bernardino Mezzastris of Foligno.

Other churches worthy of note are those of **S.Maria di Piazza**, containing a 16C fresco by Melanzio; **S.Leonardo** (paintings by Melanzio and J. Vincioli); **S.Lucia** (12C) and **St Mary Magdalene** (13C, transformed in the 18C).

The **Town Hall** (13C) has few remaining parts of the original building; the loggia on the ground floor is a later 15C addition.

Other 15C-17C buildings include the **Langeli Palace** (once known as the *Tempestivi* Palace); the **Moriconi-Calvi Palace**; the **Santi-Gentili Palace**; the **De Cuppis Palace**; the **Senili Palace** (also formerly known as the *Tempestivi Palace*).

A little outside the town is the interesting convent of **S.Fortunato**. Its ancient origins date back to the 4C-5C, even if the building as it stands today is the result of 15C reconstruction work. In the beautiful four-sided portico are some Roman columns built from re-cycled building materials. The portal is decorated with a fresco by Benozzo Gozzoli, who also painted the *S.Fortunato* and the *Virgin and Child* which can be admired in the interior. The interesting Chapel of the Rose has 16C frescoes by Tiberio d'Assisi.

Again, in the outskirts of Montefalco stands the **Church of S.Maria di Turrita** (frescoes dating from the 14C-16C); the **Sanctuary of the Madonna of the Star** (19C paintings by artists from Rome, Livorno, Naples and Perugia) and the fortified medieval village of **Fabbri**.

Montefalco, the Town Hall.

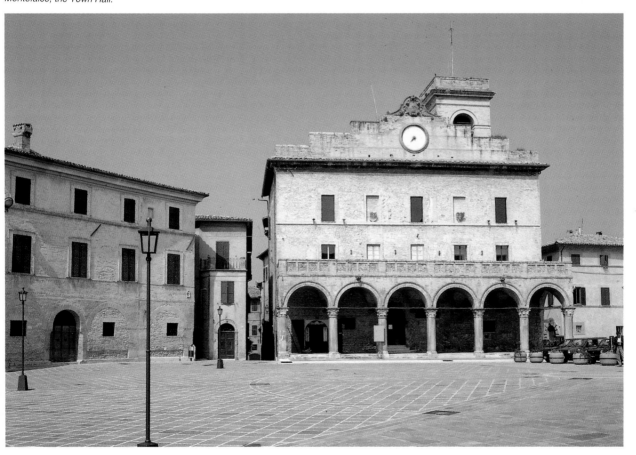

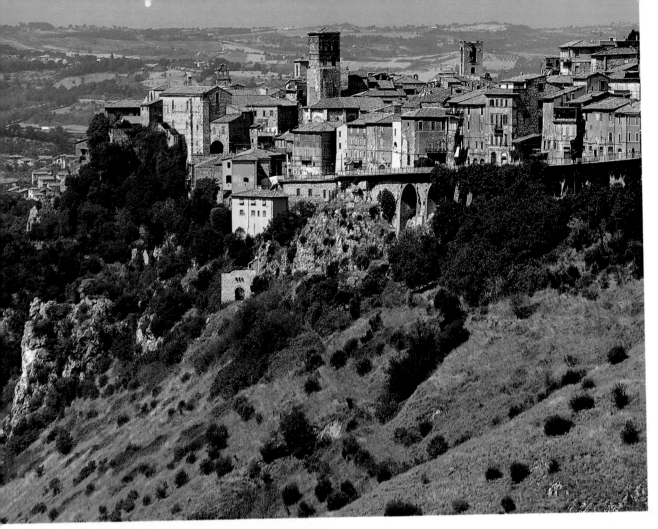

Narni, panorama.

Narni, partial view of the Loggia dei Priori with the Civic Tower.

NARNI

An important industrial town in the district of Terni, Narni is situated on a calcareous rocky ridge, covered with olive groves. Below it lies the plain of the river Nera, upon which stands the major town of the province (Terni). An Umbrian foundation, known as *Nequinum*, it then changed its allegiance to Rome and became known as *Narnia*, a strategic centre and flourishing *Municipium*. It fell into decline with the fall of the Roman Empire, and went on to become a Lombard stronghold: it then rebelled against the Papacy and became a free commune. Erasmo da Narni (Gattamelata), the famous Captain of the Republic of Venice, was born here in 1370. After a period of unrest and upheaval, in which the town fought against the Emperors and the feudal armies of the Orsini family, it was invaded by the Lanzichenecchi mercenaries (first half of the 16C), who inflicted serious damage upon the town, which in turn led to its relentless decline.

The local festivities include the *Tournament of the Rings*, a kind of medieval tournament in costume dress (second Sunday in May). The town also hosts the *Theatre Festival of the Town of Narni* (last ten days in June).

At the centre of the medieval town is the characteristic *Piazza dei Priori* (Priors' Square), the site of a beautiful polygonal **Fountain**. Overlooking the square is the ele-

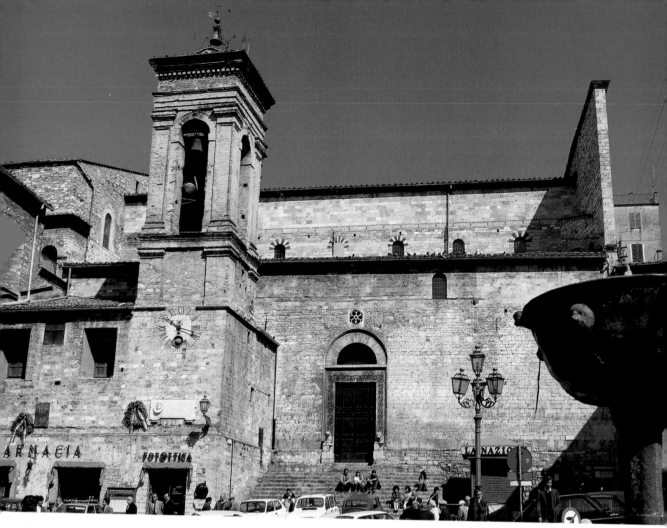

Narni, the Cathedral of S. Giovenale.

gant **Town Hall** (13C); the present day building is an amalgamation of three tower-houses. The facade is decorated by Romanesque bas-reliefs situated near the portal and by a charming 15C window believed to be by Benedetto da Settignano. The atrium (or entrance hall) has mosaic decorations by Cosmatesque artists and also contains interesting exhibits and archaeological finds. Amongst the rooms situated in the interior is the Town Council Chamber, which contains paintings by Ghirlandaio and Spagna. Opposite this building stand the imposing arcades of the **Loggia dei Priori** (Priors' Loggia), which support the cross vaults, a typical feature of 14C buildings. The construction, believed to be the work of Gattapone (Matteo di Giovannello), has an exterior pulpit overlooking the square, from which the communal edicts were read. It is surmounted by the simple, uncluttered massive structure of the **Civic Tower**.

The **Cathedral of S.Giovenale** is a beautiful Romanesque construction (1145), which was later enlarged and transformed. The simple facade has a 15C portico, decorated by a beautiful frieze. Of note are the beautiful main Romanesque portal and an arch which rises up from a Renaissance chapel. Above the whole building stands an imposing brick and stone bell tower, which is decorated with multicoloured majolica reliefs. The interior, which has one nave and two aisles, has a masterly frescoed apse and an additional aisle, which was built in the 15C. Some outstanding features include two wooden pulpits (by the Comacini masters), who also decorated the third Chapel on the right; *the Oratory of S.Giovenale and S.Cassio* (beautiful facade built of architectural fragments, Early Christian and Romanesque sculptures and reliefs, a beautiful mosaic of the *Redeemer* (9C); the wooden inlaid choir in the apse; the 16C *Tomb of Bishop Gormaz* built by pupils of Bregno; and a wooden sculpture by Vecchietta depicting *St Anthony the Abbot*, dating from 1474.

Dominating the town is the square-shaped **Fortress**, built in the second half of the 14C, inspired by Albornoz and constructed by Ugolino di Montemarte, probably helped by Gattapone. The square shaped building is dominated by robust corner towers and a high keep.

The **Church of St Augustine**, a 15C construction, has a bare facade with a portal, at the side of which is a fresco by Antoniazzo Romano. The interior, with a nave and two aisles, contains a *Crucifix and Saints* by disciples of Antoniazzo Romano, 16C frescoes by Torresani, a *Virgin and Saints* (15C) attributed to Matteo d'Amelia and a wooden 16C *Crucifix*; the dividing arches of the nave and aisles are similar to those of the portico.

The **Church of St Francis** is a 14C Gothic construction originally a small oratory, which was part of a Franciscan convent. It has a fine portal with an aedicule; the interior, which has a nave and two aisles, contains masterly 14C-15C frescoes.

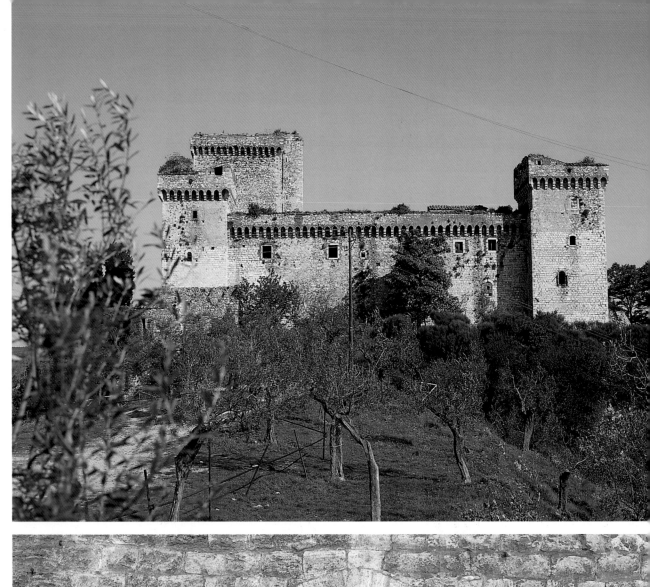

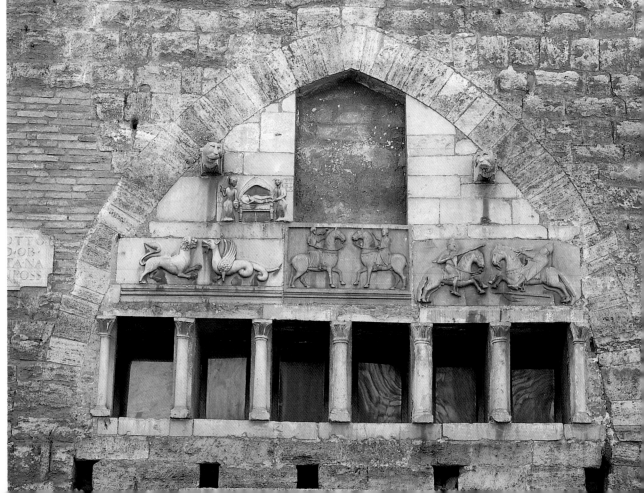

Narni, ruins of the Bridge of Augustus

Convent of the Sacred Cave (Narni), partial view of the Franciscan complex.

Narni, view of the Rocca fortress with the keep and the corner towers.

Narni, the Romanesque bas-reliefs enriching the facade of the Town Hall.

The **Church of St Domenic**, a 12C Romanesque construction, has now been turned into a museum. The facade has a beautiful decorated portal; the imposing Romanesque bell tower is also an interesting feature. The interior, consisting of a nave and two aisles, contains an *Annunciation* by Benozzo Gozzoli; the *bust of S.Bernardino*; a valuable terracotta by Vecchietta; a fresco by Matteo d'Amelia *(Madonna and Saints)* and a 15C marble tabernacle, attributed to Agostino di Duccio.

A little outside the town, at the Nera river, stands the robust arch of **The Bridge of Augustus**. This arch, which is the only one of four arches to have survived, is built of travertine blocks and is the most important remaining feature of Roman Narni. The beginning of "via delle acque" (lit. the road of the waters) *(Via Tiberina)* was once situated near the bridge.

It is worth making an excursion to the **Convent of the Sacred Cave** founded by Saint Francis in the 13C. The building, which is located in a pleasant setting amongst ilex groves and chestnut trees, was transformed by S. Bernardino in the 15C.

NOCERA UMBRA

An important town set in the upper valley of the Topino River, the town stretches out along a hilly ridge situated between Mt. Subasio and the Apennine mountains of Mt. Pennino and Mt. Acuto. The district of Nocera has been inhabited since the Neolithic era, but it was the Umbrians who built the first village here, which was called *Nukeria* (or *Noukria* meaning "new fortress"). Colonized by the Romans, who named it *Nuceria*, it then acquired the title of *Municipium* (municipality) and was an important staging post along the Via Flaminia. References to the town can be found in the writings of Ptolemy, Pliny the Elder and Strabo. It was razed to the ground during the time of the barbarian invasions. Having been acquired by the Lombards (6C), it then became a fortress and a stronghold under the Dukes of Spoleto. As a result of the spreading of Christianity, Nocera was soon elevated to an episcopal seat, and became a free commune during the 12C. At the beginning of the 13C it was taken over by Perugia, and towards the middle of the century, it was razed to the ground by the soldiers of Frederick II. It then became a fief of the Trinci family and formed part of the lands under Papal domination. Since the 17C, Nocera has been a popular holiday resort and a spa town (because of its mineral water).

The modern town of Nocera Umbra has a thriving ceramics industry, an artisan tradition which has been handed down since ancient times. The place is also famous for its thermal waters. Local festivities include the patron saint's day of *S.Rinaldo* (9 February), the *Festival of the Waters* (August) and the *Horse Race of Satriano* (September).

The **Campanaccio**, also known as the *Trinci Tower*, is the last remaining feature of the fortress of Nocera. The turreted building, which has a square-shaped plan, is in actual fact a bell tower, its origins dating back to the 11C.

Nearby, in a position dominating the town, stands the Cathedral; it has been subjected to several reconstructions. It was originally built in the Romanesque period (11C), although few sections of this building remain. It was then destroyed by Frederick II. After having been rebuilt (15C), it was then damaged by earthquakes and restored in the Neoclassical style towards the end of the 18C. In its interior, which has a nave and side chapels, lie the mortal remains of the Bishop S.Rinaldo. The Chapel of the Madonna is decorated with stucco work by Francesco Silva di Morbio and with paintings by Giulio Cesare Angeli.

The **Church of St Francis** has a beautiful rectangular stone facade, decorated with two portals, one of which is clearly Gothic in style (pointed and trilobate). The building houses the **Town Picture Gallery**. The collections, including archaeological exhibits dating from the Palaeolithic era to the Renaissance period, contain frescoes by Matteo da Gualdo and works by various artists. Amongst the most important are paintings by Niccolò Alunno (*Nativity of Christ, Coronation of Mary*) and Segna di Bonaventura (*Madonna and Child*). Finally, there is also a masterly *Crucifixion with Virgin and Saints* (13C) by pupils of Maestro di S.Francesco and fragments of *The Funeral Monument of Bishop Favorino*, a 16C work by artists of the studio of Rocco da Vicenza.

Also worthy of note is the **Old Gate** (once the gate of *St Francis*), the only one remaining of three town gates which were once situated in the encirclement of the medieval walls; the Byzantine **Palombara Tower**, and the churches of **St Philip** built in the Neogothic style by Luigi Poletti (19C), the Romanesque **St Clare**, with paintings by C. Maratta (17C) and **St John**, Romanesque in origin and once known as *S.Maria Antica*.

Nocera Umbra, panorama.

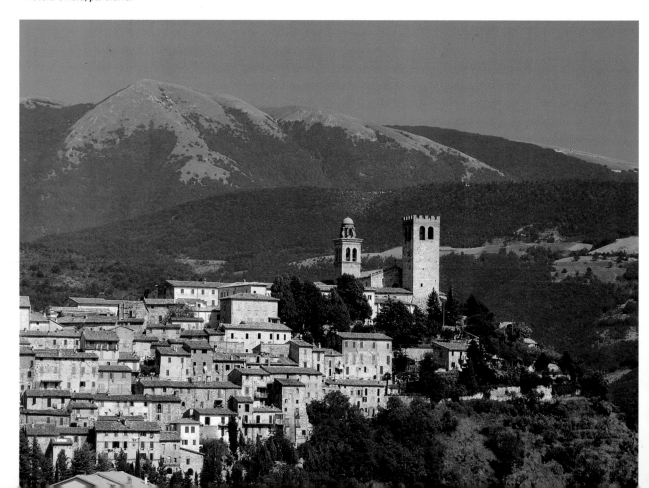

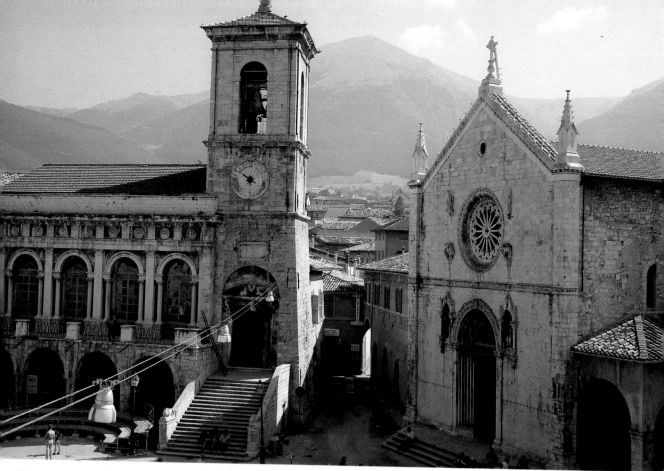

Norcia, partial view of the Town Hall and the Basilica of St Benedict .

NORCIA

HISTORICAL BACKGROUND - *In mystical, artistic and monumental terms, Norcia is a very interesting city, spreading out along the edge of the Plain of St Scholastica, an ancient Pliocene lake, crowned by the Apennine mountains, which culminate in the scenic ramparts of the Sibillini Mountains. Probably a centre founded by the Etruscans, which was also inhabited by the Umbrians and the Sabines, it was mentioned in the works of famous poets and Latin writers (Virgil and Cicero), a fact which demonstrates the importance held by the town in Roman times. From the 2C B.C. Nursia became a* Municipium *(municipality) to all effects and purposes. In 71 B.C., a memorable, bloody battle between the Romans and the gladiators led by Spartacus was fought out on the plain of St Scholastica. On the one hand, the dark centuries which followed as a consequence of the decline of the Roman Empire also affected the history of Norcia, which was sacked and destroyed many times (by the Goths, the Lombards and by the Saracens). However, on the other hand, it was also the birthplace of Benedict, the founder of Western Monasticism and patron saint of Europe and his twin sister, Scholastica. By a strange coincidence, both were born in the same year (42) and also died in the same year (St Benedict died in March 547, almost forty days after the death of Scholastica). Donated to the Church by Otto I (second half of the 10C), Norcia then underwent a period of upheaval and waged war against the nearby centres of Cascia and Visso. Between the second half of the 16C and that of the 18C,* it formed part of the so-called *Prefettura della Montagna (Mountain Prefecture), set up at the request of Pope Pio V. As with many other Italian towns, Norcia became part of the Kingdom of Italy in 1860.*

Today Norcia is a popular holiday resort, an ideal base for excursions into the natural amphitheatre of the Sibillini Mountains. In winter, the nearby Forca Canapine (construction work on a fast road link with Ascoli is well under way) is a ski resort, where various winter sports can be practised. However, Norcia is famous above all for its pork meat production (the famous "norcini" - pork butchers) and sausages, which provide the perfect accompaniment to other features of the local cuisine, such as the delicious lentils and the exquisite truffles. The local handicraft industry also produces wrought iron work and wood carvings. Local festivities include the Market/Exhibition of Black Truffles *and other typical produce of the Valnerina (February-March), the* Festival of St Benedict *(21 March), the* Good Friday Procession *and the* Faoni *(9 December, a bonfire is lit to symbolize the mingling of local folklore traditions with the superstitious beliefs of the population of Norcia).*

A small compact 19C town, which has a considerable number of medieval ruins, the whole of Norcia is enclosed within the 14C town walls. These walls, which are crowned with towers, reinforced by bastions and contain town gates within their perimenter, are one of the most charming features of Norcia.

THE BASILICA OF ST BENEDICT - Its construction was undertaken during the late 13C on the site, where the house of the patron saint's parents is believed to have stood. The white **facade** in the Gothic Umbrian style, has a sloping roof, with corner spires and a magnificent central rose window. In the middle of the facade stands a masterly Gothic portal, which is exquisitely decorated. In the lunette is a fresco depicting *Madonna and Child with Angels*. On each side of the lunette are exquisite small Gothic aedicules containing sculptures of *St Benedict* and *St Scholastica*. Above, *Figures of the Evangelists* surround the rose window. Annexed to the side of the building is the small portico "delle misure" (lit. of the measures). At the end of this stands the late 14C **Campanile**. The **interior** which contains 18C reconstruction work has a nave and is in the form of a Latin Cross. Paintings include *St Benedict and Totila*, attributed to Filippo Napoletano (Filippo di Liagno of Norcia, 17C); the *Resurrection of Lazarus* by M. Carducci; the *Madonna and Child, St Scholastica and Saints* by V. Manenti. The **Crypt**, which contains features of Roman masonry and 14C frescoes, is probably all that remains of a pre-Romanesque place of worship, built over the birthplace of St Benedict.

TOWN HALL - The present day building is the result of several reconstructions. The portico on the ground floor is all that remains of the most ancient part of the construc-tion (13C). The upper part of the **facade** has Neoclassical features designed in the second half of the 19C by Domenico Mollaioli from Perugia. The annexed bell **Tower** stands on a 17C flight of steps and was reconstructed in the 18C. Some of the most important rooms in the interior include the **Council Chamber** with a 16C altar-frontal by Jacopo Siculo (*Coronation of the Virgin)* and the **Sala dei Quaranta** (Lit. Chamber of Forty), whose walls are lined with 18C tapestries depicting the *Four Continents*. Finaly, also to be seen in the **Priors' Chapel** is the reliquary of St Benedict, a fine example of Gothic-Renaissance gold carving (16C).

CASTELLINA - An imposing 16C fortress, it was built to plans by Vignola. It is a square-shaped construction with sloping corner turreted towers. In the courtyard is a four-sided portico with a double loggia. The **Civic-Diocesan Museum** is located inside the building. Amongst the more important works are an *Annunciation* by a pupil of Andrea della Robbia (16C); the so-called *Tertiary Panel* by Antonio da Faenza (16C); a painted 12C *Cross*; a 13C wooden statue of the *Deposition* by an Umbrian artist; a *Resurrection of Christ* by Nicola da Siena (15C); a *Glory of St Francis* of the Siennese school (15C); a *Pietà* of the German school (15C) and numerous other works and exhibits from the district of Norcia.

Norcia, the imposing Castellina byVignola faces onto the Piazza S. Benedetto.

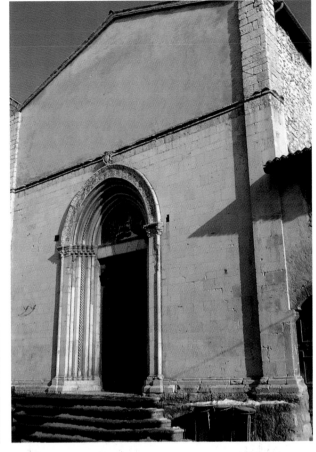

Norcia, the Church of St Francis, the Church of St Augustine and the so-called Aedicule.

THE CHURCH OF ST FRANCIS - A splendid ashlar stone construction dating from the second half of the 14C. It has a beautiful splayed Gothic portal with a lunette containing a fresco, and a masterly rose window in the upper part of the **facade**.

The **interior** has a nave and contains parts of the ancient pointed vault. Among the remaining frescoes are those depicting the *Virgin and Child Enthroned with Saints* and *St Anthony of Padua in Glory*. Both works betray features of the Ascoli School of Painting (15C).

THE CHURCH OF ST AUGUSTINE - Once dedicated to *St Agatha*, it is a 14C construction and its facade is decorated with an elegant Gothic splayed portal and a lunette containing a fresco.

The **interior**, which has one nave, contains an exquisite 17C wooden choir and some 15C-16C paintings, including the *Virgin and Child with Saints*, believed to be by Ansovino da Camerino, and *S.Rocco with St Sebastian and St Barbara* attributed to pupils of Spagna.

AEDICULE - This is the name given to a small temple, formerly known as *La Maina*, built in the second half of the 14C by Vanni Tuzi and beautifully decorated with delicate bas-reliefs. The small square building has a travertine facing.

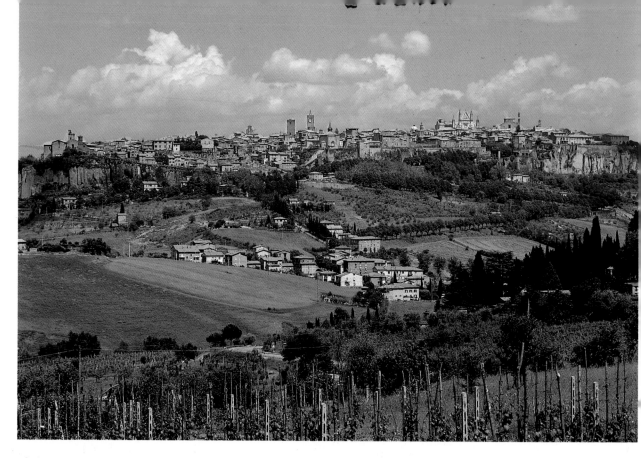

Orvieto, panoramic view over the city and the famous cliffs.

Orvieto, a splendid view of the magnificent Cathedral.

ORVIETO

HISTORICAL BACKGROUND - *An enchanting city situated close to the border with Lazio, Orvieto rises up on a crag of tufa emerging from the serene profile ofthe Umbrian hills, dominated by the spectacular Maitani Mountains. The territory of Orvieto has been populated since remote times, even if its first known inhabitants were the Etruscans, whose presence here is marked by a considerable amount of archaeological remains (the Necropolises of the Cannicella and the Tufa Crucifix). Even though there are few known facts about the Etruscan* Volsinii, *it has been clearly ascertained that it was destroyed by the Romans (first half of the IIIC B.C.). Having been colonized by the Romans, the natural communication networks of roads and rivers were exploited, to the detriment of the town itself, which in the meantime came to be known as* Urbs Vetus *(the old city). Between the 3C and the 4C, the river port of Pagliano,situated at the confluence of the Tiber and Paglia rivers, grew in importance. With the decline of the Roman Empire, Orvieto was also subjected to the inevitable spate of Barbarian invasions. Having been seized by the Goths and then conquered by the Byzantines, it went on to become a stable possession of the Lombards up until its inclusion in the Marches of Tuscany (11C). It became an independent free commune in the 12C. With the setting up of the Captaincy of the People (i.e. controlled by the "condottiere" - a leader of troops) (mid 13C), Orvieto enjoyed a period of prolific artistic and political advancement, extending its possessions from the coastal regions of the Maremma (Orbetello) to the region of Mt. Amiata and the valley of the Tiber. From the 13C, Orvieto was the scene of the fatal battles fought between the local "bigwigs" i.e. the Guelph faction (Monaldeschi) and the Ghibellines (Filippeschi). It was annexed by Cardinal Albornoz to the Papal State (second half of* the 14C) and then conquered by Rinaldo Orsini, Biordo Michelotti, Braccio Fortebraccio and by the Monaldeschi della Vipera nobles. Later it became a favourite refuge of the Popes, due to its easily defensible strategic position (a well known feature of the town being St Patrick's well, near the fortress, built on the orders of Pope Clement VII in the first half of the 16C). At this time Orvieto enjoyed a flourishing artistic and cultural period, thanks to the patronage of prelates and the local aristocracy. Under Napoleon Bonaparte, Orvieto became an important administrative centre up until its re-establishment (1816). It was annexed to the newly formed Kingdom of Italy by an army of volunteer troops united under the insignia of the Cacciatori del Tevere (Huntsmen of the Tiber) (1860).*

Today, Orvieto is one of the most beautiful towns in Italy, and tourists flock here in their thousands, drawn by the rich array of Urban medieval features and the shining architectural characteristics, which represent a kind of continuity between the Gothic and Renaissance styles. The vast proportions of its cultural, artistic and monumental heritage are complemented by the delicious specialities of the local cuisine, accompanied by the Orvieto Bianco, the indisputable "prince" of Umbrian wines. The olive groves situated around the district produce an excellent quality of olive oil. The composite handicraft industry features the production of ceramics (artistic paving and wall tiles, jugs, vases etc), wrought ironware, jewellery, wood carving and manufacture, lace making and the manufacture of umbrellas. The most famous local festivities include the Festival of the "Palombella" *(horse race) (Whitsuntide), which has important analogies with the Florentine "Scoppio del Carro" (lit: Explosion of the Cart - a fireworks display), and the* Procession of Corpus Domini.

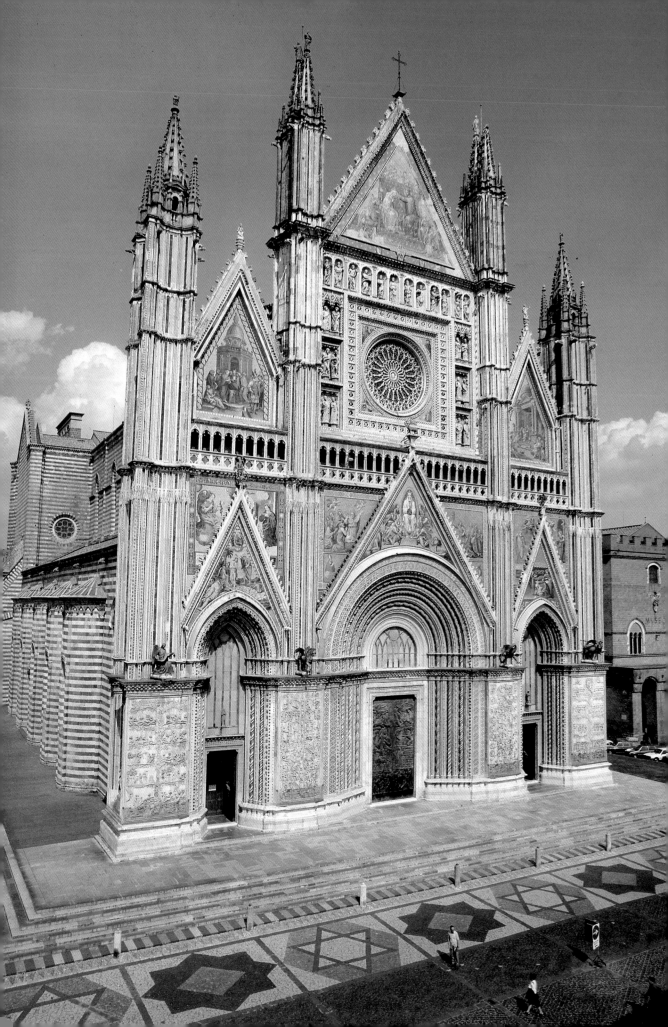

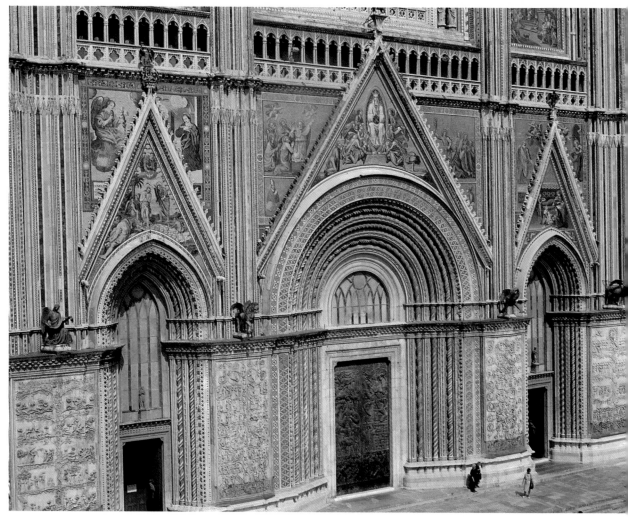

Orvieto, detail of the Cathedral portals.

Orvieto, Cathedral:detail of the rose window on the facade.

THE CATHEDRAL - The Cathedral was constructed on the site of the pre-existing cathedrals of St Mary and S.Costanzo in 1290. There are many doubts as to who designed the first construction (which was probably Romanesque). It is more widely attributed to Arnolfo di Cambio and Fra' Bevignate of Perugia. The first authentic references date back to 1308, when Lorenzo Maitani began restructuring work on some parts of the interior, the completion of the apse and the design and construction of the facade, which was completed in the first years of the 17C. After the death of the Siennese architect, the project was taken over by his son Vitale, Niccolò and Meo Nuti, Andrea and Nino Pisano, Matteo di Ugolino of Bologna, Andrea di Cecco of Siena and Andrea di Cione (Orcagna). Around the middle of the 15C, Antonio Federighi introduced some modifications inspired by Renaissance architecture, while in the 16C the construction work was supervised by several different architects, including Michele Sanmicheli, Giovanni Mosca, Moschino, Raffaello da Montelupo and Ippolito Scalza. Further work was carried out over the years, until the Cathedral of Orvieto was finally completed in the 17C, even if subsequent ornamental designs and restoration work have continued to be executed up until the present day. The **facade** is a stunning example of the decorative Gothic style, created by Lorenzo Maitani; it can be said to

have reached completion in the first years of the 17C. The facade of the Cathedral rises up from a flight of dichromatic steps and is divided vertically by four enormous fluted pillars crowned with spires. In the lower part of the facade are three magnificent pointed portals. Above these is a charming small loggia, which separates the lower portion of the facade from the upper one. This series of small arches is crowned with spires and small aedicules and by three beautifully decorated triangular tympana. The centre of the facade contains Orcagna's masterly rose window. Due to the exquisite wealth of decorative sculptures and mosaics contained here, this section of the facade could almost be described as a separate "museum", even though several features have been restored or substituted by copies. The bas-reliefs visible in the lower portion of the facade depict *The Creation, The Prophecies of the Messiah, The Stories of the Gospel and The Last Judgement.* The bronze doors are contemporary works by Emilio Greco (1964). Above these, the bronze *Symbols of the Evangelists* are attributed to Maitani. The lunette above the main portal was once decorated by a 14C fresco depicting *Angels* and a 14C *Madonna in Judgement*, attributed to Arnolfo di Cambio (they have now been removed to a safer destination in order to undergo the usual interminable process of restoration). The figures of *Prophets* and *Apostles* which surround the rose window were exe-

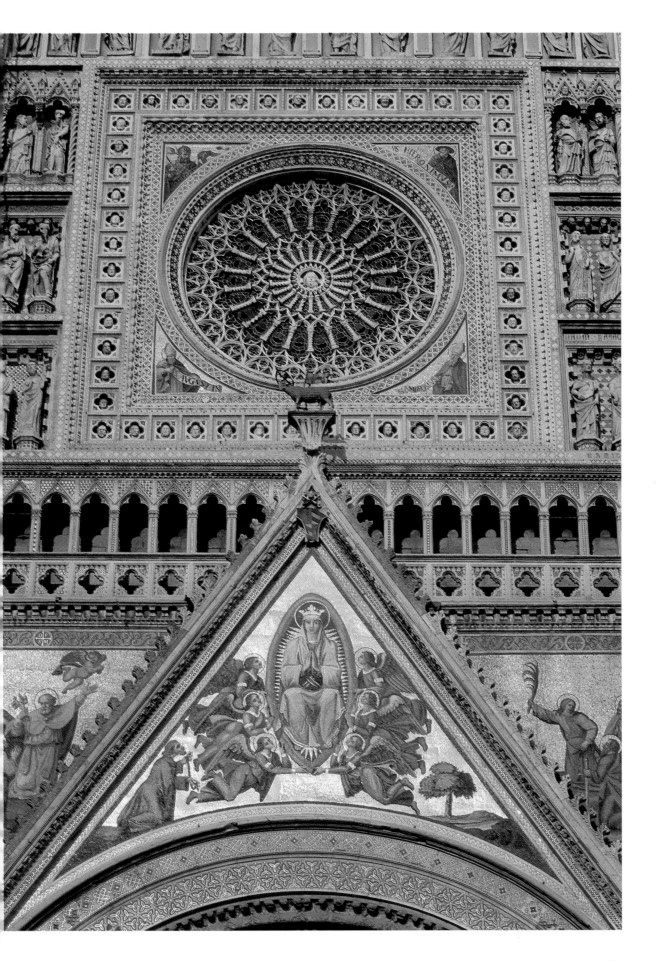

Orvieto, Cathedral: symbols of the Evangelists (L. Maitani), the winged Ox (St. Luke).

Orvieto, Cathedral: the Angel (St Matthew)

Orvieto, Cathedral: the winged Lion (St Mark).

cuted between the 14C and the 16C (I.Scalza, F.Toti, R. da Montelupo) The mosaic surrounding Orcagna's rose window is by Piero di Puccio (14C), who was also responsible for the mosaics which embellish the lateral triangular tympana. The highly decorative **side walls** consist of alternating horizontal layers of black basalt and pale limestone. Also visible are the protruding apses of the side chapels and pointed portals (two on the left side, one on the right).

The grandiose, monumental **interior** is divided into a nave and two aisles by robust columns and pillars, which support the central arches. The interior is a mixture of Gothic and Renaissance styles. The christening font is the work of several different artists (Luca di Giovanni, Pietro di Giovanni, Iacopo di Pietro di Guido, Sano di Matteo, 14C-15C). The holy-water stoups are by A. Federighi, V. da Siena, I. Scalza, C. Cardinali). The apse, lit by 14C stained glass windows by Giovanni di Bonino, contains 14C frescoes by Ugolino di Prete Ilario, restored by Pinturicchio and by Pastura, and a wooden choir by G. Ammannati (14C). The side altars (*of the Visitation* and *of the Magi*) are by Moschino, Simone Mosca and Raffaello da Montelupo. In the right transept, behind an artistic wrought iron railing (16C), is the beautiful **Cappella Nuova** (New Chapel) (or Chapel of *S.Brizio*). This chapel contains exquisite frescoes by Luca Signorelli and in-

ludes his superlative painting of the *Last Judgement*, considered to be one of the greatest frescoes in Italian Art. The chapel also contains medallions depicting poets and philosophers, ranging from Homer to Dante, with scenes from some of their works. This cycle of frescoes is considered to be one of the best examples of Renaissance art and is acclaimed as being the inspiration for Michelangelo's *Last Judgement* in the Sistine Chapel. Two of the ceiling vaults contain frescoes by Beato Angelico (*Prophets, Christ in Judgement*). On the 18C altar by B. Cametti is a painting depicting the *Madonna di S.Brizio* (13C). In the left transept stands the 14C **Cappella del Corporale**, which one enters by means of a 14C wrought iron railing. The vaults and walls contain frescoes by Ugolino di Prete Ilario (14C). On the altar is the valuable *Tabernacle "del Corporale"*, by Nicola da Siena and Orcagna, which contains the *reliquary "del Corporale"*, a silver casket by Ugolino di Vieri (14C). The reliquary contains the sacred "corporale" (altar cloth) of the Miracle of Bolsena (1263) and was the reason behind the institution of the feast of "Corpus Domini". Other features of the chapel include the 18C *Archangels* by A. Cornacchini and a *Madonna dei Raccomandati* by Lippi Memmi (14C). Finally, note should also be made of the 16C organ by Scalza, a wonderful 16C *Pietà*, again by Scalza, and the wooden pulpit by G. Mercanti (17C).

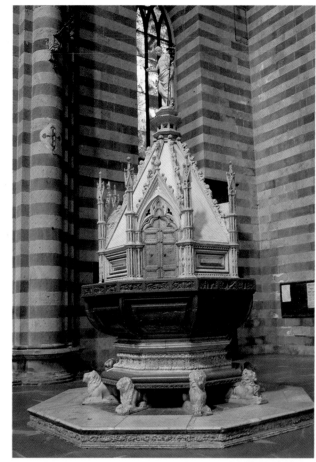

Orvieto, Cathedral: the font.

Orvieto, view of the grandiose, monumental interior of the Cathedral.

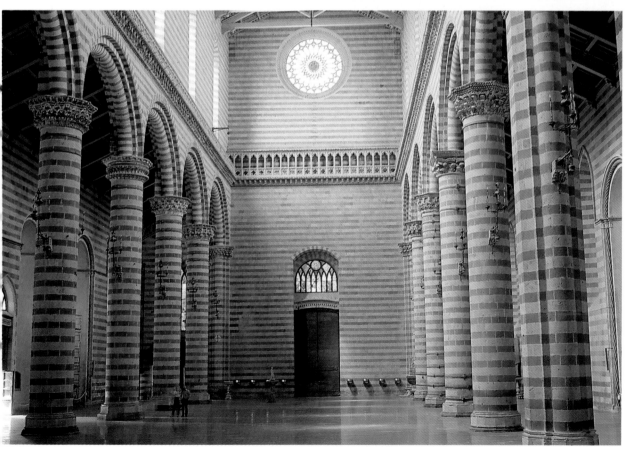

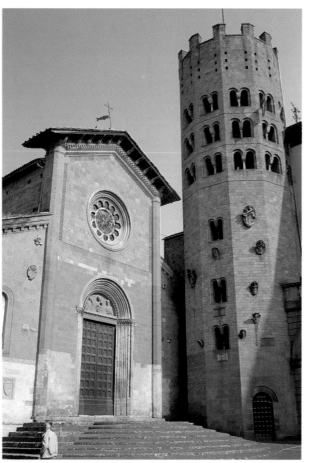

THE CHURCH OF ST ANDREW

THE CHURCH OF ST ANDREW - This historical building, which played an important part in several episodes of the town's history, was built between the 6C and the 14C, on the site of a pre-existing Early Christian church. Its brick **facade** has a large splayed portal, surmounted by a rose window. The adjacent twelve-sided brick **campanile** is a masterly architectural complement to the church and has three orders of mullioned windows with two lights and a turreted top section. On the left side of the church stands a portico. The **interior** , with a nave and two aisles, contains a raised transept and cross vaults. Worthy of note are a wooden altar by I. Scalza, a pulpit by the Cosmatesque sculptors and the funeral aedicule attributed to artists from the studio of Arnolfo di Cambio. Below the church are ancient ruins which date from the Iron Age to the medieval period.

THE CHURCH OF S.GIOVENALE - This place of worship, originally a Romanesque building, was rebuilt in the 13C and also contains Lombard features. To the side of the simple, bare facade stands a massive **bell tower**. The interior has a nave and two aisles; worthy of note is the high altar decorated with reliefs, - an exquisite Romanesque work. The transept is in the Gothic style. The walls have frescoes containing votive motifs by the Orvieto school (13C-16C).

Orvieto, the Church of St Andrew with the beautiful dodecagonal Campanile.

Orvieto, the Church and Campanile of S. Giovenale.

Orvieto, Chuch of S. Giovenale: partial view of the ciborium and the apsidal fresco.

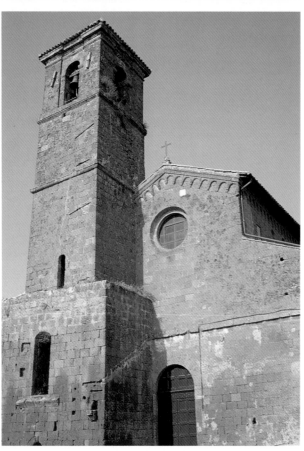

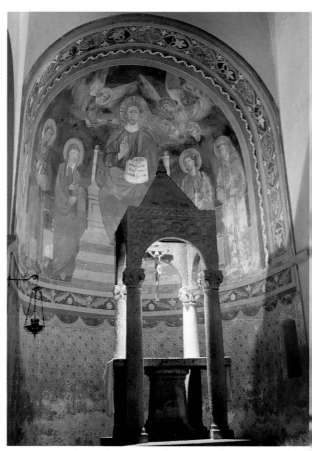

THE POPES' PALACE - Formerly the residence of a long line of Popes, the construction has three wings built in the second half of the 13C. Restored in the 1960s, it now houses the **Archaeological Museum**, which has collections of burial apparel and objects found in the Etruscan necropolises in the surrounding district.

SOLIANO PALACE - Also known as the *Palace of Bonifacio VIII*, the building dates back to the late 8C.
The ground floor rooms contain the **Museum of Emilio Greco**. The museum has only recently been set up and exhibits numerous works by the sculptor from Catania.
On the first floor is the **Cathedral Museum** which houses paintings, detached frescoes and church furnishings.

THE CHURCH OF ST DOMENIC - The original church dates from the 13C; the present day construction is the result of later alterations, which have reduced the size of the building. The Gothic portal visible in the **facade** was transferred here from another place of worship. St Thomas Aquinas taught in the *studium* of the Church (the desk at which he taught is still visible). One of the outstanding features of the **interior** is the 13C *Tomb of Cardinal de Bray* by Arnolfo di Cambio. There is also a wonderful wooden *Crucifix*. The **Petrucci Chapel**, situated under the apse, was built by Michele Sanmicheli.

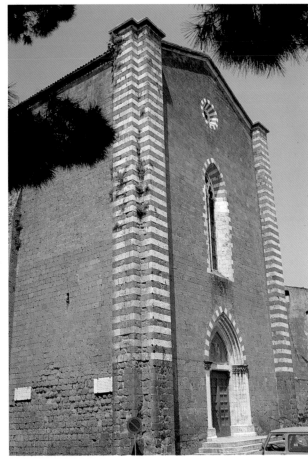

Orvieto, facade of the Church of St Domenic.

Orvieto, a view of the Popes' Palace, seat of the Archaeological Museum.

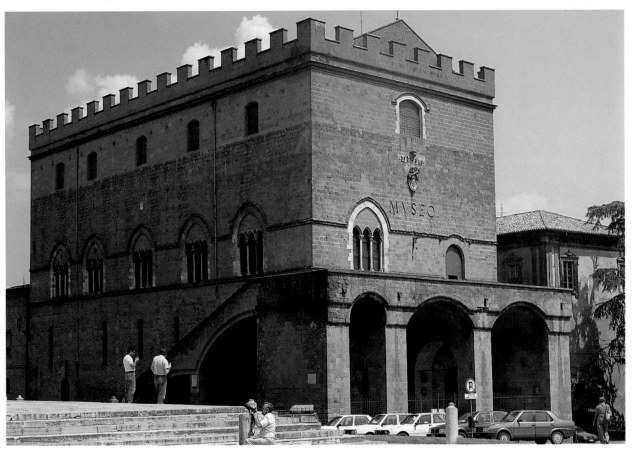

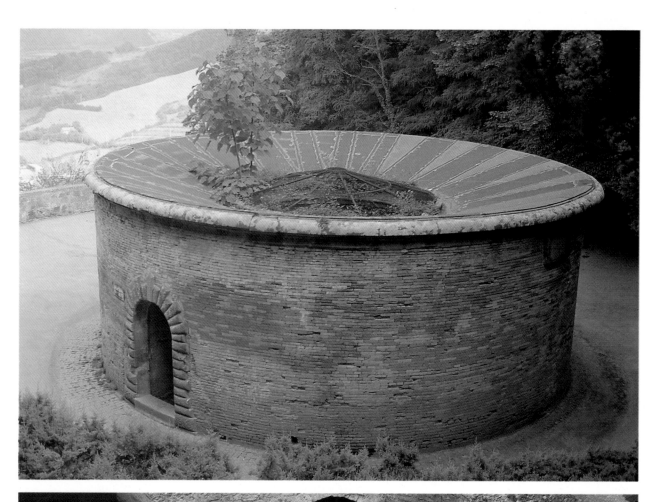

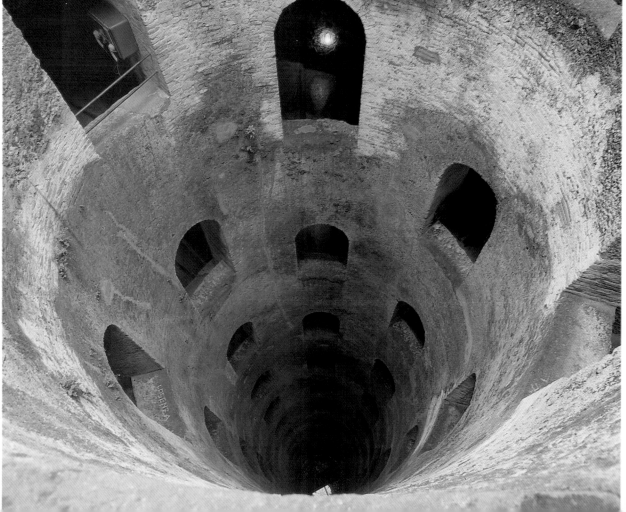

ST PATRICK'S WELL

ST PATRICK'S WELL - St Patrick's Well and the Cathedral are the most famous constructions in Orvieto. It was known as the *Fortress Well* in ancient times and was built on the instructions of Pope Clement VII. It was intended to serve as a reservoir providing water to the nearby fortress (built by Albornoz) in the event of the city being besieged. The ingenious design for this masterpiece of Renaissance architecture was the work of Antonio da Sangallo the Younger, who completed the project in the first half of the 16C. Around the cylindrical cavity, which has a depth of 61.32 metres, are two parallel concentric staircases (each one having 248 steps), which never cross (the stairs are lit by large windows). The water carriers and their donkeys used one of the spiral staircases for going up and another for going down, getting in and out of the well by different entrances. Acccording to Vasari, Antonio da Sangallo drew inspiration for this project from the internal staircase of the bell tower of the Church of S.Nicola in Pisa.

ETRUSCAN NECROPOLISES - The necropolises were built at the base of a tufa formation, upon which the first Etruscan settlements were formed. The **Necropolis of the Tufa Crucifix** to the north and the **Necropolis of Cannicella** to the south east, date from the 6C B.C. Interesting remains of chamber tombs and burial apparel have been discovered on this site.

Orvieto, an external view of the celebrated St Patrick's Well and a charming partial view of the interior.

Orvieto, a picturesque glimpse of the calc-tufa cliffs.

Orvieto, detail of the Etruscan Necropolis of the Tufa Crucifix.

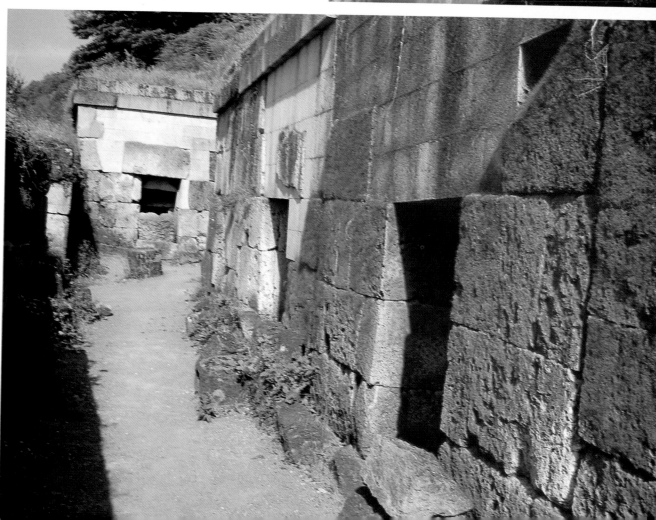

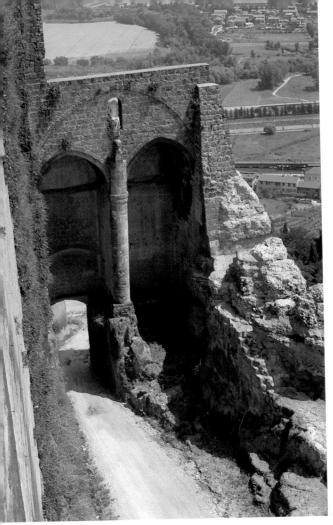

ALBORNOZ FORTRESS

ALBORNOZ FORTRESS - Ugolino di Montemarte is attributed as having built the fortress at the behest of Cardinal Egidio Albornoz (14C). Nearby stands the **Fortress Gate**, which was built during the same period as the fortress itself; it was later restored by Lorenzo Maitani.

Environs

The Premonstratensian Abbey buildings of **S. Severo and S.Martirio** are dominated by a superb twelve-sided brick tower, crowned with merlons. The structure of this Romanesque tower, commissioned by Matilde di Canossa at the beginning of the 12C, is decorated by mullioned windows with one and two lights. The church of the abbey contains masterly 13C-14C frescoes and a remarkable floor built by the Cosmatesque marble sculptors.
Sugano, a charming village situated along the high green plateau of Alfina, looks down on the city of Orvieto, in an enchanting scenic location. It is an extremely ancient village, dating back to the first Etruscan settlements of the 4C B.C. The locality is renowned for the basalt quarry situated here, and enormous amounts of igneous rock were used to construct many of the buildings in the City of Orvieto. Here too are situated the underground springs containing the curative waters of the Tione.

Orvieto, view of the Porta Rocca.

Orvieto, view of the mighty bastions of the Albornoz Fortress.

Orvieto, panorama.

Abbey of SS. Severo e Martirio (Orvieto), view of the abbey complex with the fine dodecagonal tower

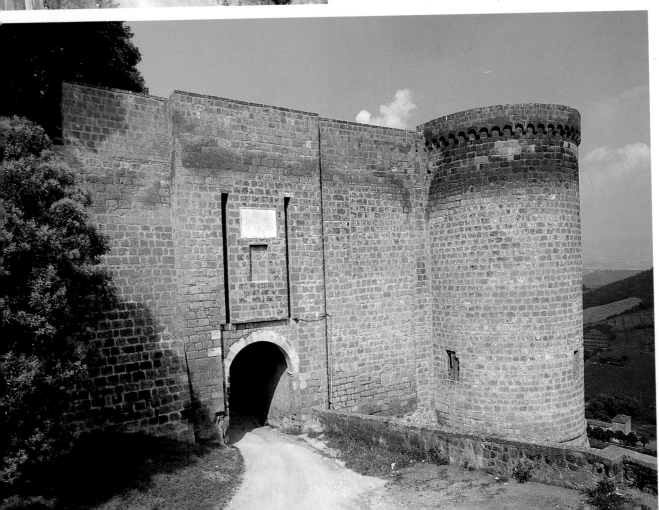

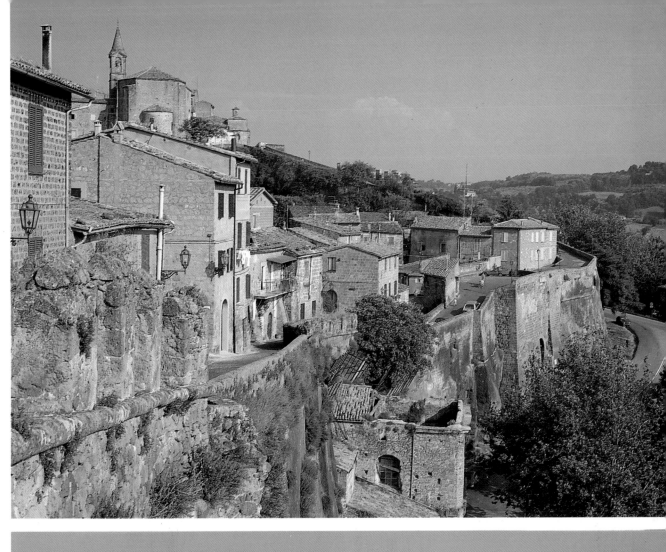

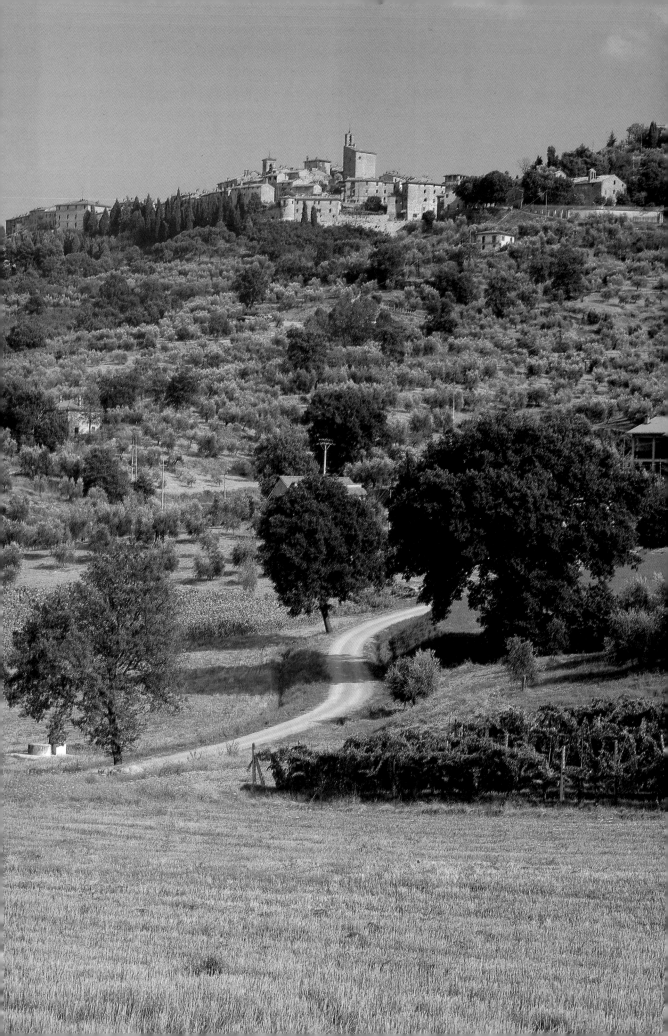

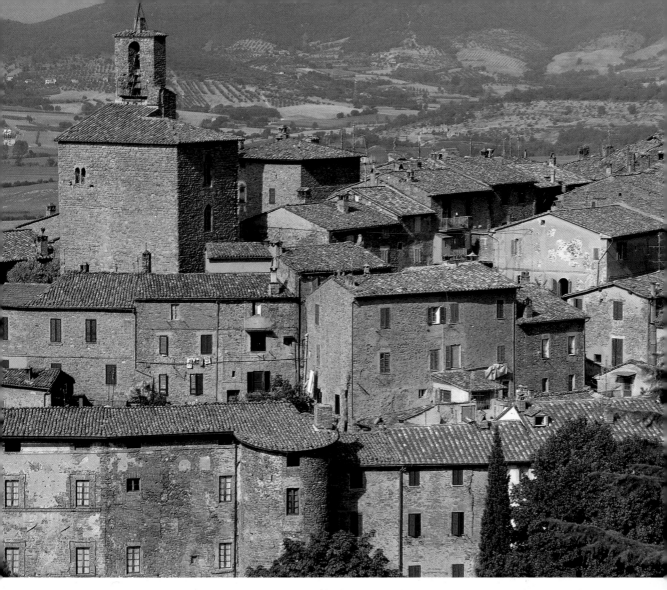

The picturesque hamlet of Panicale dominates the lovely Umbrian scenery.

Panicale, panoramic view of the medieval centre.

PANICALE

An enchanting village, situated along the hills which encompass the southern district of the "amphitheatre" of Lake Trasimeno. Panicale is characterized by the elliptical configuration of its medieval village, which is still enclosed within the encirclement of its ancient walls. The enchanting serenity of this hilly landscape, which seems like the background to one of Perugino's canvases and the magnificent panoramic views over the lake, make Panicale a popular tourist attraction and an ideal spot for relaxing holidays. The first references to the place are contained in a document bearing the seal of Berengario (10C). In medieval times, Panicale was a stronghold of the city of Perugia, which had fully appreciated its important strategic position. In the 16C-17C, it was sacked by the armies of Valentino (Cesare Borgia)and those of the Farnese nobles. Recently its importance has declined in favour of the market town of Tavernelle.

Embroidery work and wrought iron are the main handicraft industries of the locality. Local festivities include the *Procession of the Dead Christ*, a local event which is accompanied by the torch-lit procession of the *Fiaccolata di Pasqua* (Easter). The local saint's day of *St Michael the Archangel* (29 September) is also a local festival.

The *Piazza Umberto I* is characterized by a fountain and by the **Magisterial Palace**, the facade of which is decorated by civic coats of arms.

The **Collegiate Church of St Michael** looks out over the piazza bearing the same name and has two stone portals. In the interior is a *Nativity* by Caporali. The **Palace of the Podestà**, characterized by a mullioned window with two lights, dominates the village.

Outside the walls stands the **Church of St Sebastian**, which contains two masterly frescoes by Perugino: *The Martyrdom of St Sebastian* and *The Coronation of the Virgin*.

Nearby, close to Tavernelle, is the Renaissance **Sanctuary of the Madonna of Mongiovino**. The construction has a central plan (16C) and is crowned with an eight-sided cupola. It also has two 16C portals, carved by Rocco di Tommaso of Vicenza and other artists. The interior contains a high altar by Francesco di Alessandro of Fiesole and frescoes by Arrigo Fiammingo and Niccolò Circignani, better known as "Pomarancio".

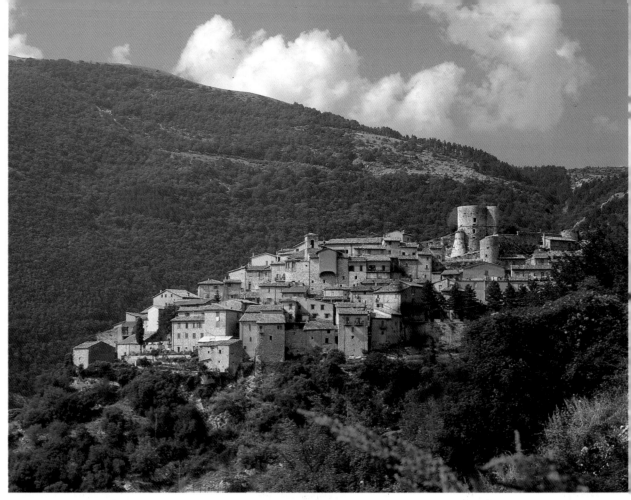

Polino, partial view of the mediaeval hamlet surrounded by the green scenery of the Umbrian mountains.

POLINO

The village bestrides the top of a rise, a short distance from the border with Latium (Lazio) in a dale of the lower Nera Valley (Valnerina). Its felicitous positioning on the far North-East spurs of the Reatini mountains and the decidedly mediaeval air of the ancient settlement makes it one of those minor centres in Umbria which nonetheless deserve a mention. Its foundation dates from the Middle Ages and it enjoyed a certain importance as a mining
centre; there were marble quarries, iron deposits and a silver mine, all active. Today the economy of the area is based essentially on the primary sector, even though commuting with Terni is widely practised.
The ancient nucleus of the mediaeval hamlet still offers an outlook of old stone houses and narrow paved alleyways, whilst, to crown the hamlet, is a polygonal Tower, with the vestiges of ancient fortifications.
The nearby zone of **Monte La Pelosa** (1635m) has recently been developed as a summer and winter resort, with infrastructures allowing the sport of ski-ing.

SAN GEMINI

A well-known locality in the district of Terni, it is situated in gentle, hilly countryside, in view of the Martani Mountains. The centre has a bipolar aspect, with an obviously mediaeval hamlet and a more recently-expanded zone which has spread along the main road leading to the spa proper. Developed in the Middle Ages in an area certainly used by the Romans (as can be proved by the nearby archaeological remains of *Carsulae)*, it was assigned to the popes by Henry II of Bavaria. Subsequently it was yielded up to Narni and Todi and subdued by the Orsini family who made it into a Duchy in the final decade of the sixteenth century. It received the title of city from Pope Pius VI in 1781. Its fortunes as a spa go back to the nineteenth century, when systematic studies of the curative properties of the waters were undertaken.
The best-known manifestation, which takes place in September and October, is the *Giostra dell'Arme,* which is the historical commemoration of a mediaeval competition.
To be remembered in the mediaeval centre are: the **Palazzo del Popolo**, characterized by a tower, reduced in

San Gemini, panorama of the ancient nucleus at the centre of typical Umbrian countryside.

Carsulae (San Gemini), detail of the Church of St Damian.

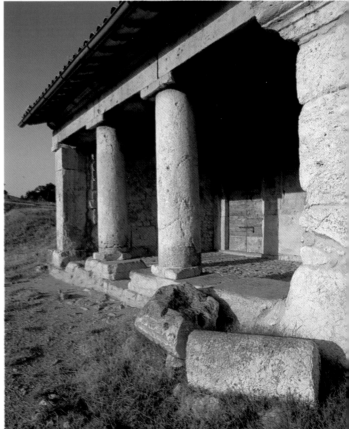

height, and an external staircase; the one-naved **Church of St Francis** (C13 to C14) with its distinguished Gothic architecture; and the **Church of St John** with, on the left side, the ancient Romanesque façade enhanced with a portal bearing mosaic decorations of the Cosmatesque school. A short way from the centre is the beautiful Romanesque **Chiesa di S. Nicolò** with its stone façade interrupted by a central oculus and adorned with a fine portal and steps decorated with historical scenes and lions bearing columns. At its side rises a delightful stone bell gable.

The **San Gemini Spa** is situated at the **San Gemini Fonte.** The *Sangemini* and *Fabia* waters have a content of calcium and bicarbonate, are cold and afford relief to those suffering from digestive problems, urinary infections and metabolism disorders and in pathologies of the liver and biliary tract.

The archaeological area of **Carsulae** is laid out in glorious surroundings in the green Umbrian countryside. The ancient Roman city, datable from the third century BC was abandoned following a disastrous earthquake. Of outstanding interest are a stretch of the consular road, the complex of the **Spa,** the **Amphitheatre**, the **Theatre** and the **Trajan Arch (**or of *St Damian).* In the neighbourhood there is the little high-mediaeval church of **St Damian.**

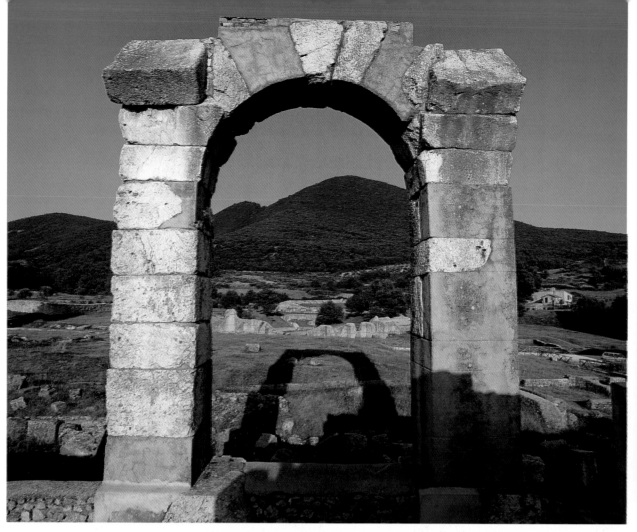

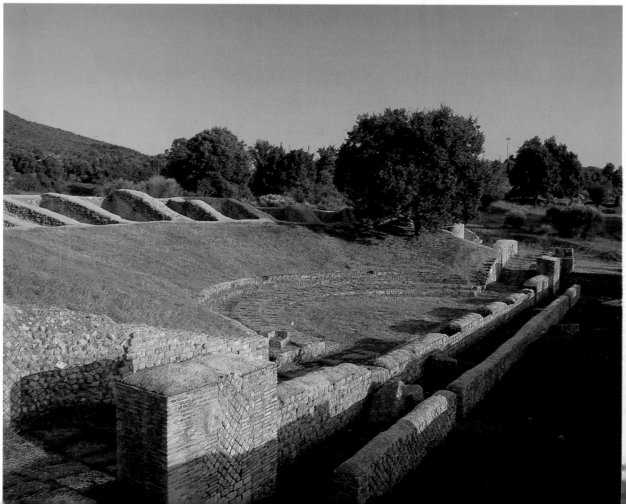

arsulae (San Gemimi), the Trajan Arch (or of St Damian); e Roman Theatre.

San Giustino, panorama of the town and the Upper Tiber Valley.

SAN GIUSTINO

n the upper Tiber Valley, practically on the borders with uscany, it is the chief town of a territory which is interesting for its historical content, ancient ruins and architectonic elements. An important road meeting-point, it is situated at the beginning of the road for the Bocca Trabaria nd it lies along important roads of access connecting Jmbria with Tuscany and Romagna. Its foundation at the ands of the Umbri is proved by various findings. Used n the Roman epoch (it takes it name from the Christian nartyr), it was subdued in the Middle Ages to various milies (Dotti and then Bufalini), finally passing under ne control of Città di Castello. The history of the place is haracterized by the dealings of Cospaia, a tiny village vhich was an autonomous republic for 386 years between ne fifteenth and nineteenth centuries, taking advantage f the struggles between the Tuscan and papal governors nd developing a flourishing trade with tobacco smugling.

Toted for the lace and ceramics crafts and for antique and eproduction furniture, this town allows the tasting of ex-

quisite truffles, washed down with the excellent Panicale wine. Outstanding among the folkloristic manifestations is the Corpus Domini Flower Festival, the *Infiorata*, which originated in the seventeenth century.

The **Castello Bufalini,** of noble fifteenth-century architecture, looks like a mighty fort, girdled by great imposing corner towers and crowned with a bell tower. However, the refined elegance of Vasari's loggia and the wide profusion of decorations in the interior (frescos by Cristoforo Gherardi, called "Doceno", Signorelli and Guido Reni; antique furnishings; and Roman busts from the probable villa of Pliny the Younger), hint at its subsequent use as a leisure haunt and princely residence. The castle is surrounded by a green park with Italianate gardens.

In the **Chiesa di S. Andrea a Selci** a precious *Enthroned Madonna among the Saints,* executed by Francesco da Castello (C16) is kept.

In the locality **Colle Plinio**, excavations of a **Roman Villa** believed to have belonged to Pliny the Younger can be admired. Not far off at **Celalba**, rises the splendid **Villa Magherini-Graziani**, the result of a seventeenth-century transformation of an ancient manor house. Of note is the interesting turretted crowning.

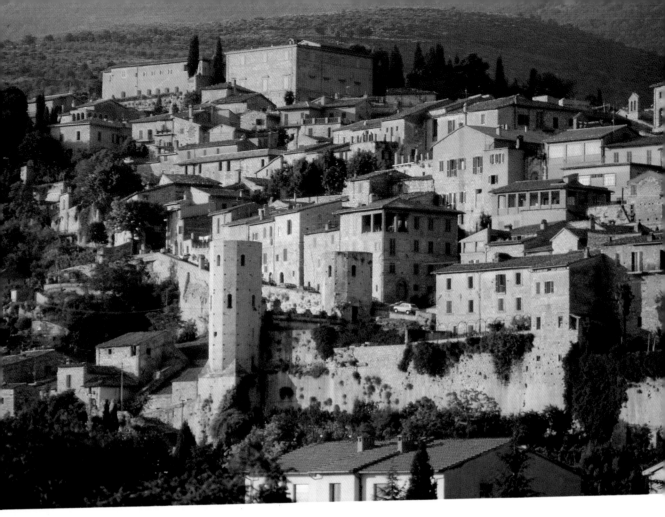

Spello, partial view of the ancient mediaeval nucleus.

SPELLO

A charming old town happily situated on the southern slopes of Monte Subasio, it is of lively interest as regards town planning, architecture and art, with evidence of the Roman age and a mediaeval nucleus which has remained intact with Renaissance buildings blending in admirably. It was founded in the age of the Umbri, became a flourishing Augustan colony (*Julia*), and was called *Flavia Constans* at the time of Constantine. The Barbarian invasions caused its decline until it came under the Dukes of Spoleto. Subsequently it received a free, municipal constitution, but, having come into conflict with Frederick II, it was destroyed by him. After that it belonged to the Church and was for a long time governed by Perugia, before being finally integrated into the papal states (1583).

The craft of weaving is still practised in the township. Among the traditions, it is worth mentioning the *Festa dell'Olivo* (along with the village festival of bruschetta - toasted bread with oil and garlic - in February) and the *Flower Festival of the Corpus Domini*).

The historical centre of Spello is still by and large included within the circle of the ancient **walls;** ample stretches of these may be dated from the Roman age, just like some of the major gates.

The **Porta Consolare** goes back to the time of Augustus.

It is a noteworthy example of a Roman gate with three arches. In the upper portion three statues from the Republican period are visible, obviously moved from the archaeological area.

The fourteenth-century **Cappella Tega** is frescoed with interesting pictures carried out by Umbrian artists of the fifteenth century. A *Crucifixion* by Alunno and a *Maestà* by Pietro di Mazzaforte are outstanding.

The **Chiesa di S. Maria Maggiore** has very old origins (C11), indeed there was a certified restoration of it in the second half of the thirteenth century. Around the mid seventeenth century, this place of worship, built on the remnants of an altar consecrated to Juno and Vesta, was profoundly transformed. The Romanesque portal (C13) is a noteworthy work by the marble-workers Binello and Ridolfo. In the baroque interior there is the Baglioni Chapel, celebrated for the frescos executed in 1501 by Pinturicchio (Bernardino di Betto), portraying the *Annunciation*, the *Dispute in the Temple*, the *Nativity* and the *Sibyls*. The floor consists of valuable Deruta majolica tiles (C16). In the small museum next door, pictures from the period between the fourteenth and sixteenth centuries can be admired.

The **Chiesa di S. Andrea** has a thirteenth-century façade whereas the interior (very much changed) houses frescos of the Foligno school (C15). Noteworthy are the great picture by Pinturicchio, *Virgin and Child Enthroned with Saints*, and a *Crucifix* realized in the manner of Giotto's painting.

The imposing monumental **Porta Venere** of the Augustan age is enclosed between the twin **Propertius Towers** of a dodecahedral lay-out. This mighty construction with three supporting arches is a superlative example of Roman architecture.

The **Palazzo Comunale Vecchio** is the work of Maestro Prode, according to an epigraph on the façade. The building has kept a few parts of its original thirteenth-century construction. Note the sixteenth-century fountain and the atrium, with a display of archaeological finds. A **Museum-Picture Gallery** has been set up in the palace.

The **Chiesa di S. Lorenzo** was built in the twelfth century but it carries signs of the successive transformations (C16 to C17). In the interior, seventeenth century in taste, is the Sacrament Chapel, inside which there is a late sixteenth-century marble tabernacle, the work of Flaminio Vacca. The wooden choir bears engravings from the sixteenth century. The seventeenth-century wooden crib should also be noted.

Through the **Augustus' Arch,** from the Augustan age, we reach the **Chiesa di S. Maria di Vallegloria**, with the attached monastery (fine **Cloisters** from the second half of the C16). The building, from the first half of the fourteenth century, houses sixteenth-to seventeenth-century frescoed pictures.

The **Chiesa di S. Girolamo,** with the attached Convent, goes back to the fifteenth century. In front of the building, there is a Renaissance-style portico frescoed by Umbrian painters of the fifteenth century. A small chapel preserves frescoes by artists from Pinturicchio's circles. The interior displays a wooden *Crucifix* (C16) and a fresco in the manner of Pinturicchio's followers.

The **Porta Urbica,** or *S. Ventura,* has a single opening and goes back to the Augustan age. Decorated with a triangular tympanum, it is inserted into a stretch of the Roman and mediaeval walls. Not to be forgotten is the small but charming **Chiesa di S. Martino** (Romanesque) and the **Porta dell'Arce** (or *Capuchin Arch*), an ancient Roman building, in a panoramic spot looking over the Valle Umbra.

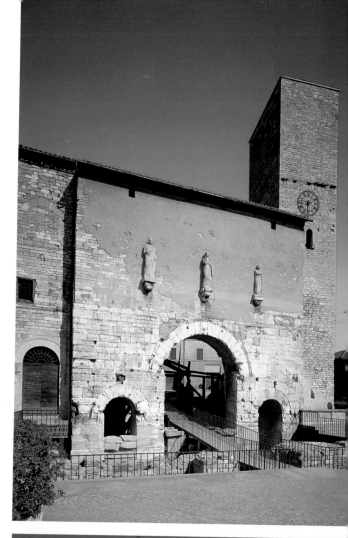

Spello, view of the Porta Consolare with the statues from the Republican period.

Spello, the Chiesa di S. Maria Maggiore.

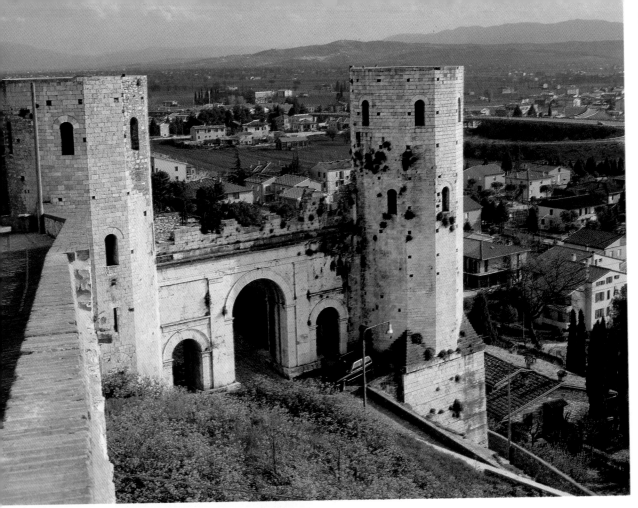

Spello, a delightful view of the turreted Porta Venere with the backdrop of the Valle Umbra.

Spello, view of the ancient Porta dell'Arce (or Capuchin Arch).

Outside the walls, the remains of the **Roman Amphitheatre,** first century AD, are visible. Of the building, which once must have been of considerable import-ance, only fragments of flooring, pilasters and other remains are left.

In the surroundings there is the beautiful Romanesque façade of the **Chiesa di S. Claudio** (C12). Constructed in Assisi stone, it is enriched by a two-light window and a lovely rosette. On the crest, an interesting double-ordered bell gable rises up. Numerous frescos from the Umbrian school are housed inside. Those above the apse, believed to have been by Cola Petruccioli (C14), are outstanding.

The **Villa Fidelia**, of the sixteenth century, was transformed in the eighteenth and nineteenth centuries and in-cludes a delightful Italian garden. Arranged here is the *Straka-Coppa Collection* (pictures, sculptures and antiques).

The **Chiesa Tonda** was executed in the first half of the sixteenth century by architects of the Lombard school. A Greek-cross temple, with an octagonally-planned dome overhead, it bears a superlative coeval portal, held to be by Simone Mosca. The interior is enriched by numerous frescos of the Umbrian school, including one by Mezzastris (1533).

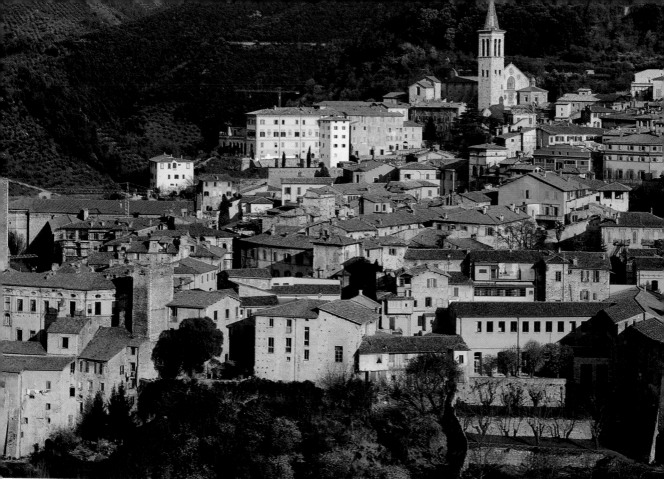

Spoleto, panoramic view of the historical centre.

SPOLETO

HISTORICAL NOTE - *The city is felicitously situated on a sunny hillside, surrounded by green rises, near the lower border of the Umbra Valley, where the Tessino stream laps against the most recently-developed quarters. A centre founded by the Umbri, with probably Etruscan influences, it was Romanized at the time of the Samnite Wars. It was a colony under Latin law (Spoletium, 241 BC) and was a faithful ally of Rome in the latter's struggle against the Carthaginians. In the course of the second Punic War, it drove back Hannibal's attacks, thus in practice discouraging his prosecution of the advance on Rome. Having become a Municipium, it suffered during the civil war and was sacked (80 BC). After the fall of the empire, Spoleto was the capital of a flourishing Lungobard duchy. Round about the mid twelfth century, it was destroyed by Frederick I and suffered severe damage shortly afterwards at the hands of the archbishop, Cristiano di Magonza. When it came under papal influence, it became a papal residence, but it underwent the strife between the Guelphs and the Ghibellines and was subdued by Perugia. Released by Albornoz, it subsequently came under the Visconti, Braccio da Montone and Pirro Tomacelli. In the second half of the fourteenth century,* it rose up, together with Todi, against the excessive power of the popes, but it was taken over by Giuliano della Rovere and entrusted to Lucrezia Borgia. In 1809 it became the main town of the French Department of the Trasimeno and was annexed to the newly-formed State of Italy on 17 September 1860.

Present-day Spoleto is a city with a lively archaeological, artistic, monumental and urbanistic content (in the historical nucleus above all, a large part still lying within the city walls). The city boasts a consolidated cultural tradition and interesting handcrafts customs (cloth, lace and embroidery, horse saddles and harnesses, model-making equipment). The excellent cuisine, based on truffles and other local specialities, such as "strangozzi" (home-made pasta) complete the panorama of a place not to be missed. Among the most representative manifestations we shall mention the Carnival of Spoleto *(February and March); the* Study Week on the High Middle Ages *(the week following Easter); the* Festival of the Two Worlds *(June and July); the* Experimental Season of Lyrical Opera *(September); and the* Laud of the Nativity and the Living Crib *(24-25-26 December, 1 January).*

97

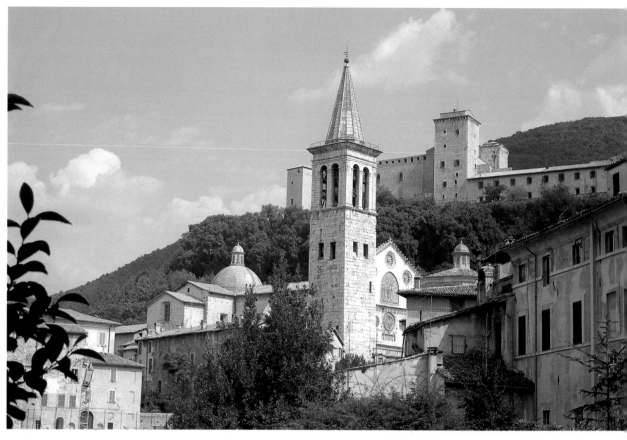

Spoleto, a delightful partial view of the Cathedral with the Rocca fortress in the background.

Spoleto, a splendid view of the Cathedral with the cuspidate Campanile.

CATHEDRAL - It looks onto the **Piazza Duomo**, distinguishable by the sixteenth-century **Palazzo Arroni** (the decorations embellishing the façade are by Giulio Romano), by the coeval **Chiesa di S. Maria della Manna d'Oro,** by the **Teatro Melisso** and by the building housing the **Museo Civico.** A Romanesque construction (C12) which was internally transformed in the seventeenth century, it is introduced by a mighty **façade,** preceded by a portico carried out at the turn of the sixteenth century. The main façade, probably heightened after the end of the twelfth century is embellished with five rosettes, of which the central one is surrounded by *Symbols of the Evangelists*. At the centre of the superior order, there is a precious mosaic decoration executed by Solsterno and dated 1207, above which there are three other small rosettes. Beside the façade is silhouetted the imposing outline of the spired **Bell Tower,** made with stone material removed from ancient Roman constructions.

The **interior,** late Renaissance, is of a simple, but essential, architectural configuration. It is articulated in a nave and two aisles, the nave still preserving the flooring from the original Romanesque construction, with a large profusion of polychrome stone tesserae. On the counter façade there is a *Bust of Urban VIII*, a valid bronze work by Bernini. In the right aisle lies the **Chapel of Bishop Eroli,** frescoed by Pinturicchio, who depicted the *Pietà*, the *Eternal*, and the *Madonna with Child and Saints*. In the right portion of the transept is the *Sepulchral Monument of Fra' Filippo Lippi*, undertaken by his son, Filippino, with an epigraph by Poliziano. There is a portrayal of the *Virgin with Child among SS. Francis and Dorothea*, carried out by Annibale Carracci, at the altar (right transept). The apsidal section glows with the magnificent frescos executed by Filippo Lippi and his pupils (1467-69) on the themes the *Annunciation*, the *Passing away of the Virgin*, the *Nativity* and the *Incoronation of the Madonna*. The **Reliquary Chapel** used to house a beautiful *Cross* painted by Alberto Sozio (1187) (now collocated in view of the left side of the principal entrance), and wooden sculptures of sixteenth-century Spoleto artists.

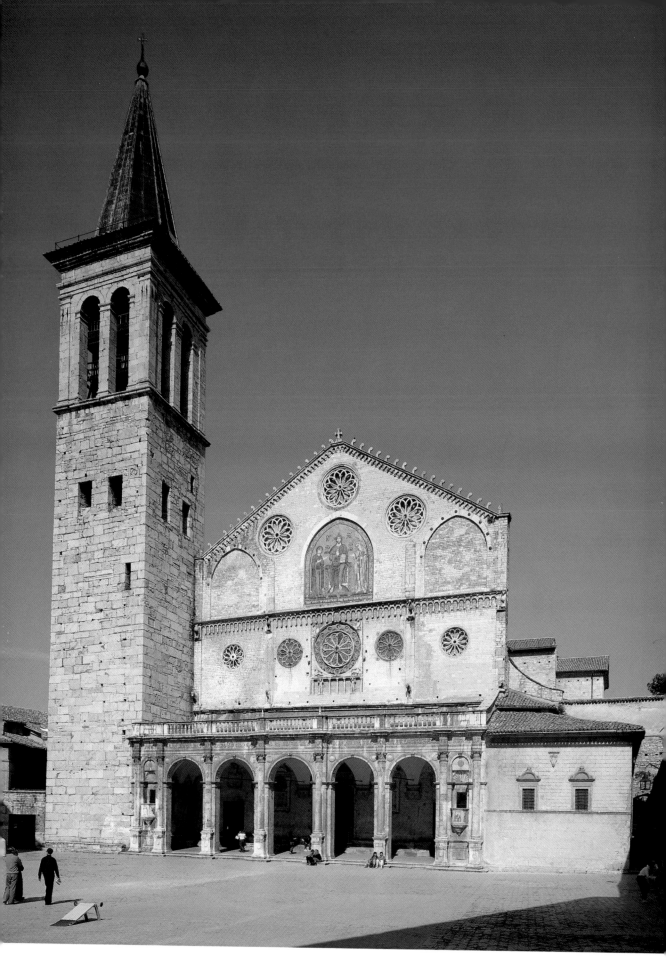

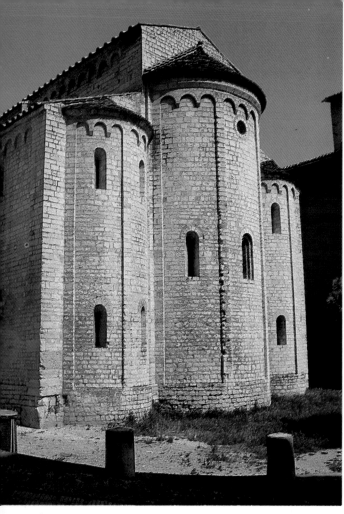

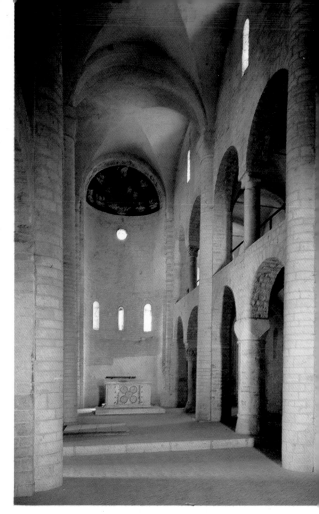

Spoleto, apse and interior of the Chiesa di S. Eufemia, Umbrian jewel of the Romanesque style.

Spoleto, view over the Roman Theatre.

Spoleto, the so-called Arco di Druso.

Spoleto, a street in the mediaeval nucleus.

CHIESA DI S. EUFEMIA - A basilican building which rises up in the enclosure of the Bishop's residence, it is considered one of the finest examples of Umbrian-Romanesque architecture, even though the conditioning of the Lombard current appears evident. Constructed in the first half of the twelfth century, it has a lovely **façade** that is enlivened in its essentiality by a portal, a window with one opening, a mullion and a sweep of arches on the crowning part.

The **interior,** austere and stark, is divided into three parts having openly Lombard characteristics in the women's gallery, which remains as the only evidence of this type of architectonic solution in the entire region. On the vault and on the two columns on the right can be seen frescos from the Umbrian school (C15) and the Cosmatesque altar-facing on the main altar (C13).

ARCO DI DRUSO MINORE - It is situated near the so-called **Arco di Monterone** (probably a gate from the third century BC). The building, also called after *Germanicus*, the son of Drusus the Elder, the brother of Augustus, dates from the first century AD and displays only one opening, decorated with pilaster strips and Corynthian capitals. Nearby, a **Roman Temple**, part of the ancient Forum, has been brought to light. In the surroundings of

the temple (of which only a few remaining elements are visible) a Paleo-Christian church rose up, subsequently modified even concerning the orientation. The place of worship, today dedicated to *S. Ansano*, displays seventeenth-century reconstruction and contains a beautiful picture frescoed by Spagna. Through the church, access is gained to the **Crypt of St. Isaac** (C12), which has three little aisles, with groin vaulting and frescos coeval to the crypt's foundation. The nearby *Piazza del Mercato* is enriched by a wall **Fountain** planned by Costantino Fiaschetti (C18) and built on the site of the ancient Church of S. Donato. The four stems decorating the upper part of the fountain are seventeenth century, after a design by Maderno, in honour of Urban VIII.

ROMAN THEATRE - A fine all-over view of this first-century construction (AD) can be had from the overhanging *Piazza della Libertà*, in correspondence with an arcaded façade, previously part of the seventeenth-century **Palazzo Ancaiani** stables. The semicircle of the cavea is well visible, whilst the stage area, no longer extant, has been occupied by the mediaeval monastic complex of **S. Agata**. However, to be noted is the marble floor of the orchestra, quite well preserved.

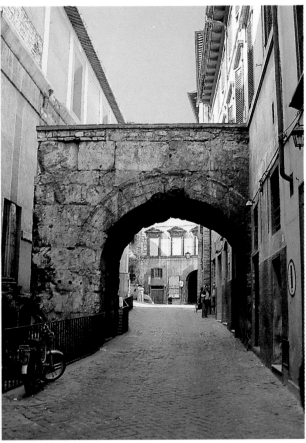

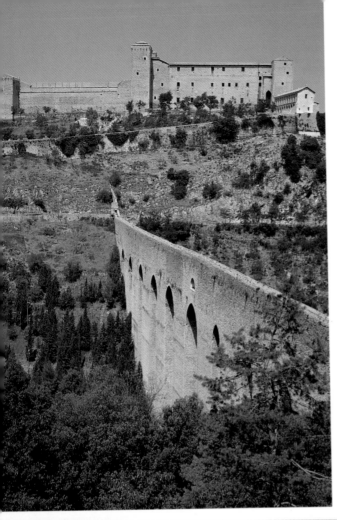

PONTE DELLE TORRI - The construction, possibly over a previous Roman building, was brought to conclusion at the turn of the thirteenth century. It is characterized by mighty piers and by high, narrow arcades. Originally it carried out the function of aqueduct.

ROCCA - The towered mass of this stronghold dominates, with its mighty glacises, the view over Spoleto. Gattapone was commissioned by Albornoz to construct it, and he carried out the work in the second half of the fourteenth century. The fortress, previously used as a prison, has an ample **Arms Court** and the notable **Court of Honour**.

Environs

The **Church of St Peter** stands out from the natural backdrop of Monteluco. The building, from the twelfth to thirteenth centuries, is preceded by a seventeenth-century sweep of steps. The beautiful façade is embellished with numerous ornamental decorations. The **interior** of the temple, basilical in shape, displays a triple partitioning of the space which continues on into the apses. Interesting archaeolgical finds have been discovered in the area overlooking the church. Worthwhile would be an excursion to nearby **Monteluco** (804m.), an area for hermits, who have

Spoleto, view of the Ponte delle Torri with the Rocca fortress in the background.

Spoleto, the ancient Ponte delle Torri, once used as an aqueduct.

St Peter's Church (Spoleto), view of the ornate façade.

Spoleto, a charming panoramic outlook with the Rocca and the Ponte delle Torri.

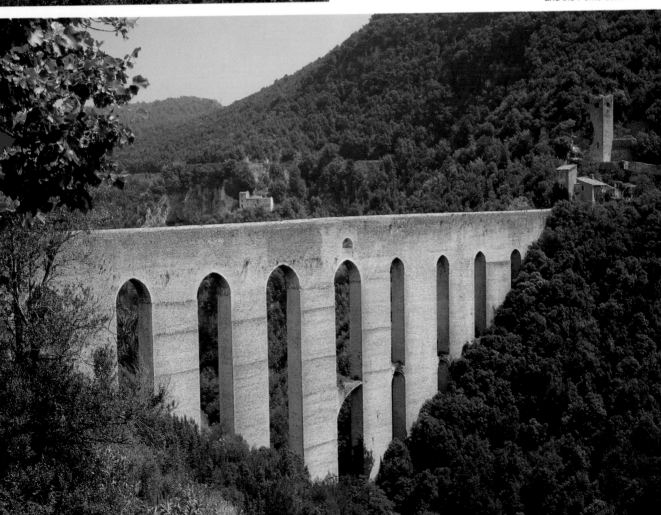

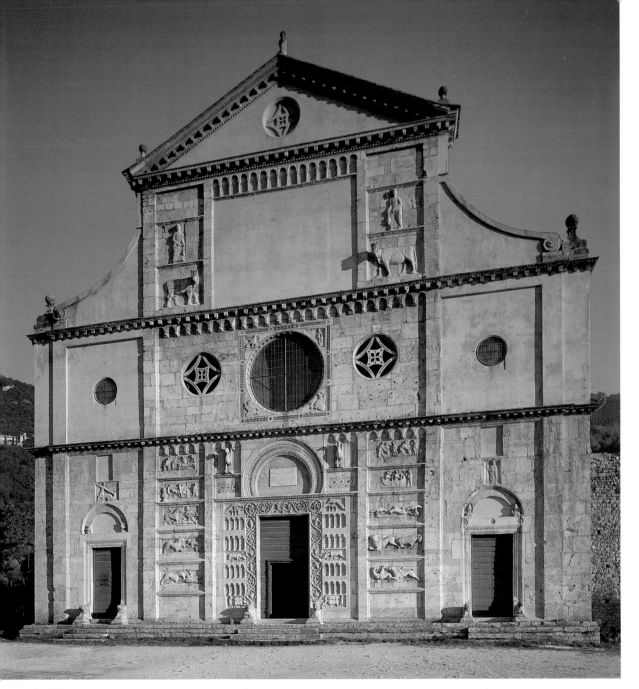

patronized it since ancient times - it was known even to St Francis of Assisi, who founded here the still existing convent. The place has become a much-appreciated tourist resort, equipped for seasonal stays and holiday homes, with a wealth of infrastructures situated in the healthy environs of the uplands.

The ancient **Chiesa di S. Giuliano** (C12), built on the site of a seventh-century church, has a façade which is mutilated in parts, with a mighty bell tower overhead. Remarkable are the portal and the ornaments on the main façade, partially attributable to the Paleo-Christian period. The **interior,** divided into three sections with apses in the manner of a semi-circle, has a raised presbytery and a **Crypt**.

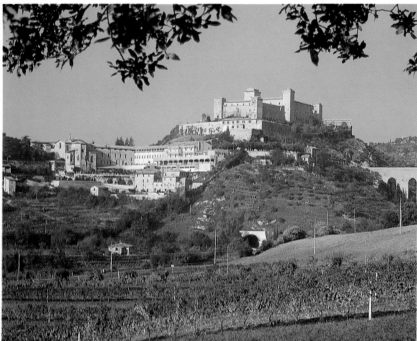

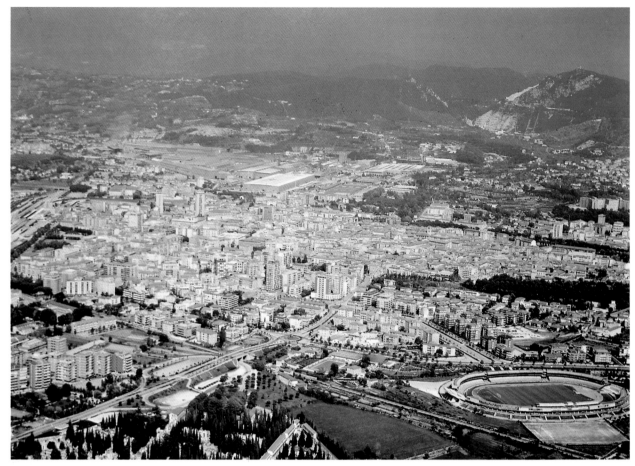

Terni, general view.

TERNI

HISTORICAL NOTE - *The second Umbrian city after Perugia (also in consideration of its demographic count), it is the principal town of the Province of the same name and spreads out over a broad hollow, thread through by the waters of the Tescino and Serra streams running into the Nera. The first settlements in the area go back to the Bronze Age, though finds from Villanovan localities and necropoleis, producing the proof of crematory practices, have been documented. It was probably a centre of Sabine foundation and, because of its geographical position, was known in ancient times as* Interamna Nahars, *or* Nahartium. *It constituted a flourishing* Municipium *under Rome and suffered from the incursions of the Barbarian populations. After its constitution as a free Commune, it was razed to the ground by Frederick I (1174) and endured various ups and downs, at times linked with the fortunes of the popes, at times with the emperors'. Dating from the first half of the fifteenth century, it was included in the possessions administered by the Church. The city was developed in the modern age, when it finally managed to avoid being overcome by civil strife.*

During the second world war, Terni suffered considerable damage to its ancient urban structure on account of the numerous bombing raids.

Today the city has a decidedly modern air about it, the outcome of post-War construction and an increase in building brought about by the proliferation of its industrial dimension. It is an important pole in particular for the iron, steel and metallurgical industries and for industry in general, and counts as one of the most striking realities of the secondary sector in Central Italy. Handcrafts are practised in the trades of goldsmithery and the making of costumes and masks. Piazza della Repubblica is the fulcrum of civic activities - a meeting place. Itinerant markets (on Wednesdays and Saturdays) offer all types of merchandise, artisan products and flowers. Next to the selling area is a curious livestock market.

Not to be forgotten among the various manifestations (concerts throughout the whole year) are the Show of Goldsmiths' Art *(February) and the* Terni Cantamaggio *(the end of April).*

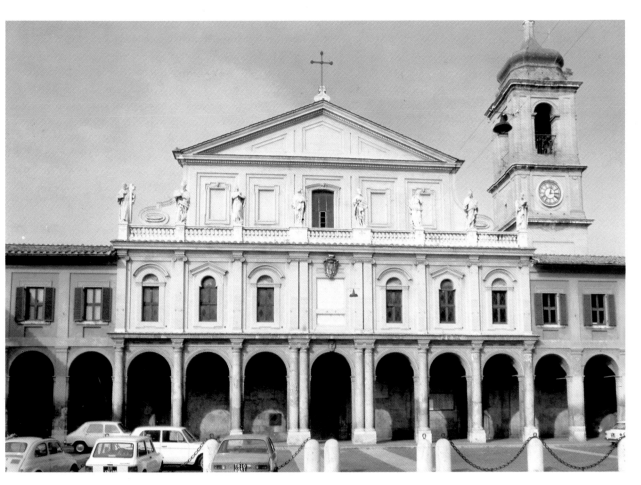

Terni, view of the Cathedral.

Terni, the beautiful façade of the Church of St Francis.

CATHEDRAL - The construction is the result of the seventeenth-century transformation of a Romanesque church. The ornate main portal, twelfth century, opens under a seventeenth-century portico as an introduction to the **façade**. The **interior,** divided into a nave and two aisles, preserves a remarkable sixteenth-century wooden choir, an imposing Baroque organ and a grandiose tabernacle of the eighteenth century. Of distinction among the pictures are an *Immaculate Conception,* executed by Flemish artists; a *Circumcision* and a *Presentation in the Temple* by Agresti (C16). Under the building is visible the apsidal **Crypt**, divided into three partitions.

CHURCH OF ST FRANCIS - A thirteenth-century Gothic building, it appears in the aspect which was conferred on it by fourteenth- and fifteenth-century additions (Angelo da Orvieto) and by some transformations carried out in the seventeenth century. The construction, overhung by a **Campanile** slendered down by two- and four-light windows (C15), has a façade opened by three portals, with a great central oculus and mullions at the height of the aisles.

The **interior,** divided into three parts, is characterized by the nave with its cross vaulting. An outstanding component is the **Paradisi Chapel** (C14), ornated with frescoed pictures by Bartolomeo di Tommaso (C15) who took his inspiration from *Episodes from the Divine Comedy*.

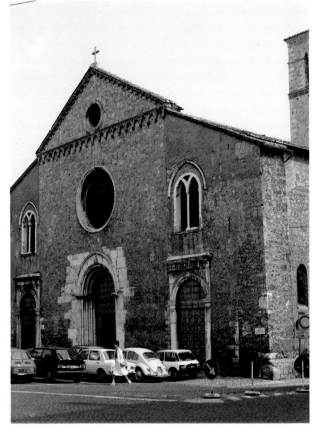

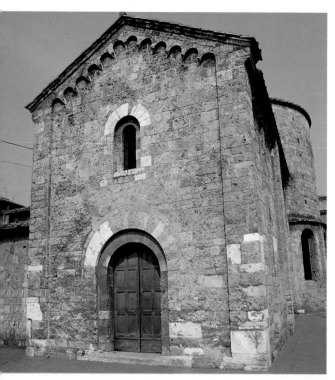

CHIESA DI S. SALVATORE - Antique and delightful construction, it is certainly the oldest church in Terni. The original building, in the manner of a circular lantern with arcades in the basement, rose up in the Paleo-Christian age (C5), probably over a Roman house. The rectangular avancorps is the outcome of a mediaeval addition (C12). The stark stone **façade** carries a portal surmounted by a window with one opening and by a triangular gable with blind arches. The **interior** preserves fragmentary thirteenth-century frescos in the circular segment. Worthy of mention is the **Manassei Chapel**, the frescos of which go back to the fourteenth century.

PALAZZO SPADA - A monumental Renaissance building, it is held to be the last project by Antonio da Sangallo the Younger before dying in the Umbrian city in 1546. The stupendous stone **façade**, framed by a fine cornice, is prolonged by two corner towers and is opened on the ground floor by three big arches.

Terni, prospect of the Chiesa di S. Salvatore.

Terni, partial view of the interior of the Chiesa di S. Salvatore, clearly of Paleo-Christian derivation.

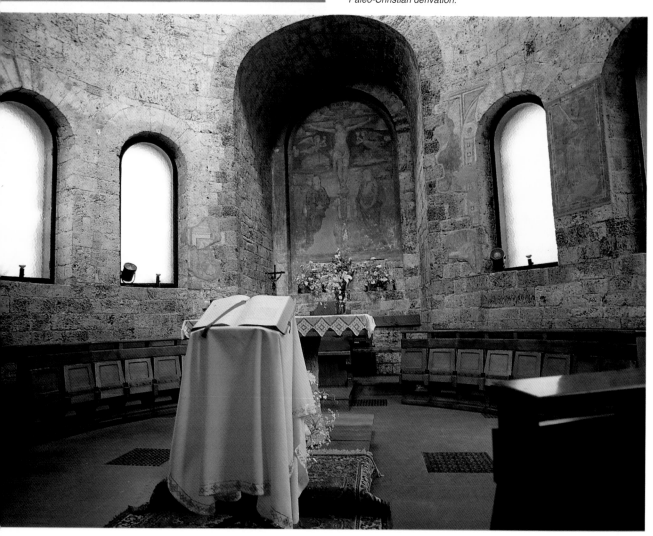

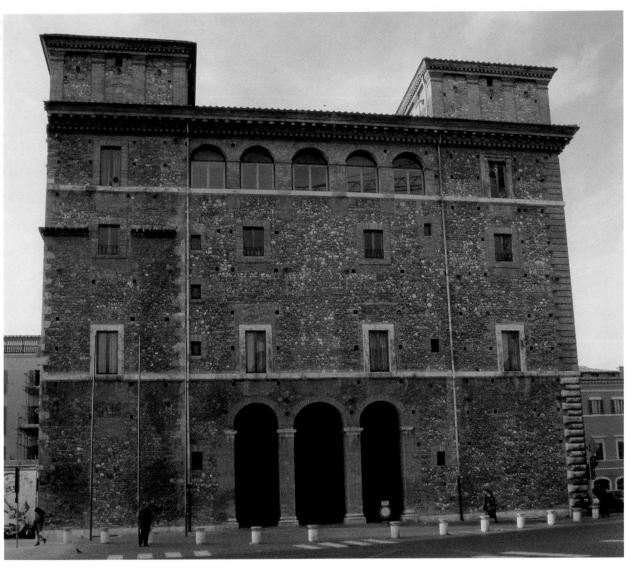

Terni, a view of Palazzo Spada.

Terni, Church of St Peter.

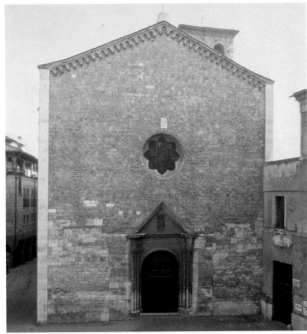

CHURCH OF ST PETER - The church, with its annexed **Cloisters**, is from the fourteenth century. The façade is embellished with a Gothic portal, ornated with a relief of the fifteenth century (*Christ blessing*).
The aisleless **interior** distinguishes itself for the vast polygonal apsis and the fourteenth- to fifteenth-century frescos.

CHURCH OF ST LAWRENCE - The building blends into the mediaeval quarter, which is characterized by the antiquity of some towers and houses. The church, originally of the thirteenth century, underwent transformation in the seventeenth century. The façade is decorated with a portal (C15) and a three-light window. In the two-naved **interior,** there is a picture of the end of the sixteenth century portraying the *Martyrdom of St Blaise.*

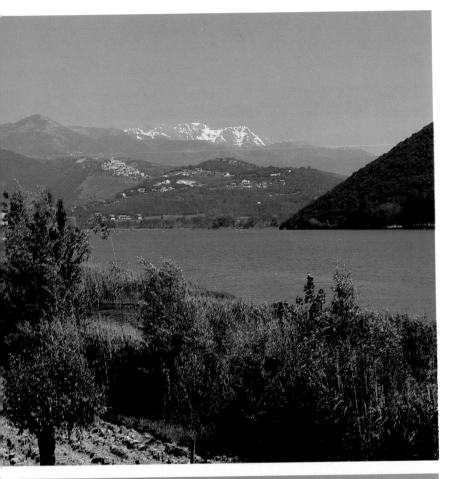

Environs

The **Cascata delle Marmore** (Marble Waterfall), so-called on account of the incrustations of calcium salts, very similar to marble, is a fantastic Roman hydraulic engineering works. So as to attract the waters of the Velino, stagnant in the basin of Rieti, a chanel was dug (C3 BC) which directed the waters to the Nera, along a drop of 165m. Today the falls are visible only on certain days and at set times because they are used to produce electric power. They constitute an awe-inspiring show which merges splendidly with the magnificent natural scenery. Two fitted-out observation points are available for tourists and visitors: the **Lower Belvedere,** near a gallery along the main Valnerina road, and the **Higher Belvedere,** which can be reached by deviating from the main road to Rieti. We recommend anyone wishing to admire the display of the waterfalls in function to find out opening times and days from the Tourist Promotion Board of Terni.

The picturesque **Lago di Piediluco,** the second lacustrine basin in Umbria after the Trasimeno, is situated in a beautiful natural tablature, among wooded hills and mountains. The transparent blue of the water reflects the houses of the hamlet of the same name, lying along the shores of the lake and watched over by a fourteenth-century **Stronghold.**

The **St Valentine Basilica** (Terni's patron saint) is just outside the township, on the site of the supposed burial place of the martyr. It is thought that the seventeenth-century church took the place of an ancient area of Paleo-Christian worship in the fourth century.

In the fifteenth-century **Chiesa di S. Maria del Monumento,** there is an interesting frescoed cycle, inspired by the *Legend of the Golden Apples.*

Piediluco (Terni), a panoramic view of the picturesque lake encircled by mountains.

Piediluco (Terni), the houses of this charming village are mirrored in the crystal-clear waters of the lake.

Cascata delle Marmore (Terni), a spectacular view from the Lower Belvedere.

Todi, a splendid panoramic view.

TODI

HISTORICAL NOTE - *An ancient, proud mediaeval city, it rises up in the midst of lovely hilly scenery on a hill dominating the confluence of the Naia into the Tiber. This particular setting emphasizes the rapport of continuity and integration that exists between the urbanized centre and the countryside. Probably founded by the Umbrian citizens of Veio, the ancient* Tutere *was certainly influenced by the Etruscans who had settled along the banks of the Tiber. It was Romanized around the mid fourth century BC, and was known as* Tuder *in the Imperial age. Sacked by the Goths and Byzantines, it became a free Commune immediately after the year 1000. Having increased in power, it extended its dominion as far as Amelia (1208) and Terni (1217). Dating from the second half of the fourteenth century, it lived under the rule of the Malatestas, Biordo Michelotti, the Anjous, Braccio Fortebraccio and the Sforzas. Successively, the city came under papal control. The sixteenth century was characterized at Todi by the figure of Angelo Cesi, patron-bishop who did so much for the urban and monumental development of the city and for its revival after a dark period marked by plague and famine. An important administrative seat of the Department of Trasimeno under Bonaparte, it was assigned once more to the pope of the post-Napoleonic restora-*tion. *An active participant in the fervent movement of the Risorgimento, it shared the fortunes of numerous other Umbrian centres, which ended up with adhering to the new unitarian State.*
The city saw the birth of Iacopo de Benedetti (1230-1306), better known as Iacopone da Todi, a spiritual Franciscan, a great Latin and Vulgar poet and the author of the renowned lauds. The urbanistic dimension of Todi has happily been preserved at the measure of man, mostly enclosed within the perimeter of the ancient town walls. Included are buildings wonderfully enlivened by the use of limestone. Todi artisan crafts are notable principally for the production and restoration of antique-style furniture, however workmanship connected with ceramics, majolica and jewellery is not lacking. Among the tasty tit-bits of the area mention should be made of pan nociato, *bread made of sheep's cheese, walnuts and sultanas. Manifestations are numerous; the* Antiquarian Exhibition of Italy *(March-April), the* National Trade Fair of Antiques *(June - July), the* Festa di S. Maria della Consolazione *(8 September), the exhibition* Todi Festival *(September), the feast day of the patron* S. Fortunato *(14 October) and the* Fair of St Martin *(11 November).*

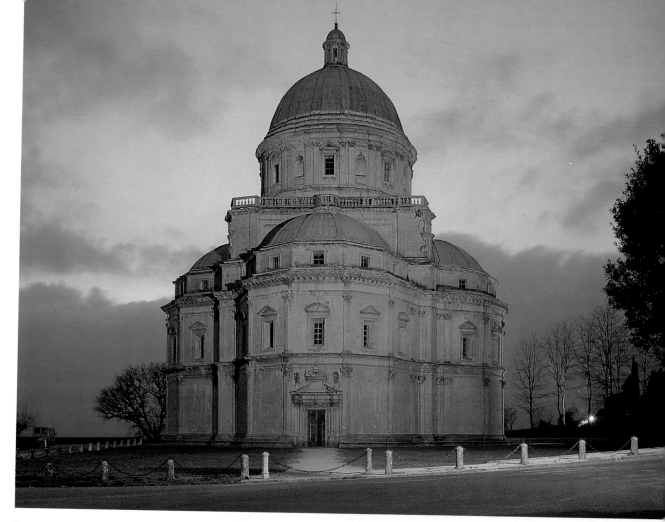

Todi, a delightful partial view of the Tempio di S. Maria della Consolazione, and a detail of the interior.

TEMPIO DI SANTA MARIA DELLA CONSOLAZIONE -

A noble example of Renaissance architecture, it is the first Todi monument that presents itself to the sight of travellers coming off the motorway. Its construction - undertaken on the site where there lay a revered effigy of Mary, subsequently called *S. Maria della Consolazione* - was begun in 1508 probably after a draft by Bramante. The temple, completed almost a century later, received proposals and suggestions, presented over the whole century by distinguished architects of the time, such as Peruzzi, A. da Sangallo and Vignola. The structure of the building, in the shape of a Greek cross, stands out because of its big central dome, imposed on an elevated drum rising out of a terrace with a balustrade. Underneath are the four apses, crowned by the same number of hemispheric calottes.

The **interior,** of great monumental significance, houses the afore-mentioned picture which gives its name to the temple and seventeenth-century sculptures of the *Apostles,* carried out by pupils of Scalza.

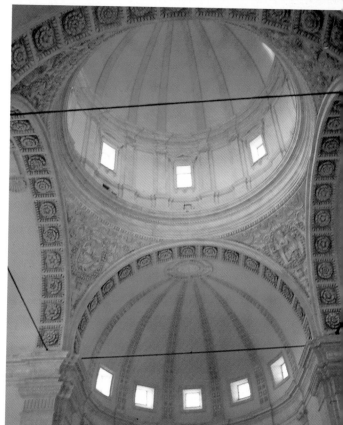

111

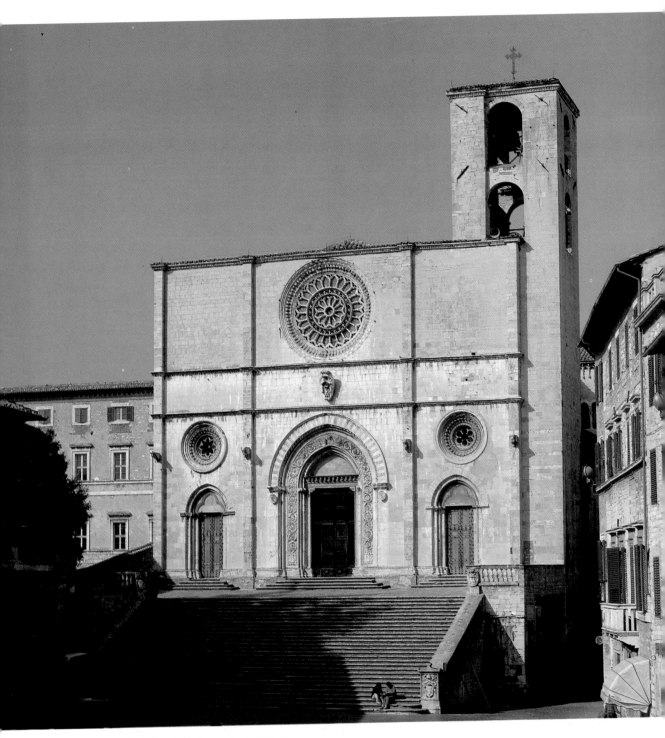

Todi, the façade of the Cathedral, flanked by a robust bell tower.

CATHEDRAL - The construction dominates the monumental *Piazza Vittorio Emanuele* from the height of a flight of travertine steps. The **Crypt**, constitutes the most ancient part, being, together with the apsis, from the eighth century. The present-day church, erected in an area near the Capitol which had already been sacred to the Romans, initially was Roman in character (C12). Subsequently it was transformed with Gothic elements (C13), and was concluded practically in the sixteenth century. The temple, dedicated to *S. Maria dell'Annunziata*, has a fine rectangular façade, partitioned by pilaster strips and mouldings and opened by three rosettes (the central one, which is double, is splendid) and the same number of Gothic portals. The present main façade, recently restored, replaces the original Romanesque imprint, and it is flanked by a robust **Bell Tower** (previously for defence purposes) of the thirteenth century.

The **interior**, basilical, is divided into three sections, even

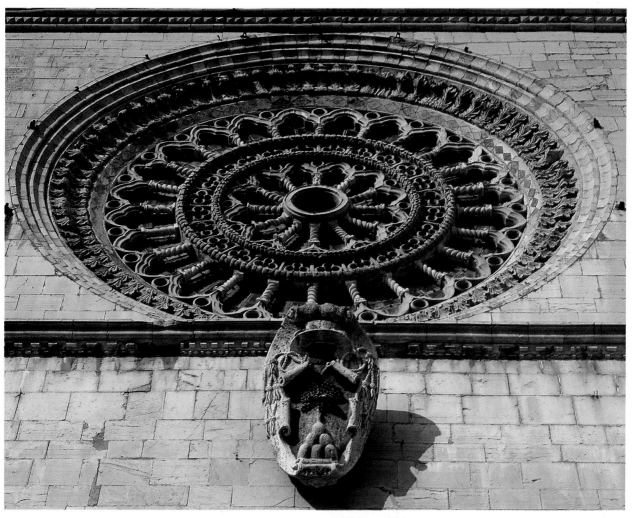

Todi, Cathedral: detail of the main façade, the central rosette.

Todi, Cathedral: detail of the wide staircase at the entrance.

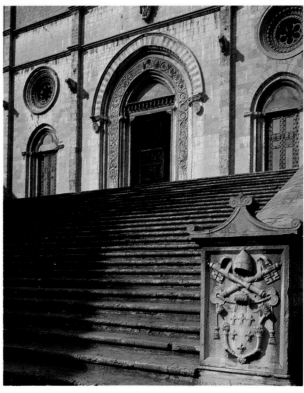

though another aisle was added in the second half of the fourteenth century. On the counter façade, there is a *Last Judgement* frescoed by Faenzone (Ferraù da Faenza, C16). The left aisle preserves some sculptures by Giovanni Pisano. In the smallest aisle are displayed pictures by Spagna and Giannicola di Paolo and a fifteenth-century font. In the apse covering, the walls of which bear eighteenth-century frescos, there is a thirteenth-century *Cross* painted after the manner of Giunta Pisano. Note also the precious wooden choir, executed by Antonio Bencivenni of Mercatello and his son (C16). The two paintings portraying *St Peter* and *St Paul* are the work of Spagna.

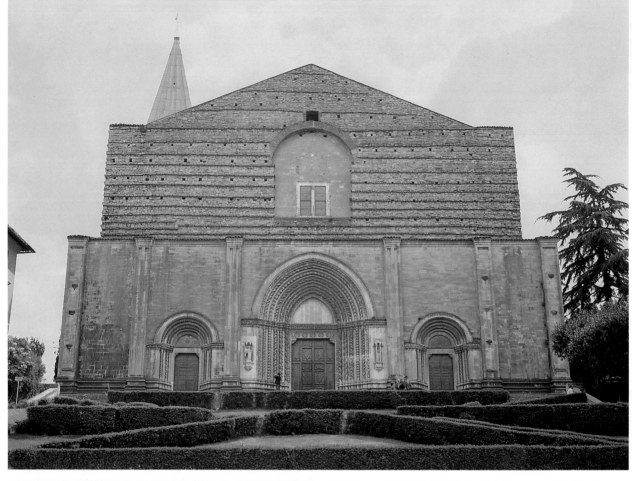

Todi, the rough façade of the Chiesa di S. Fortunato embellished with the lovely central portal.

Todi, detail of the interior of the Chiesa di S. Fortunato.

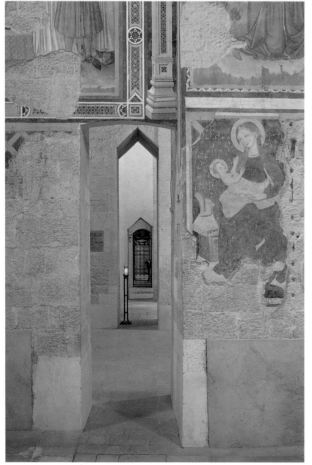

CHIESA DI S. FORTUNATO - A splendid Gothic church built between the thirteenth and fifteenth centuries on a pre-existing place of worship (dating from the end of the eleventh-century) which had been annexed to a conventual building. The **façade** of the temple rises up at the top of a scenic although steep and fatiguing series of steps. The aim of accomplishing a marvellous decorative work is clear in the completed lower half; however, it remained mostly unrealized in the upper order which, on the contrary, is rough and crude. Of the three portals, the middle one is ogival in shape, markedly splayed and richly decorated.It is enclosed between the fifteenth-century sculpted figurations of *Gabriel* and the *Virgin Mary*, ascribed to a scholar of Jacopo della Quercia.

The majestic **interior,** having three grandiose Gothic naves with cross vaulting, all of the same height, was recently restored and displays an excessive use of white on the plaster. In the right aisle there are some chapels with fragmentary frescos in a Giotto-type setting. The fourth chapel presents an outstanding fifteenth-century fresco (*Madonna and Angels*) by Masolino da Panicale. Behind the main altar, a seventeenth-century votive statue of *S. Fortunato* stands as a monument. In the apsis portion, illuminated by large, two-lighted windows, there is a really remarkable choir from the late sixteenth century, finely carved by Antonio Maffei from Gubbio. The **Chapel of Our Lady of Loretto**, on the left, has seventeenth-century decorations and a wooden figure of the *Loretto Virgin*. The *Tomb of Iacopone da Todi* is in the **Crypt**.

CHIESA DI SANT'ILARIO - The current denomination of the *Chiesa di S. Carlo* derives from the use that the Company entitled to that saint put it to as from the first half of the seventeenth century. The building was consecrated in 1249. The notable Romanesque **façade** of stone, opened up by a simple portal and a just as simple (although lovely) rosette stands out. On the crowning part an airy, double-order bell-gable rises, with ornamental mouldings which we find again in the width of the main façade. The **interior** preserves a *Madonna del Soccorso*, frescoed by Spagna.

PIAZZA VITTORIO EMANUELE II - Called *Piazza Grande* in ancient times, it was probably sited on the Roman Forum and had greater dimensions than at present. Counted as one of the most beautiful mediaeval squares, it is surrounded by numerous monumental palaces of the age and is dominated by the Cathedral. Facing the latter, on the opposite side of the square, there is the turreted outline of the **Palazzo dei Priori**. The building was terminated in the first half of the fourteenth century, joining together some pre-existent dwellings. At one time the seat of the *Priori*, it was subsequently the

Todi, the delightful façade of the Chiesa di Sant'Ilario.

Todi, Piazza Vittorio Emanuele II; at the back the crenellated Palazzo dei Priori is silhouetted, flanked by the imposing trapezoid-shaped tower

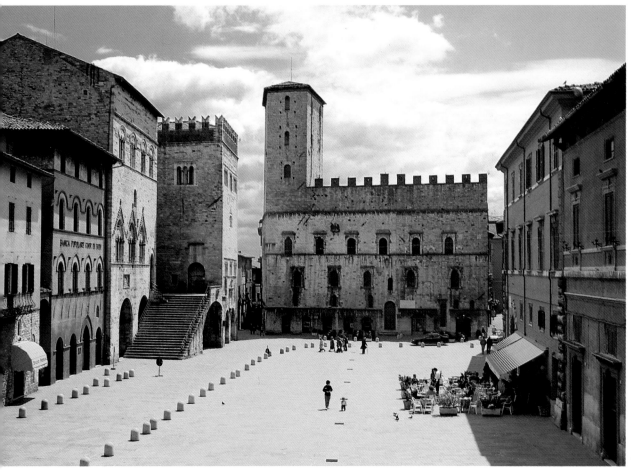

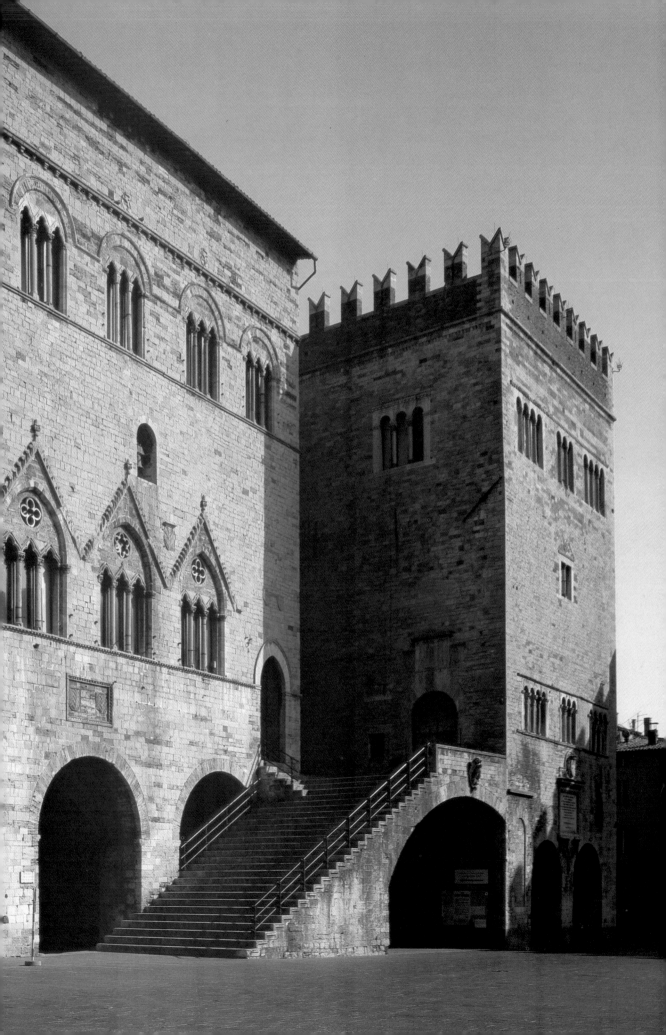

home of the papal governors, so that it is also known as the **Palazzo del Governatore**. The mighty trapezoid-shaped **Tower** was added in the second half of the fourteenth century and was originally much higher than it appears in the present day. The palace is crowned by Guelph crenellation. The windows of the two orders are the outcome of sixteenth-century transformations. The bronze *Aquila tuderte* (an eagle, symbol of Todi) which stands out over the second order is the work of Giovanni di Gigliaccio (1339).

The **Palazzo del Capitano** is a thirteenth-century construction with a ground floor loggia and a broad flight of steps to the entrance. The façade is embellished with threefoiled, cuspidate, three-light windows in the first order, while in the second order, the same windows, but without the cusps, seem to be more inspired by a Romanesque concept. On the first floor there is a vast hall with two arches, enriched with stems and fragments of frescos. The building is used as a museum site.

The **Palazzo del Popolo**, of the thirteenth century, is distinguished by the Ghibelline crenellated crowning and is joined to the latter building by the same flight of steps. The façade is ennobled by two orders of mullioned windows with several lights, whilst on the ground floor two arches open right in the middle.

ROMAN-ETRUSCAN MUSEUM AND CIVIC PICTURE GALLERY - They are collocated in the **Palazzo del Capitano**. The Etruscan and Roman antiquities include numerous finds coming from a necropolis in the district. Numerous are the objects in terracotta (c4 to c2 BC), the bronzes for offerings and also a minter. There is a copy of the *Todi Mars* as well, the original having been moved, along with other finds, to the Vatican Museums. Among the pictures enriching the *Pinacoteca*, we may mention parts of a fifteenth-century triptych by Sienese artists, a *Crowned Virgin* by Spagna, and works of other Umbrian and Tuscan artists. Finally even articles in gold and antique ceramics can be found.

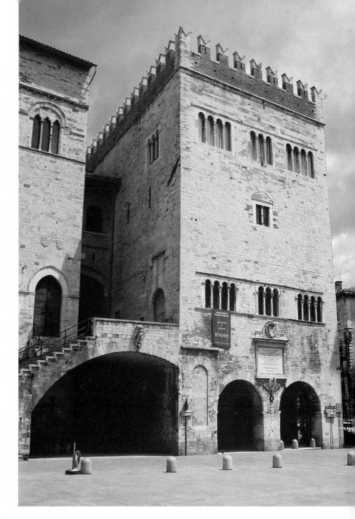

Todi, two views of the splendid Palazzo del Popolo, crowned with a Ghibelline crenellation.

Todi, the elegant façade of the Palazzo del Capitano.

Followings pages:

Todi, detail of the mediaeval walls and gate.

Todi, the Porta Catena.

Todi, panorama.

Todi, the Tempio di S. Maria della Consolazione seen from the Belvedere of the Rocca stronghold.

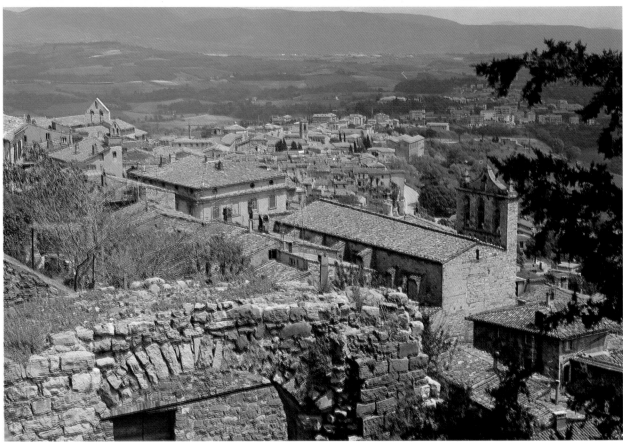

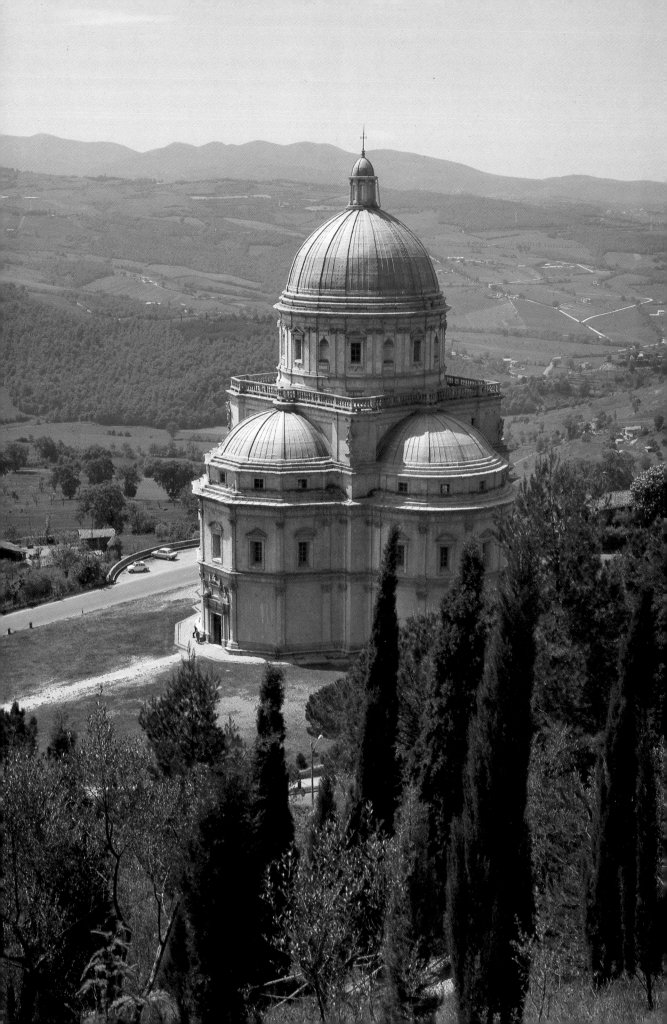

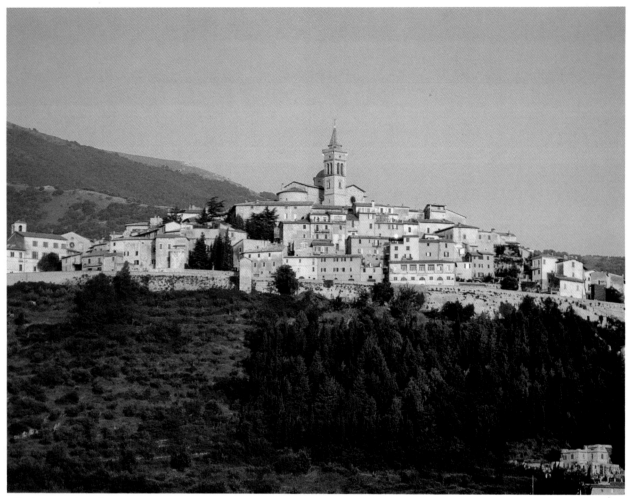

Trevi, panoramic section.

TREVI

A mediaeval hamlet of considerable dimensions, it extends over a green hill in a dominating position of the Umbra Valley, in the stretch that the Clitunno flows through. The first settlements of Umbri had been established on the plain, on the site of the present-day Pietrarossa. After becoming the Roman municipality of *Trebiae*, it expanded along the *Flaminian Way* and was a Lungobard possession at the time of the Dukes of Spoleto. With the advent of freedom as a Commune (C13), it had to undergo the conflict between the powerful nearby cities of Perugia, Foligno and Spoleto. Around the mid fifteenth century, it became part of the territory governed by the Church. Having obtained the status of a city from Pius VI (1784), it was annexed to the Kingdom of Italy in 1860.

Among the manifestations, we wish to remember the *Processione dell'Illuminata* (27 January) on the eve of the feast day of the patron saint S. Emiliano, the *Tombola of the Town Districts* (a live tombola in costume, June) and the *Palio dei Terzieri*, a mediaeval contest with a historical retinue of figurants (October).

The fourteenth-century **Palazzo Comunale** has a portico from the fifteenth century and a balcony from the seventeenth. Numerous were the transformations enacted in the fifteenth to seventeenth centuries. At the side soars the stone **Torre Comunale** of thirteenth-century construction, crowned with corbels and four battlements and complete with a great bell from the sixteenth century.

The **Pinacoteca,** ordered in the rooms of the Palazzo Comunale, includes archaeolgical finds of the Roman period. Works of Spagna (*Our Lady's Crown*), Pinturicchio (*Madonna and Child*), and Giovanni di Corraducci (*Episodes from the Life of Christ*), are exhibited, along with a votive picture by pupils of Alunno, a painted thirteenth century *Cross* and a *Crucifix* with fourteenth-century painting.

The Renaissance **Palazzo Valenti** stands out among the numerous upper-class palaces. Previously the home of an ancient, illustrious Trevi family, it has a façade enriched by a fine ornate portal. The internal courtyard is charming with its portico, covered steps and well-head.

The **Church of St Francis**, of the thirteenth century, denotes Gothic characteristics in the windows and portals opening in the sides. The lunette over the main portal is decorated with a barely perceptible fresco of the fourteenth century. The interior houses the fourteenth-century sepulchre of *Gioacchino Valenti* and the remains of a co-eval tomb. The walls preserve scraps of an antique fresco cycle. Note also the fourteenth-century *Crucifix* in the apsis (of the Umbrian school).

The ring of thirteenth-century **town walls** - actually the second urban circle - exhibits an extremely panoramic, circular **Tower**. The **Torrione della Neve** (Snow Tower), exposed to the north wind, derives its curious name from its past function as an ice-box.

Built in the twelfth century, the **Chiesa di S. Emiliano** has suffered from the transformations brought about in the fifteenth to eighteenth and nineteenth centuries. Three apses from the original building are today visible on the right side. The fine fifteenth-century portal is crowned with a tympanum bearing precious high reliefs (*S. Emiliano among the lions*). On the inside, the beautiful Sacrament altar (C16), executed by Rocco di Tommaso from Vicenza, can be admired, together with a wooden statue portraying the *Patron Saint* (C18).

The so-called **Portico del Mostaccio** includes the remains

Trevi, view of the Tower and Palazzo Comunale.

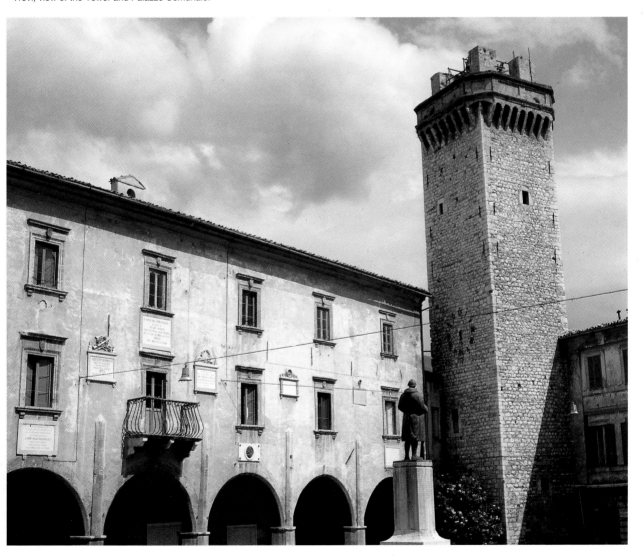

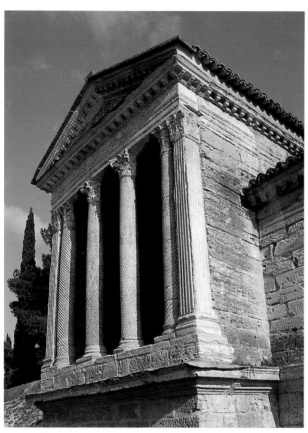

of a gate which opened within the circuit of the Roman walls. The round arch and the mullion above it are the outcome of thirteenth-century additions.

In the surrounding district there is the **Madonna delle lacrime**, late fifteenth century, named thus after a miraculous event which happened to the revered effigy of the *Virgin and Child* collocated in the interior and which provided the cue for the construction of the temple. The church has a delightful Renaissance portal and houses pictures by Perugino (*Adoration of the Magi, SS Peter and Paul*), frescoed pictures by Angelucci da Mevale and seven *Sepulchral Monuments to the Valenti* (C16 to C17).

The **Church of St Martin**, with its annexed convent, is situated in a beautiful panoramic position. The fourteenth-

Tempietto del Clitunno (Campello sul Clitunno), view of the façade of this building, also known as the Chiesa di S. Salvatore.

Fonti del Clitunno (Campello sul Clitunno), a picturesque view of the idyllic springs celebrated by scholars and poets.

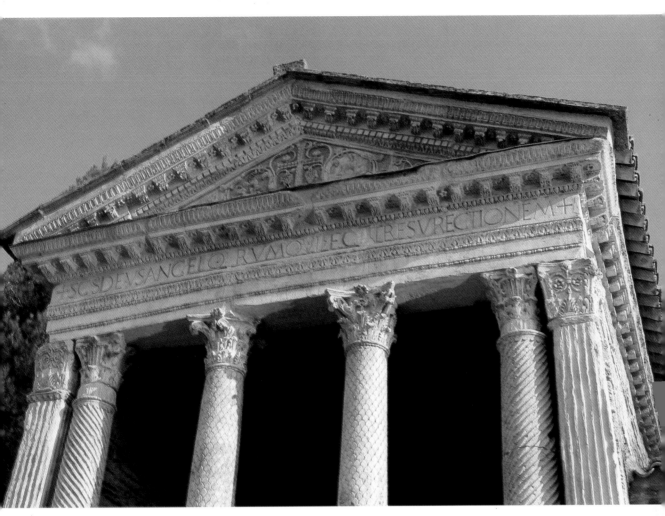

Tempietto del Clitunno (Campello sul Clitunno), a detail of the temple façade.

century building bears a fresco by Tiberio d'Assisi in the portal, while in the interior we can distinguish works by P. Mezzastris, one of the best-known exponents of the Foligno school of painters (*St Martin and the Beggar, Virgin and Child among the Saints and Angels*). A little nearby chapel houses frescos by Spagna and Tiberio d'Assisi.

On the site of the ancient Roman city, most probably where the spas were, there is the **Chiesa di S. Maria di Pietrarossa** (C14). The porticoed building is extremely rich in frescos and votive paintings from the fourteenth to fifteenth centuries (there are over 90).

In the little hamlet of **Bovara** there is the note-worthy **Church of St Peter** (C13). The construction has kept some elements from the original Romanesque building - the rosette and bas-relief of the pediment. The interior, divided into three sections, has the form of a basilica, but was distorted by the raised presbytery and the apsis (C14). A wooden *Crucifix* (C15) is kept here.

The most important touristic element of the district around Trevi is the **Tempietto del Clitunno** (or the *Church of S. Salvatore*), which is included in the Commune of Campello sul Clitunno. This is a Paleo-Christian building (C5) constructed using material from disused Roman edifices. Note the fine architectonic workmanship of this temple, with the pronaos and pediment supported on Corynthian columns. In the interior mural pictures are visible (*Christ Omnipotent among the Angels* is worthy of note) which are counted among the most ancient expressions of Paleo-Christian art in Umbria (C7 to C8).

The alluring **Fonti del Clitunno** nearby are inserted into a picturesque setting of great charm. The tranquility of the place and the beauty of the senery which is characterized by numerous creeks and weeping willows mirrored in the little lake have caused this watering place to be celebrated by poets and scholars (among whom Virgil and Carducci are counted). In the past, the water gushing from the living rock and numerous springs used to charge some mills.

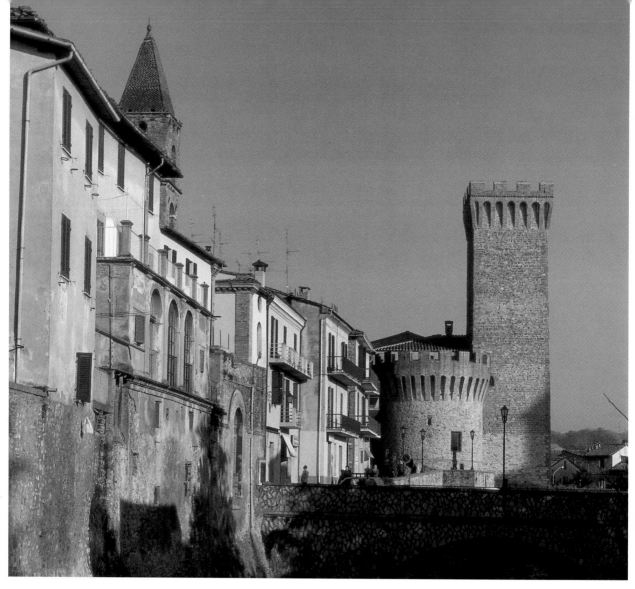

Umbertide, perspective view over towards the Rocca stronghold.

Umbertide, detail of the crenellated tower dominating the mighty Rocca.

UMBERTIDE

A town functioning as an important road junction in the upper Tiber Valley, it boasts historical, cultural and artistic interest. The locality must have enjoyed a degree of greatness even in ancient times, if it is true that it constituted a meeting and exchange point between the Etruscan and Umbrian populations along the banks of the Tiber. Little more than a village in the Roman age, when it was called *Pitulum*, it disappeared under the devastation brought about by the Ostrogoths and by Totila. Risen up again as *Fratta* at the wish of the sons of Uberto, marquis of Tuscany (end of C8), it governed itself autonomously until the second half of the twelfth century, when it was placed under the control of Perugia for defensive reasons. Almost a century later, it gave itself a free constitution and was provided with a stronghold where Braccio Fortebraccio was imprisoned. Around the mid sixteenth century, the town was briefly entrusted by papal concession to Paolo di Niccolò Vitelli. In 1643, Fratta opposed the Florentine besiegers, who were obliged to give up the venture, not without a heavy toll of casualties and with considerable devastation. For a long time it remained under the control of the Church, with the exception of the brief Napoleonic interlude, and was integrated into the Kingdom of Italy in 1860. Three years later, it acquired the present-day name, to the everlasting memory of Uberto, father of the founders of the ancient Fratta. Today Umbertide boasts an ancient tradition of the artisan craft of ceramics, added to an excellent gastronomy. Among the various festivities, the August concerts of *Rockin' Umbria* and the celebrations on the occasion of the *Festa della Madonna* (8 September) are the most significant.

A turretted **Rocca** with battlements constitutes the most notable evidence of Mediaeval military architecture in the town. The building, girdled by mighty walls, is made up of a great, high tower and three other towers, crowned with crenellation supported on corbels. Built after a project by Trocascio (Angelo di Cecco), it was completed between 1374 and 1390.

The **Chiesa di S. Maria della Reggia** (or *Regghia*) is a singular sixteenth-century domed construction on an octagonal plan. The circular interior is delightful, with Doric columns supporting the trabeation on which the dome rests. A *S. Isidore* of the school of Reni (C17), an *Our Lady of the Assumption* by the eighteenth-century Perugian

Umbertide, view of the Chiesa di S. Maria della Reggia.

Montecorona Abbey (Umbertide), view of the interior of the church.

painter, G. Laudati, and a fifteenth-century fresco portraying the *Madonna and Saints* can be admired here.

Not to be forgotten are also the churches of **St Francis** (with annexed cloisters, C14) and of **S. Croce** (C17) for the works of art they contain (*Madonna and Saints* by Pomarancio and the *Deposition* by Signorelli).

Finally, in the surroundings, there is the notable **Montecorona Abbey**, founded by St Romuald (C11). In the church of the abbey, highly prized architecturally, with the nave divided into three parts and a raised presbytery, there is an interesting fresco of the fourteenth century (*Annunciation*). The beautiful crypt preserves Byzantine and Romanesque designs.

INDEX

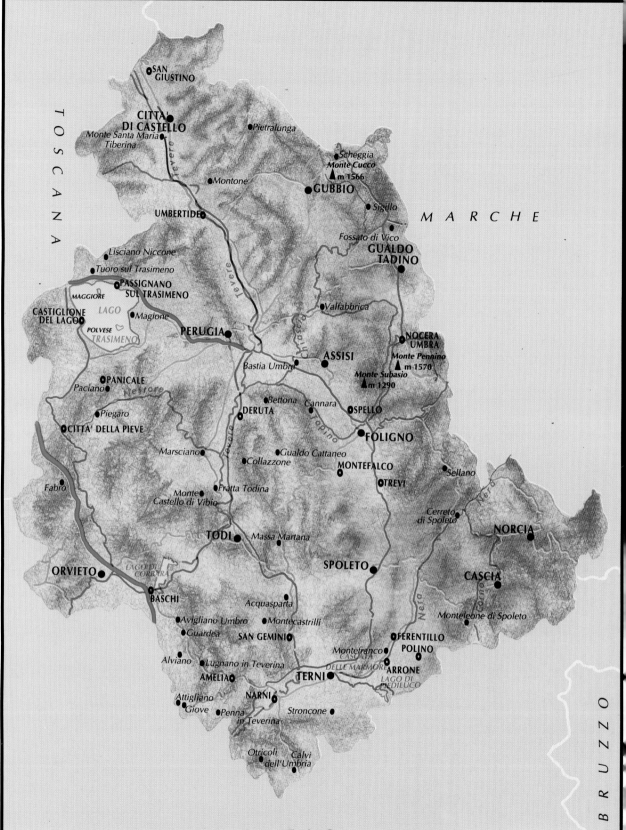